Colored Pencil Society of America

SIGNATURE SHOWCASE

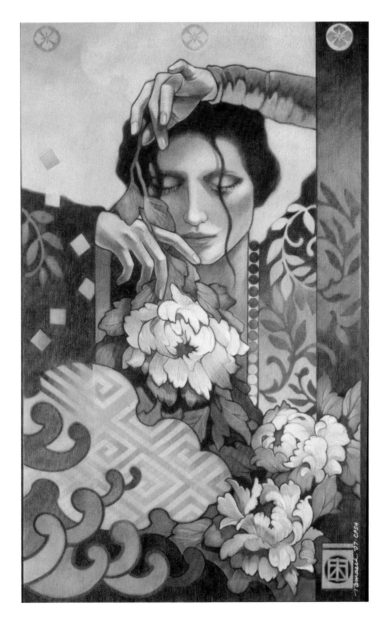

Complied by

Vera Curnow

CPSA

Colored Pencil Society of America

First published in the United States of America by:

CraneDance Publications

PO Box 50535, Eugene, Oregon 97405-0983

Telephone: 541-345-3974

Available for purchase online from CPSA:

www.cpsa.org

Or

write to Vera Curnow, 211 Main Street, Rising Sun, IN 47040.

Signature Showcase

The Colored Pencil Society of America

ISBN 978-0-9708895-6-0

Editors: Vera Curnow, Kay Schmidt

Design: Rick Boggan

Front Cover Art: *Labino Tribute*–Bonnie Auten

Title Page Art: *Cybele*–Carol Tomasik

Back Page Art: *Enter the Night II*–Rita Mach Skoczen

Back Cover Art:
Toni James (1)
Sylvia Westgard (2)
Elizabeth Patterson (3)
Jeff George (4)
Monique Passicot (5)
Linda Koffenberger (6)
John P. Smolko (7)

Printed and Manufactured in the United States by:

Lynx Group Printing, Salem OR

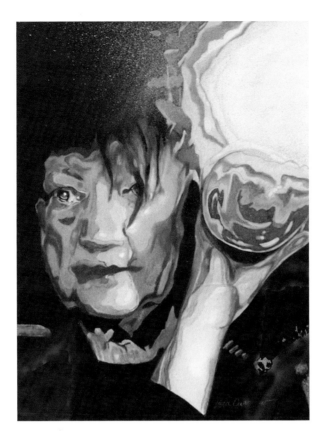

FOREWORD

The CPSA Signature Showcase book has been in the making for the last twenty years. It was back then that I began my quest to connect with other colored pencil artists. Yes, I admit that initially it was a self-serving act. At the time, there was very little information published about the medium, and I knew of no other artist who worked with it. So, for a few years, I plodded along, experimenting as I went. Then, in 1989, I wrote a letter to *The Artist's Magazine*. This simple act changed my life, opened new doors, and brought a flood of wonderful colored pencil artists into my world–and The Colored Pencil Society of America was born.

This book acknowledges the many members who have earned CPSA Signature Status over the years. They accomplished this by having their artwork juried into three of our seventeen International Exhibitions within a ten-year period. As you turn the pages, you will be amazed at the broad range of subjects and styles–from photorealistic renderings to abstracts and graphic illustrations. The paintings are as diverse as the artists who created them.

Thank you for joining us in this milestone celebration of art and artists. Enjoy.

Vera Curnow, Founder
Colored Pencil Society of America
www.cpsa.org

DEDICATION

This book is dedicated to all
CPSA Members and to our
many Patrons and Sponsors
who have supported us through the years.

A special acknowledgement goes to
those who have served on the
National Governing Board and to
our District Chapter Presidents.

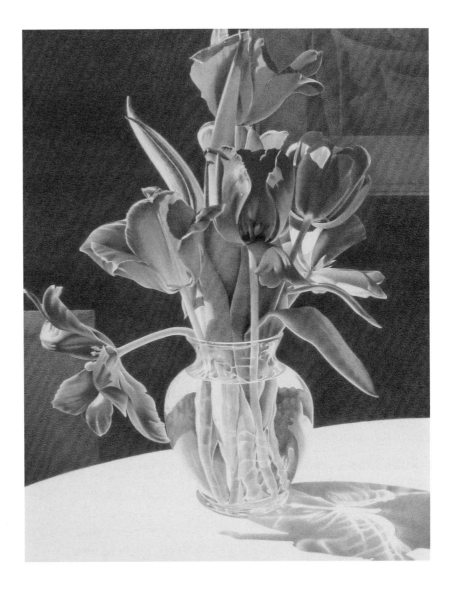

DEANE ACKERMAN
Tulip Time

20 x 16"

Rising Museum Board

My interest in art began in early childhood. Moving from one medium to the next, I first discovered sculpture in my high school art class. I found the three-dimensional form fascinating, and it has been very apparent in most of all of my work throughout the years. When I discovered colored pencil about 25 years ago, it afforded me the added ability to capture an image in its fullest dimension, plus the pleasure of working in rich, beautiful color.

Tulip Time is a very good example of my work in general and the subject matter that I love to capture. I'm always looking for a strong light source that will create interesting and intricate highlights and shadows. Objects that are transparent or reflective are particularly fascinating to me, including elements that are viewed through water. I love to examine and capture that special moment of time and light with its intricate details–colored pencil allows me to do just that.

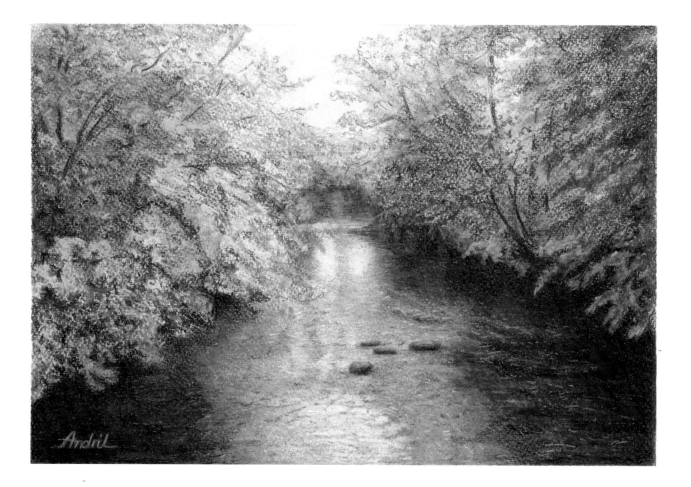

PATRICIA ANDRIL
Tranquility

6.5 x 9.5"

Watercolor Paper

The drawing, *Tranquility*, explores water and I have tried to capture the serenity of the scene. Here there is just a breath of breeze and the movement of the water appears gentle as it meanders downstream.

BONNIE AUTEN
Labino Tribute

22 x 31"

UART 600 Sanded Paper

This picture came about after I viewed some blown glass at the Hudson Gallery in Sylvania, Ohio. The pieces were not perfect or exceptionally beautiful, but they were unique and many would say historic.

These pieces were created by Dominick Labino, a very important and innovative glass craftsman. As a chemist he researched the challenging properties of glass, glass formulas and furnaces. His work is well known and is found in museums throughout the world.

My purpose in rendering this picture was to somehow honor his work and to show it from a 2-dimensional perspective. It was a wonderful challenge, and I am especially pleased with the final result.

Using water-soluble and soft colored pencils, this work was very detailed. Layers of colored pencil and washes were manipulated constantly to create the effect of the glass's unique characteristics.

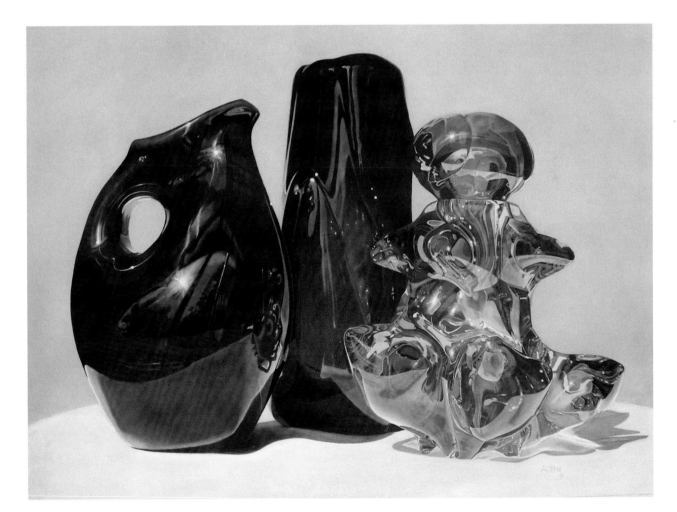

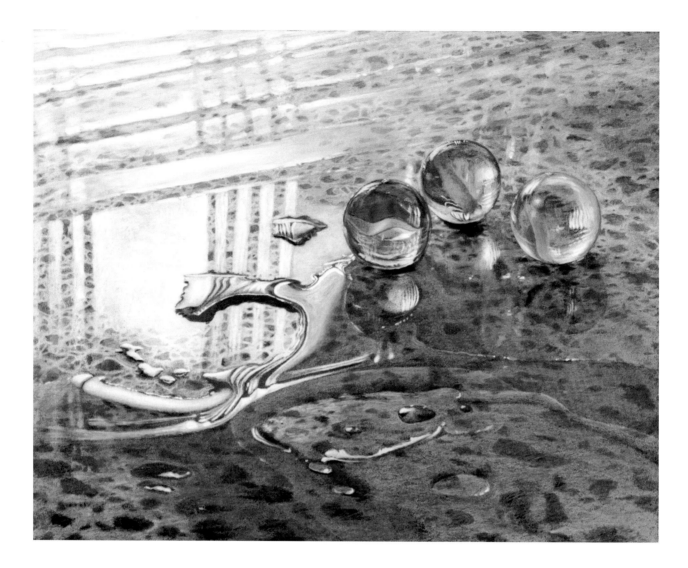

PAT AVERILL
Light Catchers

11 x 14"

Stonehenge Paper–Black

The play of light has always been an inspiration for me. One day I was busy working in the kitchen when I happened to notice interesting patterns made from a blue vase in my window and an old pressed glass butter dish leaning against the sill. Water had spilled on the counter, and I decided to add a few marbles to see how it looked. The reflections were fascinating! I took some photos and then went to work in my studio.

Since my counter was dark, I used black Stonehenge paper and made a "reverse grisaille" in white pencil. This gave me an idea of the composition and established the lightest areas. I applied layers of lightfast colored pencil to the marbles and water, and then worked on the granite using colorless blending pencils. Against the black, they helped to establish the patterns in the counter and made it easier to burnish with the proper color. Black paper tends to soak up color, so many layers were necessary to make the marbles stand out. I burnished the background and highlights on the marbles.

DANIEL BAGGETT
Summer's Moment in Time

18.5 x 20.75"

Stonehenge Paper

I have always been attracted to hot colors. This arrangement caught my interest, not only for the colors, but also for that crisp dose of reality I love so much.

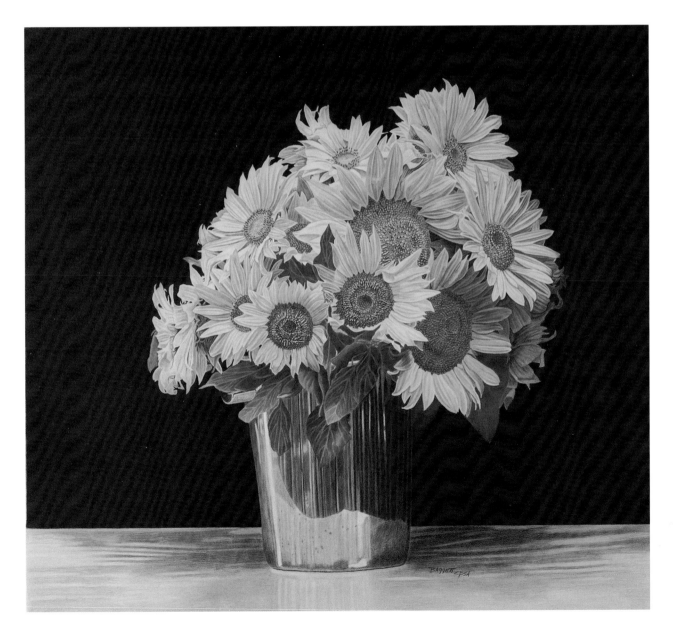

CECILE BAIRD
Time to Reflect

17 x 14"

Stonehenge Paper

This is a very personal and emotional piece for me as it is a portrait of my 86-year-old (at the time) father, Fred. I thought of doing a very traditional portrait, but I really wanted to create a work that would say something and have meaning to every viewer not just to those who know and love my Dad. Hopefully, this relates to you or someone you know, as each of us will reach a point in our lives when it is time to reflect.

JEFFREY SMART BAISDEN
Adjourned

20 x 30"

Strathmore 4-Ply Museum Board

Metal chairs, arranged in meeting format and rearranged by human activity, captured my interest in an old abandoned armory. The back lighting and shadow play on the floor and the surface of the metal attracted me. Balancing the warm and cool temperatures to present a consistency in the piece was important. Each chair reflected its own uniqueness in shape, color and varying degrees of wear. My objective in this composition was to explore the human qualities taken on by the grouping and the deafening stillness created by the dramatic light.

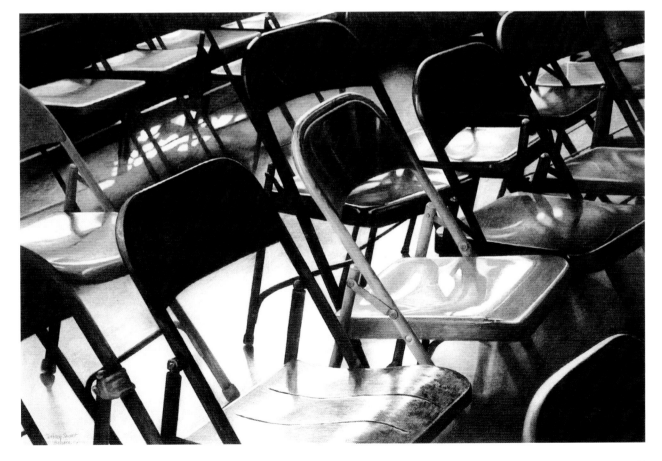

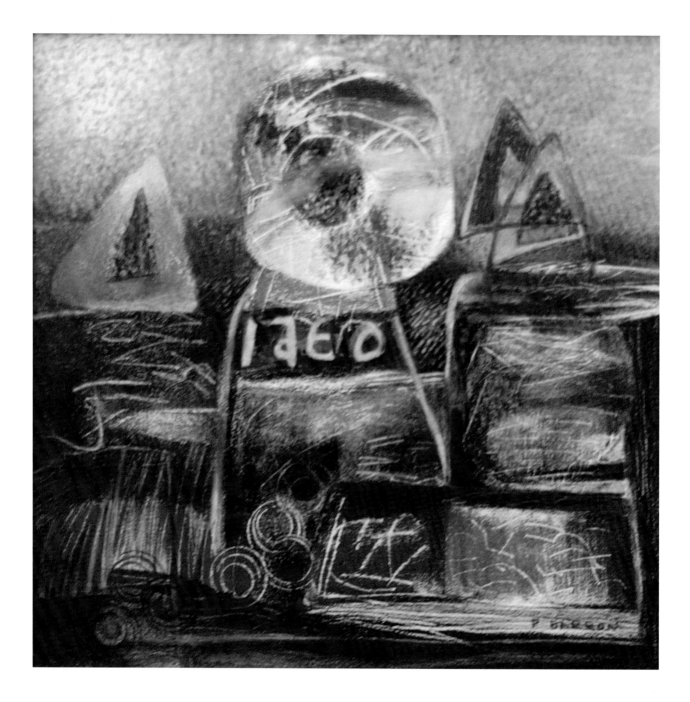

PAT BARRON
The Sentinel

12 x 12"

Somerset Book Paper

I noted that the CPSA International Shows had few abstract paintings. Pencils points don't lend themselves to abstraction. However, a frottage board under a lighter weight paper frees the pencil to make startling textures, bold shapes and heady color mixtures. The lightweight Somerset Book paper I use withstands a beating.

DONNA BASILE
My Mona Lisa

43 x 39"

Stonehenge Paper

Known for my realistic renderings in colored pencil, I wanted to reproduce a classical masterpiece with a fresh technique and explore various aspects of the subject to prove that the boundaries of colored pencil are limitless. To capture the soft luminous glow, many layers of colored pencil were applied using non-directional backward "S" strokes. Working from light to dark with just the tip of a pencil, each section of the drawing was painstakingly worked simultaneously, as opposed to completing one area at a time, in order to retain symmetry throughout the drawing. Due to the large scale, the drawing was done from a standing point of view, and I had to walk back to see the entire work—all creative and proportional decisions were made from that distance. What I did not want to produce was an exact likeness of the Mona Lisa, only my rendition.

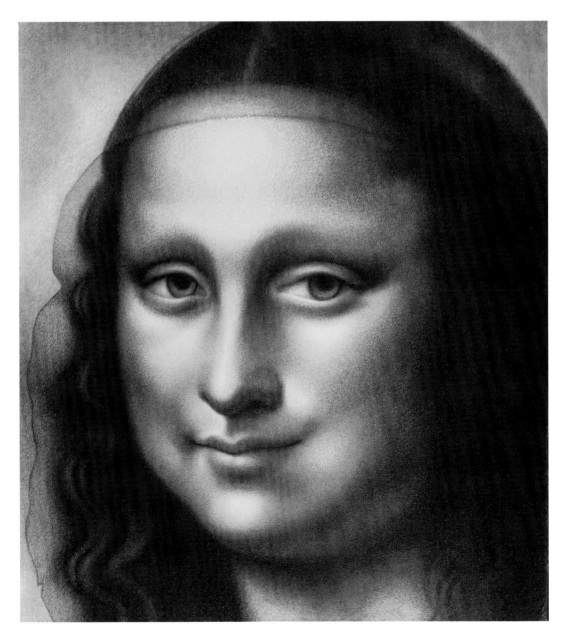

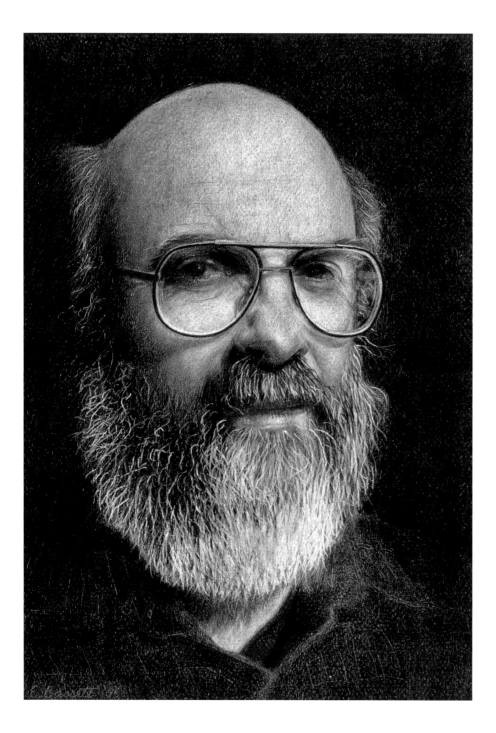

ELAINE BASSETT
Number One

12.375 x 8..625"

Canson Mi-Teintes Paper–Gray

In *Number One* I was most conscious of the impact of a close-up. It helped bring out the detail and intensity of his gaze.

I discovered that I could almost get the effect of scumbling that one can get in oil painting. Layer after soft layer, the subtle build up of several tones of greens, blues, violets and various flesh tones were possible.

MELINDA BEAVERS
Cow and Moon

7.75 x 7.75"

Arches 140-lb. Hot Press Paper

At heart, I'm an adventurer, traveler, and explorer. My artwork is innately inspired and enriched by life's experiences and adventures both at home in New Mexico and abroad. Life is intrinsically whimsical. I am influenced by a broad range of people and objects—from the classic masters to the vast array of contemporary children's book art to graphic and branding design. I enjoy creating worlds of the fantastical as well as interpreting the natural world. I use layer upon layer of color to create highly burnished colored pencil illustrations.

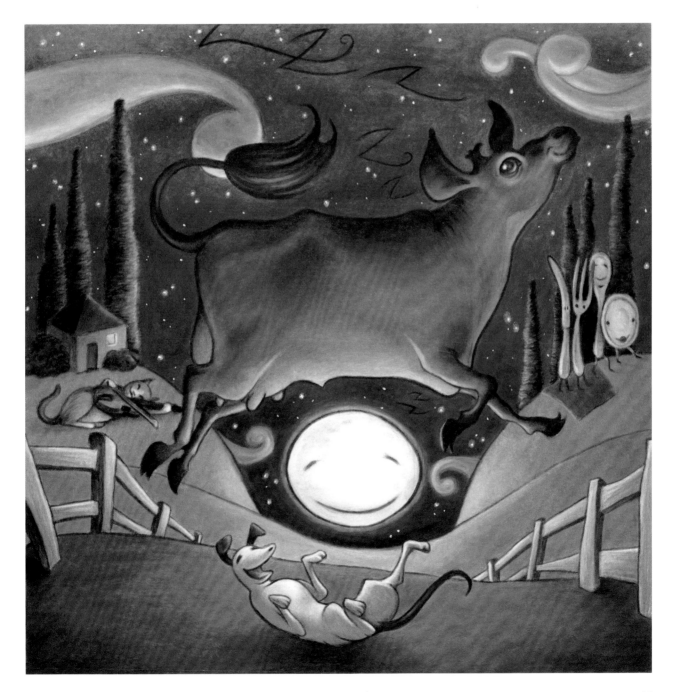

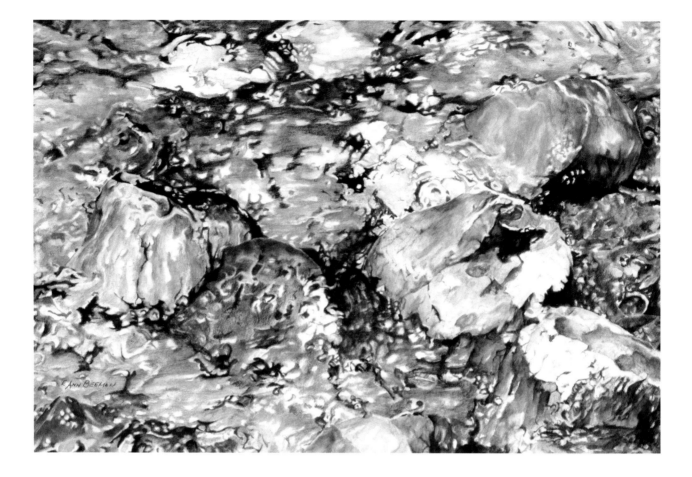

E. ANN BEEMAN
O' Spirit of Riverdance

11 x 17"

Rising Museum Board

I use photographs for reference but like to add my own inspiration to create the final painting. This series of river rocks was from photos I took while volunteering in the Bob Marshall Wilderness complex. The love for nature and its beauty and peace are my inspiration. I watched with fascination the dance of light, the colors, and motion as the water moved over the rocks; I knew they would become a painting to share.

PAMELA BELCHER
The Rock Garden

13.5 x 25"

Stonehenge Paper

As my husband and son paddled their tandem canoe down the Skykomish River in Washington, I chased them taking pictures from the car. While standing on the bridge watching groups of canoes pass beneath me, I suddenly remembered I had a polarizing filter on my lens. I put it into action and was astounded by the sharpened view of the beautiful submerged rock formations. Five photographs were combined to get a workable composition. I thought my title was very clever until my husband explained that canoe and kayak people call rock sections of rivers "rock gardens."

About this time, I was experimenting with a different drawing approach, retooling my mental processing to focus specifically on colors and shapes. I break everything down into flat shapes, and see what other shapes lay within that first shape, then look again and again at the following layers. It makes drawing extremely challenging for me, and I find I have to think constantly the entire time. This was the third drawing using this method and the most difficult to execute in this style.

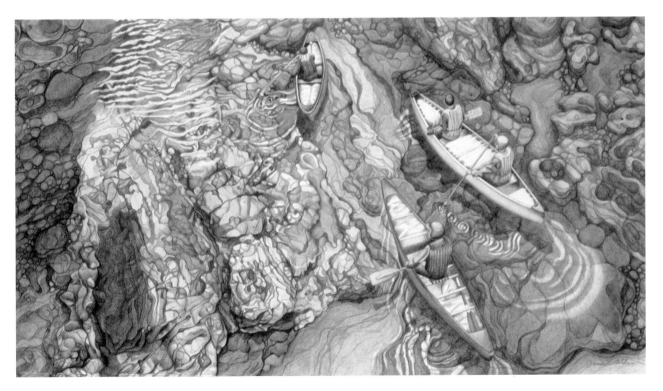

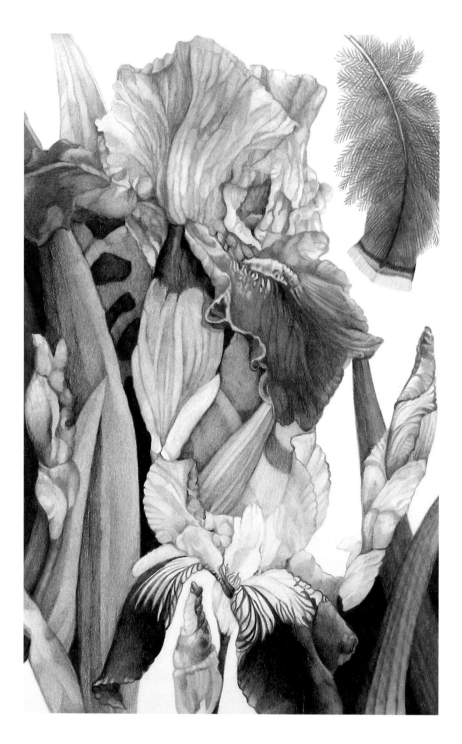

SANDRA BENNY
Blooms and Feather

17 x 10"

4-Ply Museum Board

An arranged moment in time is the best way to describe my work. The beauty in botanical forms and the wonderful designs in feathers allow me to create a lasting feeling of peace and joy. I want the viewer to enter my world and absorb the surroundings. The iris blooms reach up to the light while the feather floats down with anticipation. Cosmic time can continue, but nothing changes or is lost in *Blooms and Feather*.

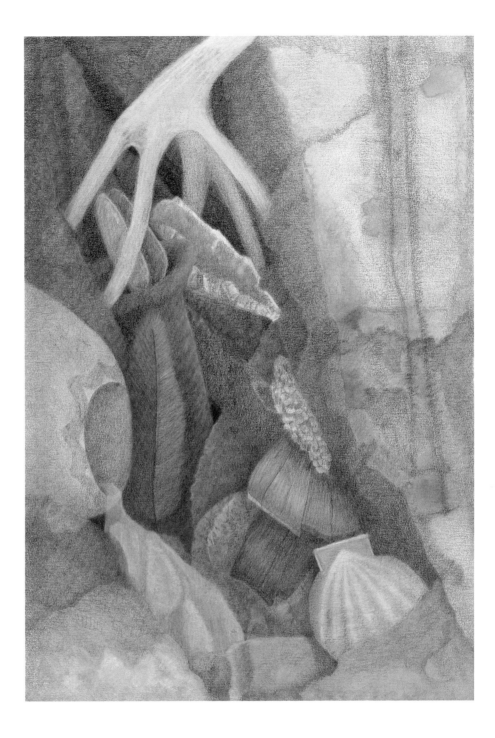

BOBBIE BRADFORD
Treasures and Totems

20 x 14.25"

Holbein Sabretooth Paper

I wanted to be an archaeologist for as long as I remember and still enjoy learning about ancient cultures. After reading Jean Auel's series the *Earth's Children*, I could not forget the idea of a naturally occurring repository of stone where a person could store items of great importance. I enjoyed capturing the various textures in this piece (i.e., feathers, pottery, stones, and water).

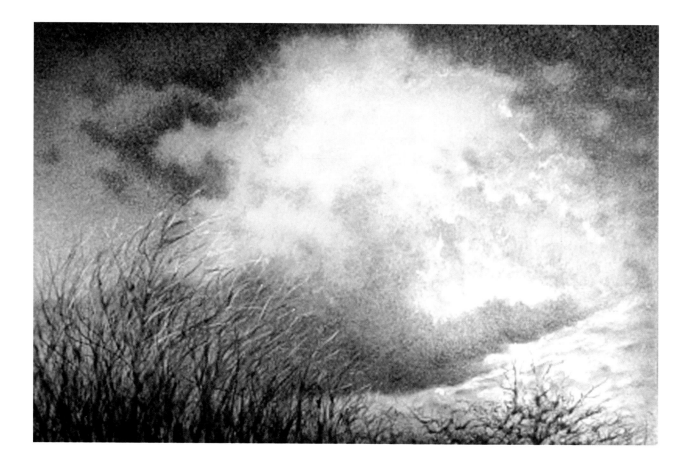

SUSAN L. BROOKS
November Roll Cloud

16.5 x 24.5"

Art Spectrum Colourfix Paper-Rose Gray

My creativity centers around the passing of time in the natural environment. Day into night, night into day; our lives are divided into parcels marked by the coming and going of light.

I look for events produced by Mother Nature that many people do not see, or simply ignore due to their fast-paced technology-driven lives. Taking time to search out these events, such as an equinox, or a solstice, and creatively translating these occurrences into art not only helps me relate back to the environment, but also to the very existence of this planet.

In studying these passages, there seems to be a moment when time stands still. A pause, if you will. For even in our own breath, a pause exists within each inhalation and exhalation, and therefore, a pause does exist in nature, if ever so fleeting.

Once inspiration takes hold, I playfully arrange my color choices in order to communicate to the viewer that these are truly special moments to savor. No matter what genre or media an artist chooses, they must be able to connect to the viewer if they are going to be successful. A certain level of mastery within a medium is required, as well as the use of strong compositional elements. But in the end, there is also an untold spark that the artist must create.

BOBBIE BROWN
Nature's Tiny Treasures

9.125 x 5.125"

Canson Mi-Teintes Paper

My grateful heart is lifted up by the wonder of nature's tiny treasures.

Rocks have always fascinated me. My mother tells me that when I was a toddler, I tried to eat them. Mom was constantly picking up pebbles in the back yard to keep me from choking on them.

This grouping of stones, twigs, and feather caught my eye on the rocky shore of Lake Superior in Minnesota. These tiny treasures, easily overlooked, are a feast for the eye. I want my paintings to be interpretations of nature that evoke an emotional response, invite the viewer's imagination, and share my sense of wonder.

I still collect rocks everywhere I travel. Although I no longer taste them, they serve as focal points and stepping stones in my garden. Rocks are ideal painting subjects. Unlike botanical specimens, they don't move, grow, or die while I try to capture and share on paper the beauty that I behold. By creating art, I celebrate life and attempt to communicate my thoughts, feelings, memories, and imagination in a spirit of gratitude.

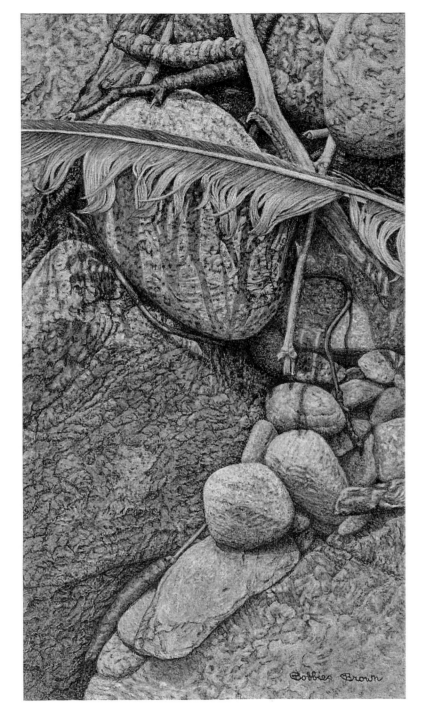

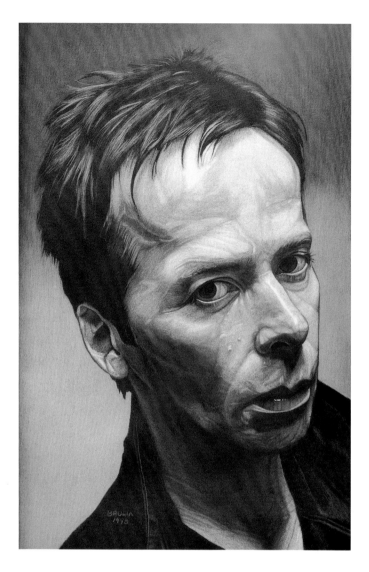

PHILIP BRULIA
Self-Portrait

19 x 13"

Bainbridge Raven Mat Board

This self portrait was done in 1998. Up until that time, I struggled to get accepted into juried shows. From a financial point of view, things were not going so well either. I worked low-paying or part-time jobs. For several years I supplemented my income with commissioned drawings of people, pets and houses. The constant regimen of drawing honed my skills at portraiture. So I figured, "why not do a self portrait?"

Maybe it was the years of disciplined time spent drawing that resulted in this self portrait which became a turning point in my art. The response to this piece was unexpectedly overwhelming. The positive response, awards, and compliments—even psychological interpretations—surprised me. At the time, I never understood why it worked so well.

Eventually I landed a good full-time job, let the commissioned work go, and concentrated solely on art shows. Needless to say, I did several more self-portraits with varying degrees of success until I felt as though I was being justifiably pigeonholed as "the guy that always draws himself."

As I look back at this drawing, I'm still not sure what made it work but can only hope that it conveys some sense of my personality —whatever that may be.

CYNTHIA BRUNK
Annabel

16 x 24"

Strathmore 500 Bristol Board

When choosing subject matter, my focus is always on dramatic lighting effects and strong format potential. I take numerous photographs as references for each piece and use computer technology to create and refine a composite reference that will serve as a basis for a captivating composition. My ultimate goal is to draw viewers into my images and inspire them to define what they see in their own way, on some emotional or intellectual level.

My preferred approach to portraiture is depicting subjects in informal environments rather than in formal, arranged settings. Backlit subjects are especially fascinating to me. On a lovely summer morning I was able to capture with my camera the unusual effect of this lighting as Annabel watched a favorite program on television. In the resultant painting, I hoped to convey the beauty and serenity of the moment as well as how special she is.

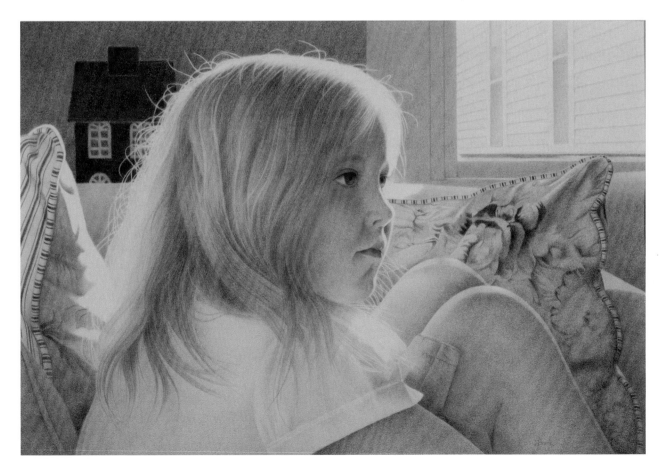

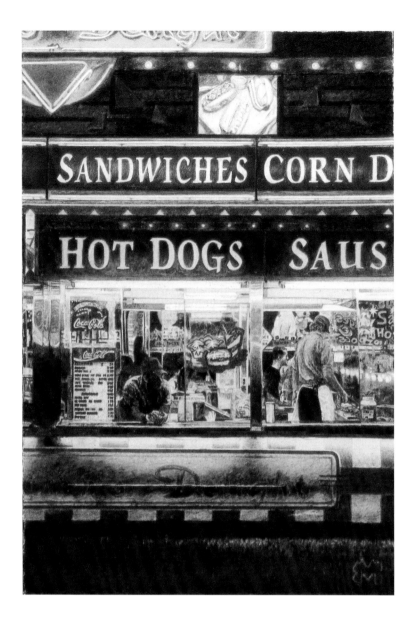

E. MICHAEL BURROWS
Diner's Delight

13.25 x 9"

Arches 90-lb. Hot Press Watercolor Paper

Nature is complex and in constant flux. It is fervently my goal to portray "living" landscapes, be they natural or manmade, and this necessitates my finding a visual equivalent for abundance and movement. My solution is to create works of detail that are hyper-real.

One of the ways in which I achieve visual complexity is by using texture boards, two-dimensional boards with a multitude of different textures on them. I place these boards under my paper as I draw. Any mark that I make with the pencil is greatly influenced by the type of texture beneath the paper. The process is a rubbing or frottage process, and a judicious selection of boards allows me to imply detail without being tedious about it.

I also routinely employ embossing tools, cellophane tape, and electric erasers to further enhance my realism. I work from my own photographs so that my work is site specific.

BARBARA BYRAM
Emily

10 x 14"

Stonehenge Paper–Gray

When my dog Emily came with us to the Outer Banks, I took a photo of her paw prints along the shoreline. It was fun to suggest the sand and try to capture all the tiny little bubbles in the tide. Whenever I look at this drawing, it brings back wonderful memories.

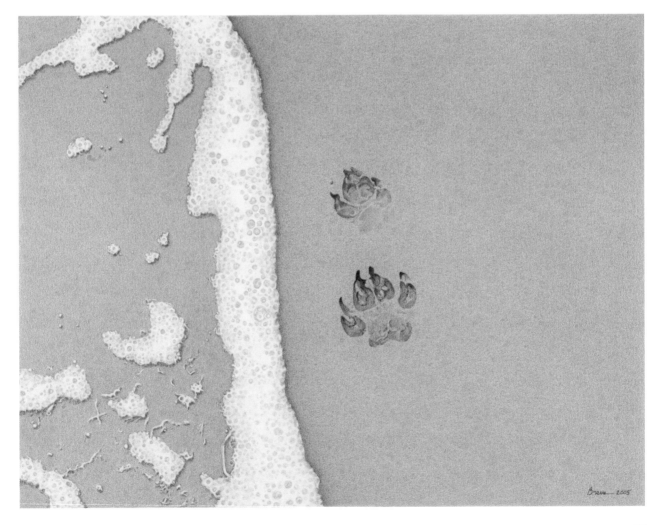

LYNN A. BYREM
Second Chances

19 x 25"

Bienfang Art-Vel 211

Armed with a copy of Bet Borgeson's *The Colored Pencil* and with a group of 10th grade Art 1 students looking at me for inspiration, I decided to teach a unit on colored pencil. It was a versatile medium, easy to clean up, and could be stored for weeks at a time with no fuss. Little did I know that colored pencil would not only open up a new avenue of art to my students, but to me as well.

Almost twenty years have passed, and I am still using my colored pencils and burnishing color, layer by layer, to achieve life-like effects. *Second Chances* was completed in 1997. I decided to go for full color, with many highlights and shadows. I like to use natural lighting as much as possible. The sunlight came through the venetian blinds and fell onto the still life, creating bands of lights and darks. The challenge was to depict the various value changes in each object.

DONNA CAPUTO
Bugsy

9 x 12"

Windberg Paper–Gray

Who could not love a face like this! The first time I met Bugsy, it was love at first sight. But he was a whirlwind–nothing slow motion about this dog; however I did catch him once just waking from a puppy nap. The juxtaposition of his sparkling eyes, his coat of many hues and the fuzzy orange blanket he rested upon was a painting waiting to happen. My goal was to convey the textures I saw as well as his feeling of contentment.

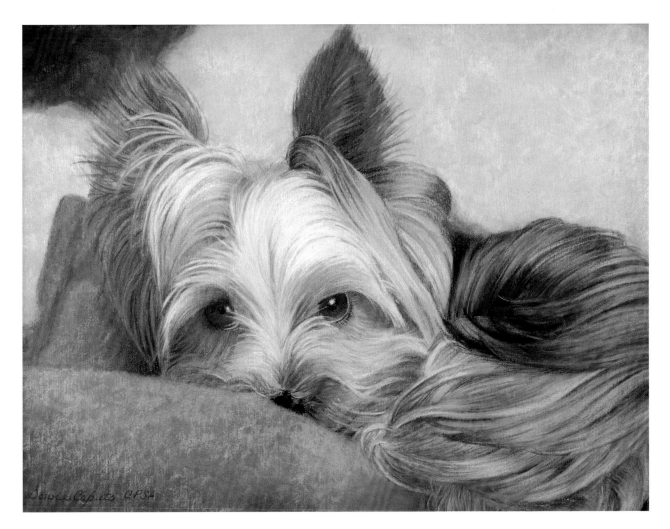

JENNIFER P. CARPENTER
Still Life Without Mom

16 x 28"

Strathmore Illustration Board

I created this piece following the unexpected death of my Mom in 2001. These items were things that belonged to her; she collected cobalt blue glass. I had given her most of these pieces over the course of many years and each holds a special memory. These are the earthly ties to benchmarks in our relationship. The water goblet and vase were from Blenko in Milton, West Virginia, where my parents took me as a child to watch the glass blowers create beautiful things and planted the seed for my adult fascination with creations from the same company. The crystal cat came from a gallery in Puerto Rico when I went there on a class trip in college. The swan bowl is what I gave her for her last birthday, just over a month before she died. She ate blueberries from the little footed bowl every morning. I had found it in an antique store and thought she'd like it.

I wanted to spend some time alone with these things after she died. This piece was created in the wee hours of the morning over the course of just two weeks. The quiet stillness of a house and going through a divorce gave me the space and time to honor her memory, say goodbye, and heal, all at the same time.

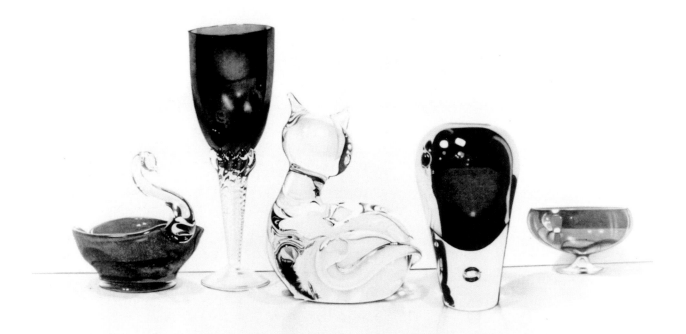

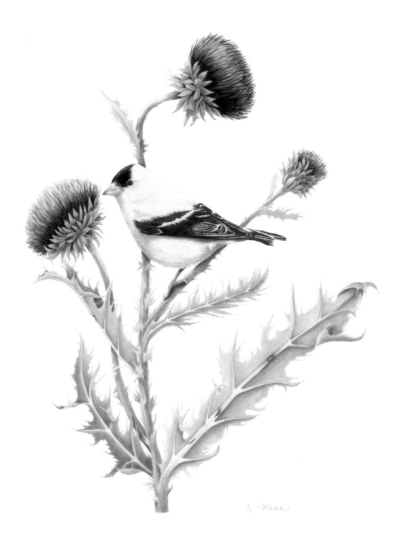

KAREN COLEMAN
American Goldfinch on Nodding Thistle, Carduus nutans

14 x 11"

Dura-Lar Drafting Film

Although I enjoy drawing and painting many types of subjects, I call myself a "nature artist" because most of my inspiration comes from nature, especially in the details. The intricate complexity of a single flower, the unique grace of a tree branch, the amazing and varied colors of insects and birds, the wonderful translucence of seashells. All of these take my breath away. These are the living things that I try to capture in my art.

My current passion is drawing and painting flora in the traditional botanical style. Many of my subjects come from my own garden or in the fields and woods where my husband and I go hiking. A frequent visitor to our birdfeeders is the American Goldfinch, with the male of the species displaying his vibrant yellow plumage in the summer to attract a mate. The bird's favorite food is thistle seed, whose plant also provides "down" to build a nest. I wanted to capture this colorful bird perched on a Nodding Thistle that blooms in fields and pastures near my house from June to October. I thought the gorgeous rose-purple flower heads, nodding at the ends of the plant's branches, were the perfect contrast for the bright yellow bird. Both were beautiful subjects and a joy to "paint" with colored pencil.

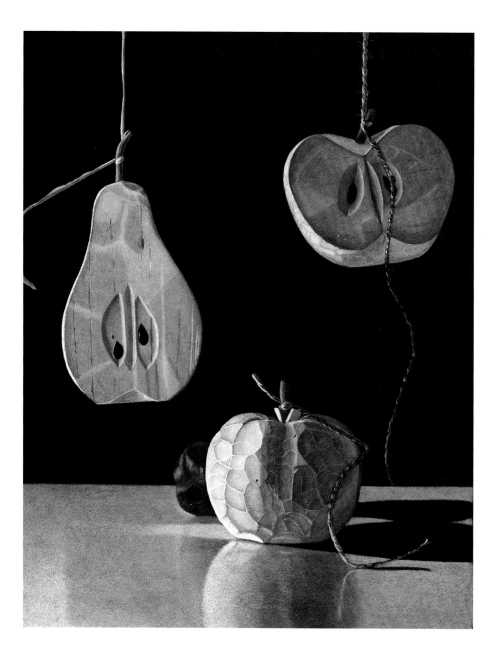

GAIL T. COLLIER
Geppetto's Fruit

18 x 14"

Windberg Sanded Pastel Paper–Black

For most of my artistic career, I have been enthralled with creating still life drawings. The beginning of a drawing is a tactile pleasure. I arrange and rearrange objects and get to know them while looking for compositions that create pleasing positive and negative shapes. Since I subscribe to the "less is more" philosophy, detailed objects are intertwined with calm, rhythmic negative space.

Geppetto's Fruit is part of my "Things on Strings" series. The carved fruits are the focus of this drawing. Using black paper adds to the mystery of this piece, and the title implies that Geppetto carved these during the lonely time when he was wondering if Pinocchio would return. The fruit hangs from strings—just as a marionette does. In these drawings I strive to make the ordinary unusual and the unusual absorbing.

KATHRYN CONWELL
Man's Devices

20.25 x 15.5"

Fabriano Uno Paper

As a child, I used to pick up my parents' magazines and trace over the faces and figures with a pencil. Through the years, I continued to draw things at home–as decorations on our dining room wall, fish on the bathroom wall and, later, pictures of Paris on my bedroom wall. Mother always liked it.

Going through a Sunday newspaper one day, I noticed a wonderful colored pencil drawing by a teacher at our Cameron University. When I saw it, I immediately said to myself, "I'm going to take a class with that teacher!" That was many years ago; and I took 12 years of colored pencil classes and loved it.

Man's Devices is a drawing of an assortment of tools. I really enjoyed drawing this subject, so I drew more tools for my grandsons when they graduated from college, and they were really pleased. I tend to be very accurate, and make sure it looks correct.

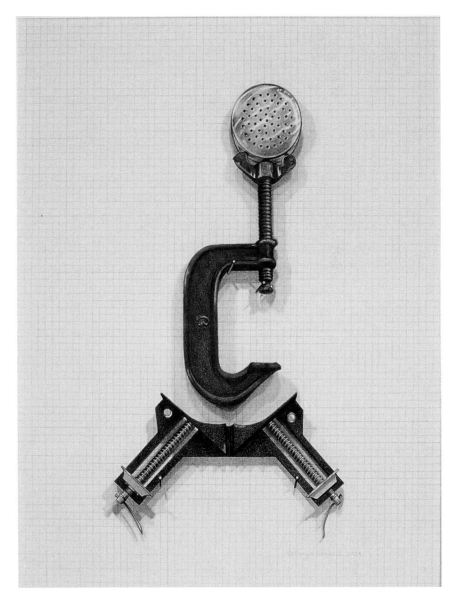

BILL CUPIT
Roots I

12 x 16"

Mat Board–Green

Having lived in Hawaii for 25 years, I find that the islands provide me with excellent opportunities to observe nature in its most glorious colors. I was fascinated by the unsuspected color in simple tree roots. This was a favorite subject of mine.

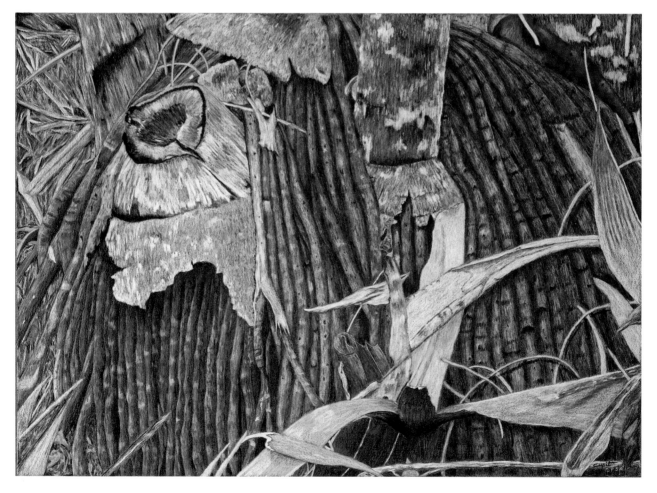

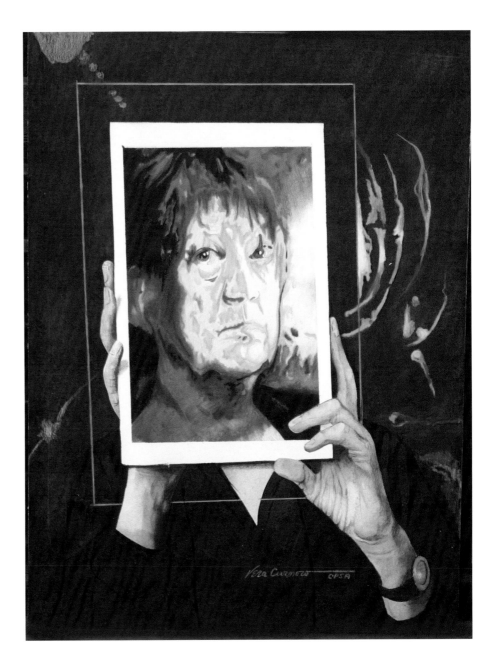

VERA CURNOW
Public Persona–Self Portrait

20 x 15"

Crescent Cold Press Illustration Board

How masochistic do you have to be to paint self-portraits at the age of 65? Is it ego–a self-indulgent homage? Is it artistic masturbation–or just a visual diary of one's life and times? The amazing thing about reflecting yourself in your art is that it's cathartic. While working on my image, I found that it was not about depicting me accurately but that it took me down a more profound road. It was good therapy, an exercise in truth and honesty, and resulted in a deeper awareness and discovery of self–not only the physical but also the psyche.

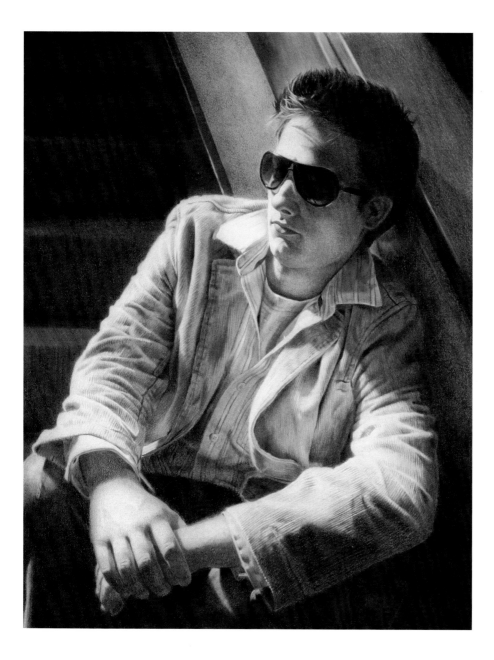

SUSAN D'AMICO
Image

30 x 22"

Stonehenge Paper–Cream

Image is a portrait of a young man dressed to meet his peers. He is aware that his acceptance to this group is related to the style and brand of the clothing he wears–from designer jeans to designer sunglasses. With the armor of a teenaged warrior, he is ready to fight a never ending battle for acceptance.

I was attracted to this project because of the light and shadow sculpting his form as well as the variety of textures I was going to have to recreate. I also work in pastel and oils, but colored pencil was the only medium with which I could get the heightened sense of realism I envisioned. Stonehenge allowed multiple layers of colored pencil as well as crisp detail and softened edges.

MARTHA DEHAVEN
Pitcher and Glasses

10 x 12"

Pastel Board–Brown

I was using colored pencil years before CPSA was founded. I was then, and still am, amazed at the variety of techniques to which this medium lends itself.

I try to capture three things in my work: color, texture, and their interaction with light and reflection. My chiaroscuro still lifes incorporate all three. My biggest influence was a late 16th century French artist named Jean Baptiste Chardin. I like to think that if colored pencils had been invented, he would have loved them too.

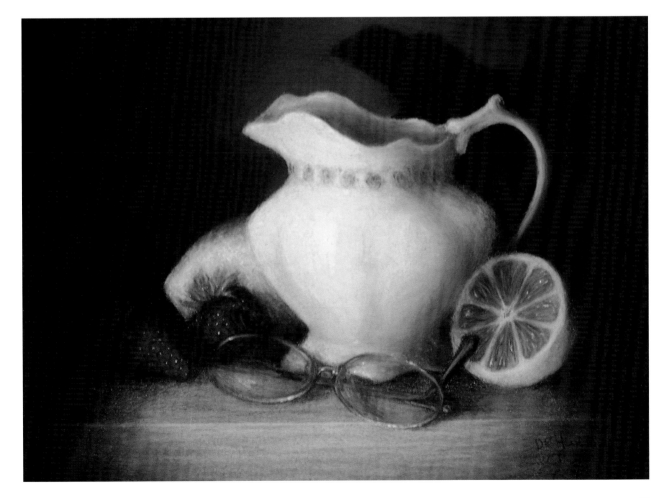

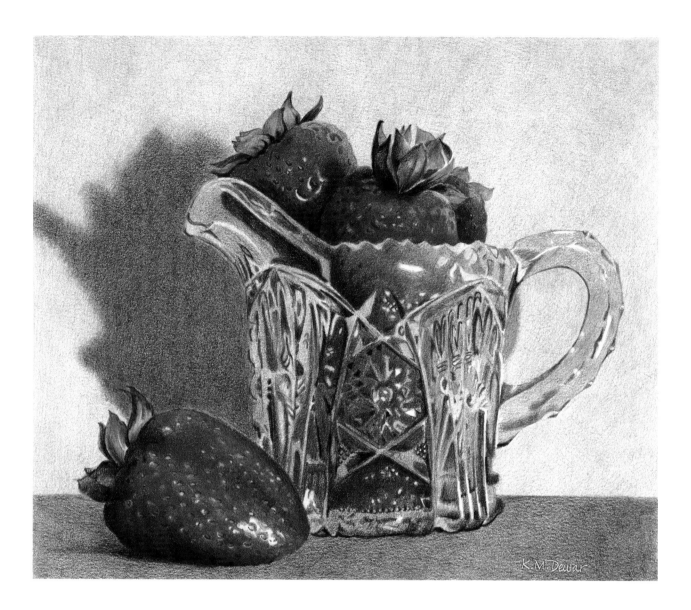

KAY DEWAR
Strawberries in a Glass Pitcher

9.75 x 10.5"

Stonehenge Paper

I have been working for several years on a series of drawings based on a premise that I designed for myself. In order to understand value and color relationships, I chose to use Prismacolor French Greys to complete a grisaille pattern for everything in the drawing–with the exception of live items such as fruit and/or flowers and their reflections. The live items are depicted with their local colors. Other items such as tables, fabrics, china, and glassware are done with values of French grey and black.

Fresh juicy strawberries in a small depression glass cream pitcher became the center of attraction for this drawing. In order to comply with my premise of French grey for non-live items, I had to "lose" the pink color of the depression glass, but maintain the pattern of color and value that the fruit created as viewed through the glass.

SHERRY EID
Patterns of Nature

18.5 x 13"

Pastel Paper

A beginning artist or writer is often told to "draw upon your own experiences, to write about what you know." *Patterns of Nature* is a good case in point. I was born in Panama, a land filled with colorful and exotic plants and animals. The golden frog lives in El Valle, where you can also find square trees. The brilliant colors and the interesting patterns on both the plant and the frog catch your eyes, but only if you are looking closely as the frog is only a little finger's length. It was part of the fun in drawing the little fellow much larger than life size so that he could not be missed. I was also tempted to title the picture "Froggie Went A-Courtin" because the patterns looked like a formal outfit with the tie.

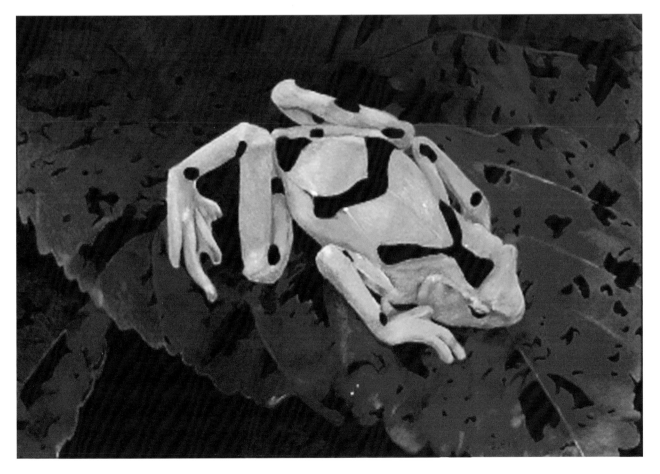

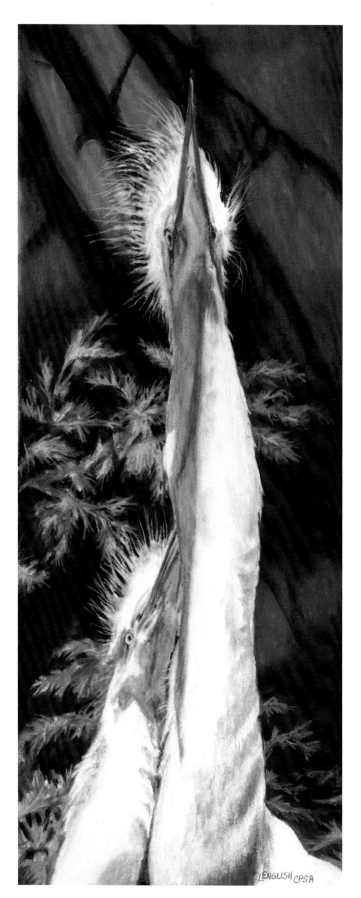

LYNDA ENGLISH
Skyward

16 x 6.5"

R-tist-x RTX 300 Board

I began working on an egret series several years ago after visiting an egret reserve in South Carolina. The first in this series was *Skyward*. The two young egrets stretching their necks upward were wanting to be fed. I loved the long vertical image of the two. So I drew the image on Rtistx board, RTX300–an 1/8 inch thick rigid pvc with a surface of clear acrylic and white in color fibers. This surface can be cut with a mat cutter. I then began layering my Prismacolor pencils. I don't need to fill in all the area with pencil because I use a brush dipped in turpenoid–this breaks down the wax and you can smooth out the color and blend. Lighter colors require more layering because there is more wax in them. I enjoyed using the colored pencils in this series because they help create an almost photographic painting.

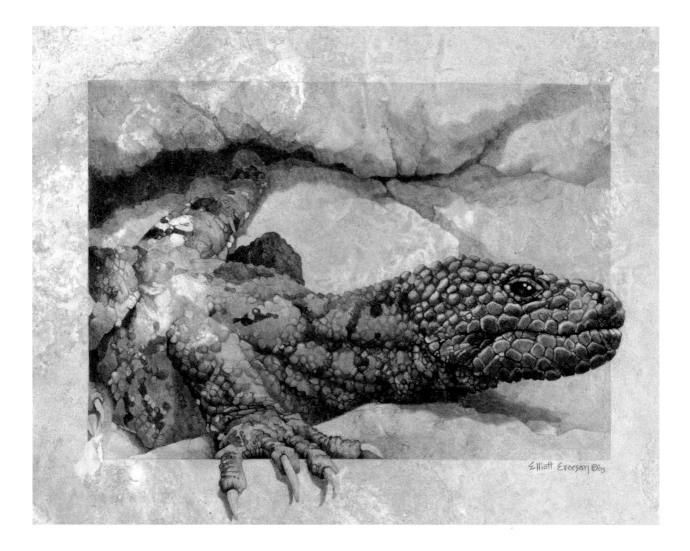

ELLIOTT EVERSON
Heloderma suspectum

12 x 16"

Travertine Stone

Heloderma suspectum is one in a series of stone drawings that harmonize the subject with an appropriate drawing surface. Recently, as a large, colorful chuckwalla looked out over the top of a boulder in my yard, I was reminded of gargoyles perched on ledges of stone buildings. To capture that feeling with colored pencil I felt that bringing out the lizards image on rock seemed natural and fitting. Desert reptiles live among the rocks, and I enjoy depicting these lizards, tortoises and snakes and their life on stone. This Gila monster is now one of the Desert Gargoyles.

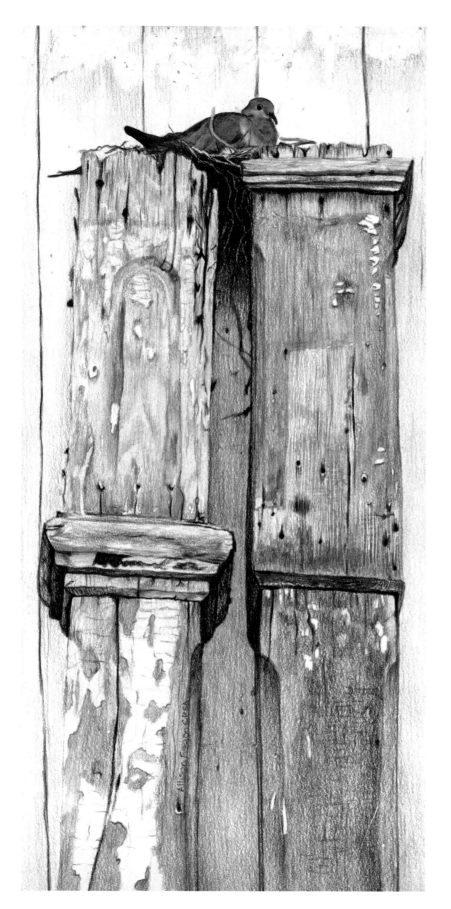

ALLISON FAGAN
Dove Gray

12 x 5.5"

Stonehenge Paper

I was visiting my cousin, Sue, who owns a great antique business called "Dead People's Stuff" in southern Ontario. As we toured the property and rounded the corner of her barn, there was a mother dove perching on her babies in their nest atop two old pillars. The bird was so a part of the scene, that one could almost miss her presence. I ran for my camera and quickly snapped several photos.

Being aware of simple beauty in everyday objects keeps me ever looking for subject matter, something I try to instill in my workshop students. Nothing makes me happier than to hear students say that they just don't look at things in the same way once they have engaged in the artistic pursuit. A heightened awareness of what lies around me, what colors, paper and techniques I'll use, plus the excitement of engaging a viewer to see the world through my eyes—these are the things which drive me as an artist.

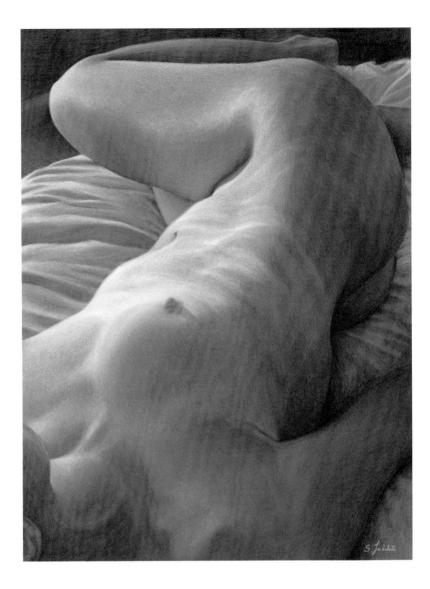

SHAWN FALCHETTI
Bend

24 x 18"

Art Spectrum Colourfix Paper–Blue

A recurring theme in my work is the evocation of mood and atmosphere through lighting and color choices. Like all artists, my current style is an evolution of different things I've tried. Many drawings still use the grisaille technique I learned as an oil painter, and some of the higher contrast pieces lend themselves to my days dabbling with pen and ink. Most of my work is on sanded supports such as Colourfix paper or Pastelbord, and careful layering produces the soft, speckled look that defines my style.

Like the rest of the series, *Bend* relies on subtle lighting transitions to convey an ethereal mood; however, this piece diverges from the other pieces through its palette, which heavily favors metallic blue, rose, and violet mixed with warm and cool grays. The effect of this is sandy, opalescent skin tones. Coupled with the heavily foreshortened and twisting pose, this helps to transform the figure and is evocative of a landscape. As such, the title derives from my perception of the figure as a winding stream traversing a quiet horizon.

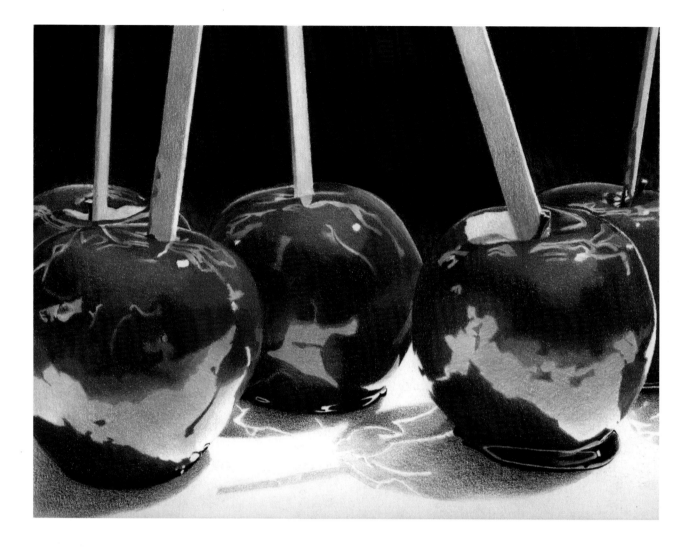

KENDRA BIDWELL FERREIRA
Apples of My Eye

8.5 x 11"

Stonehenge Paper

Most of my artwork is still life subjects. Often I set up a still life and take photos to help me plan the composition. I've been working on a series of candy apple colored pencil drawings of different layouts and sizes. I will make a batch of candy apples, set my layout and then draw it–but I have to work quickly before someone comes along and eats my subject! The candy apples are fun, nostalgic and make me smile.

I love the color red and it shows up in most of my artwork. I find myself captivated by shiny surfaces and reflected light and shapes. In this piece, I used solvent and a small brush with the colored pencil so that it could be moved like paint and cover the entire surface. This way no paper texture shows through the surface, and the apples are smooth and shiny. The background is also worked with a mixture of colorful dark pencils and solvent. The brightly reflected light on the apples creates colorful shadows that also compliment the composition. In colorful illustrations as this one, I rarely use gray or black pencils.

CAROL FOGELSONG
On and Off the Vine

14 x 11"

Bristol Board

Since I wanted to explore working with highlights, the smooth textures of the tomatoes in this painting captivated me. I had to work quickly because the tomatoes were very ripe and the light I had them under was very hot!

In general, I'm drawn to subjects that have diverse textures, interesting shapes, and high contrast. I no longer work in an ultra-realistic style, but I still strive to capture the essence of the subject as concisely as possible.

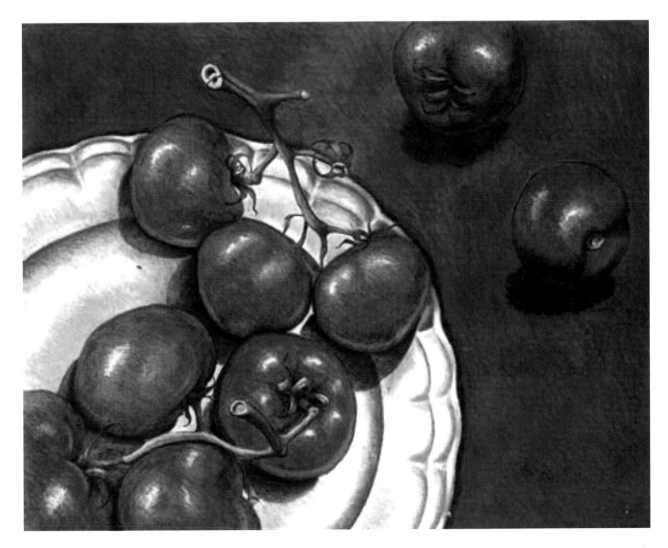

LORI GARNER
Head Rush

23 x 17"

Canson Mi-Teintes Paper

I don't just love to draw, I need to draw. It is my solace, my diversion, my relaxation, my unabashed joy, my spiritual release, my selfish pleasure. When I am not at the drawing board physically creating art, I am thinking about creating art. Ideas for drawings are in limitless supply because I see art all around me. With objects or nature I see things in colors, values, patterns, shapes, reflected light, and shadows. With people, I see art in facial expressions, in a glance, a gesture, an interaction, a conveyance of mood; a fleeting, seemingly inconsequential moment in life that I feel compelled to convey. Drawing provides me a tangible means to offer up my inner visions to the viewer.

Head Rush is a small captured moment of peaceful contentment. The cool blue and green tones help me express the temperature of the water. Its movement is captured by the stirring silt, the water's distortion of flesh and the upswept, swirling hair. The bright reflecting sun provided the brilliant diamonds of light in the water and on the wet flesh. The skin tones are predominantly warm with some pinks to depict the flush of sun on warm skin. The captivating smile authenticates her tranquility.

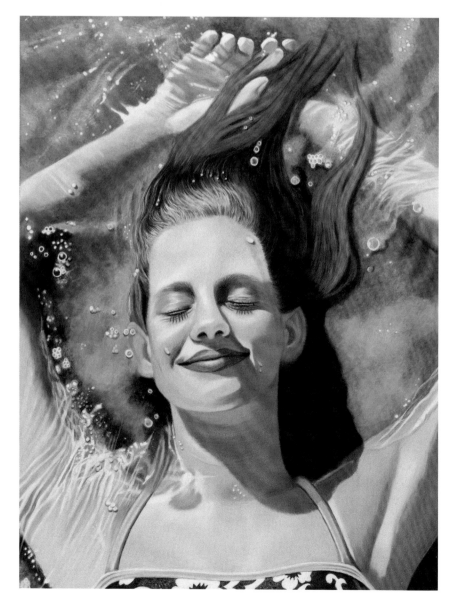

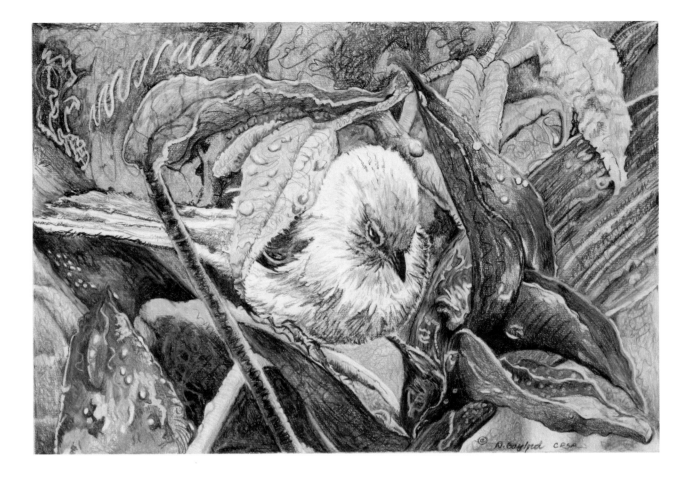

DONNA GAYLORD
Bird in the Bush

8 x 12"

Bainbridge 100% Rag Mat Board

I draw to express my response to the natural world around me. Nature has always held an endless fascination for me. For thirty-plus years, colored pencil has been my medium of choice to express my vision to my response to patterns, textures, forms, and space. Recently, I attended John Smolko's Colored Pencil Scribble & Expressive Line Workshop. I was inspired to use line in new and exciting ways. So began a fresh and inventive exploration of my nature subjects. The piece published here represents a first step down the scribble-line road. I am confident that the journey will be an adventure while growing and expressing my artist's vision.

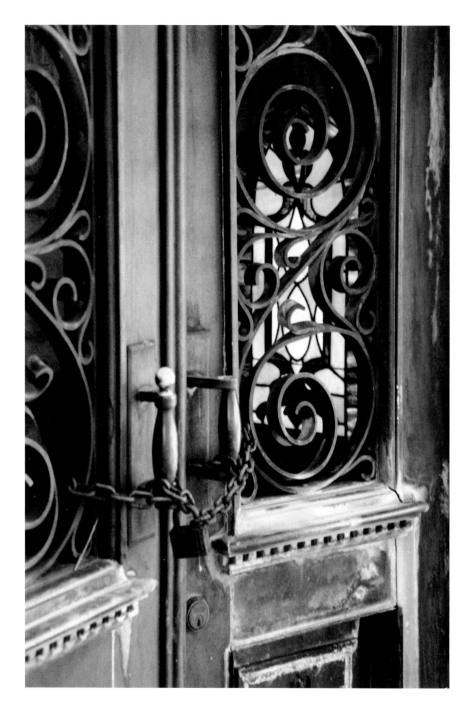

JOAN GELBLAT
Wrought Iron & Stained Glass

23 x 15.25"

Windberg Pastel Paper–Gray

This scene caught my attention at an autumn event in Atlanta called Sunday in the Park. I was intrigued by the contrasts, not only in the light and shadow, but also in the atmosphere. There is a compelling sense of antiquity and mystery from the rusted lock and chains contrasted with the inviting warmth from the glimpse of sunlit stained glass within.

I wanted to capture that thought-provoking mood of a story untold—along with the compositional elements of the angled doors, the graceful (though misshapen) curves of the wrought iron, the contrasts in color and texture with the glow of the glass, weathered doorframe and aged patinas of the different metals. This facilitated the dark areas but required a lot of careful layering to get the glow of the stained glass. I used a number of photo references for the composition, and I think the finished piece evokes the same visual impact of what I felt on that autumn day.

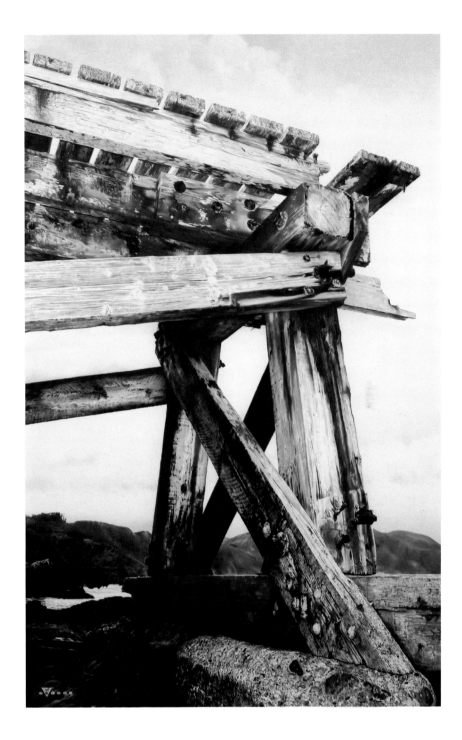

JEFF GEORGE
Of Time and Tides

36 x 23"

Strathmore 500 Series Illustration Board

I find myself attracted to those things in life which most of us bypass or overlook. What a thrill it was when I stumbled upon this old dock at the edge of the San Francisco Bay.

Though splintered, broken, and bleeding rust, this once sturdy structure stands to face another day against the relentless rhythm of time and tides.

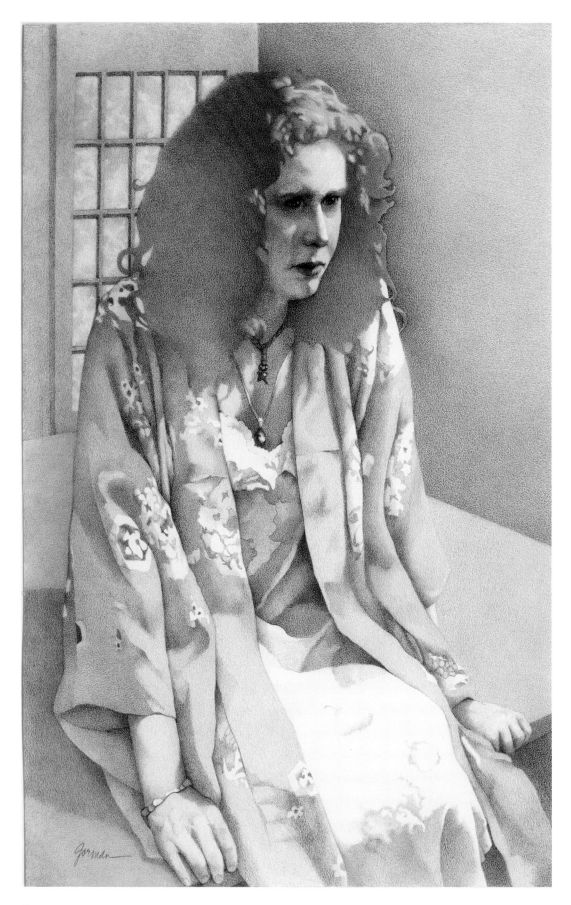

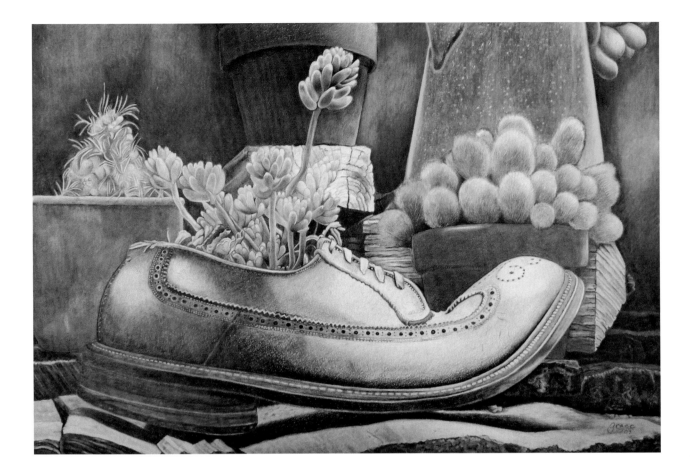

MARILYN GORMAN
Blue Morning

24 x 19"

Strathmore 500 4-Ply Bristol Board

I've realized that teens and young adults today often must gird themselves to face a difficult world with a facade I've come to refer to as "social armor." This painting was the first in a series of portraits that chronicle the value they have given tattoos, piercings, leather wardrobes, black lipstick, outlandish hairstyles or shaved heads–and never-ending attitude. As each group of youngsters comes of age, they seem to separate from their parents by causing as much negative reaction as possible. This is their common goal and their armor, and it binds them together to make the world a little less frightening. Beneath all these defenses are bright, articulate, sensitive souls–so I emphasize their eyes as a symbol of all the positives within.

The young woman pictured, Samantha Beckett, seemed to move through life in a dream state that excluded her parents. They loved the moment when she first woke, before the attitude took over. Although the now adult Samantha lives in England, her parents have promised to give the portrait to her someday, but they have no plans of parting with it soon.

CONSTANCE R. GRACE
Has Anybody Seen My Shoes?

14 x 21"

Rising Rag Mat Board

It was in a restaurant in Carmel, California, on the patio out back. We had stopped there for lunch. The weather was cool and the tall space heaters were going strong. The low stone walls that filled the patio were covered with plants in all kinds of pots. Many of them were in old shoes filled with cactus and succulents. I was fascinated. They cried out, "Draw me!" So I did. Though I strive for a lighter touch in my drawings, I always end up with something that is multi-layered and burnished. Working on a drawing in my studio with a pot of tea nearby and a recorded book playing is my idea of heaven.

PENNY M. GREINER
Thai Food

15 x 15"

Rising 4-Ply Acid-Free Museum Board

I like to express humor in my work by taking common objects and presenting them in an unexpected way using a play on words. My goal when creating works of art is to have fun.

I fell in love with colored pencils in college when taking a drawing class. The minimal supplies, along with the amount of control you have with them drew me in. I am a purist in the colored pencil sense. All I use is a very sharp pencil to build up multiple layers of color. I use graphite for the initial sketch, and do not use solvents to mix the colors.

GEMMA GYLLING
Reflections

24 x 10"

Suede Mat Board–Beige

I was so excited when I was able to capture the photograph of this magnificent animal. I photographed him while I was visiting Kalispell, Montana. I couldn't believe it when he started working his way down the log and into the water. It was so exciting! As soon as I saw what I was able to capture, I knew I just had to paint him.

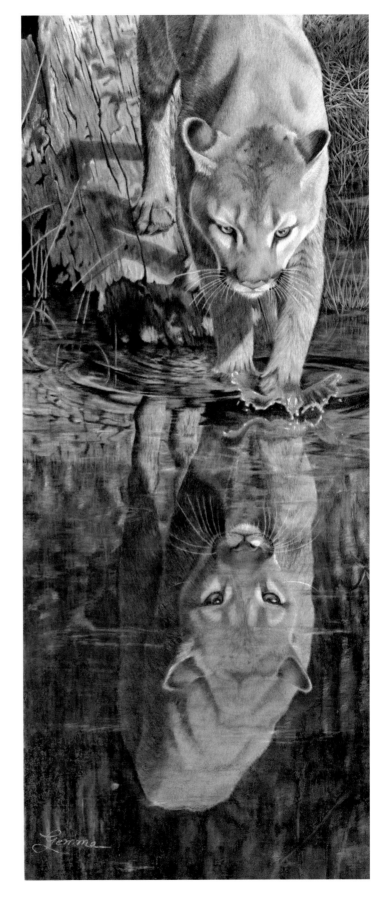

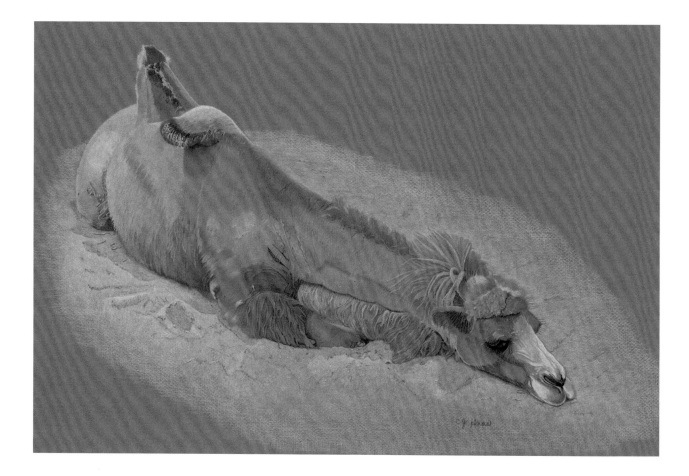

CAROLYN J. HAAS
Out of Gas

16 x 21"

Canson Mi-Teintes Paper

I came across this camel while visiting a zoo in Wroclaw, Poland. It was a zoo much like any zoo, but there was a creature here and there that I had not seen before. Although I have seen camels on rare occasion, none had ever struck me as this one did. It looked like it had just given up, did not have the will to go any further; as if it fell face-first in the sand, because it had simply run out of gas. Hence, the artwork's title. It also dawned on me that, in the world of politics, how symbolic the animal and the title are, but that was not my intention. I later found out by a local zookeeper, who saw a print of *Out of Gas* in a frame shop, that the flopped over hump is a sign of malnourishment. That further endeared me to the camel and the finished piece.

I chose to have a very simple background by eliminating all of the zoo clutter that was captured in the original photo. It almost looks as though the camel is on a flying carpet of sand, flying off to a happier, more peaceful destination. While it is for our enjoyment to view animals in captivity, I never fail to wonder how they really feel, and the look of this camel says it all. It tugs at my heart every time I walk past the piece, but it remains a favorite of mine as it is.

DANIEL HANEQUAND
The Player

19.5 x 9.5"

Fabriano Murillo Paper–360 Grade

Being a surrealistic artist by nature, my immediate instinct dictates a need to express myself as freely as possible. Using visual input as the vehicle permits my soul to expand, delivering my quest to counterbalance a "fear of the unknown." My motivation comes from my genes which are the biological source of my creativity. Yet they offer no explanation as to why or how better works ooze out. Again, the pursuit of discovery is best expressed by nurturing an overall "brain massage" that leads me to a blissful gratification, as well as losing myself to oblivion!

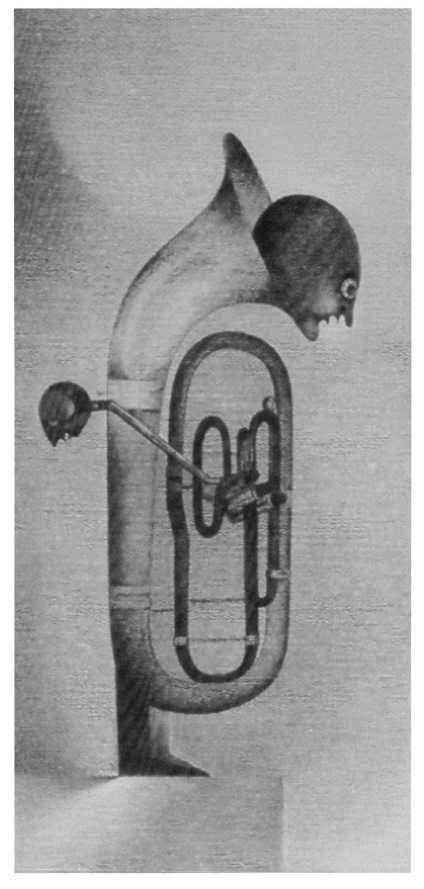

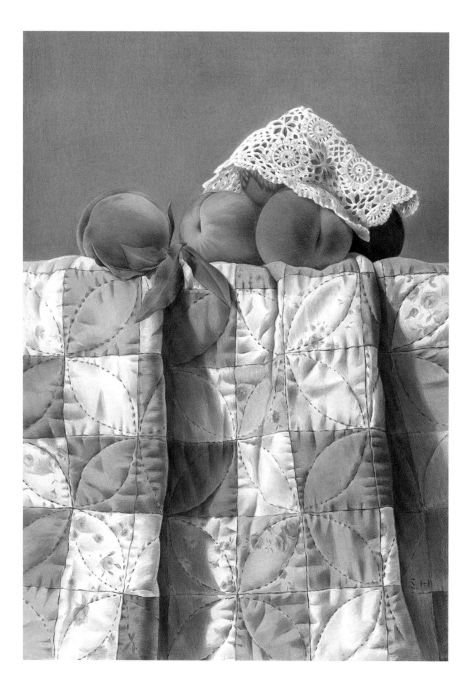

SHINJI HARADA
Quilt with Peaches

18.5 x 13"

Arches Paper

For me, drawing a picture is to face myself. I use a motif to draw the world that I want to express. I make new discoveries when I stare at myself in the world of loneliness. One piece of a picture joins one person to another person. Therefore, I continue drawing it. The next door is open again by continuing. Then, I realize that one's past helps define oneself. Sometimes I have an overwhelming desire to draw the present. I have loved colored pencils since childhood. I give thanks for this encounter with art lovers.

LINDA LUCAS HARDY
Pull to Open

13.5 x 20"

Ersta Sandpaper

*P*ull to Open was the fourth in a series of paintings I did dealing with the transparency of our lives. When I started, I thought I was just rendering fruit in a plastic bag. The appeal was how the plastic reflected the light, but I soon discovered the work had as much to do with the subject as it did the facades we hide behind. Once I realized everyone was subject to doubts, fears and insecurities that are not hidden, there was only one thing left to do, come out from behind the façade. The way out had already been provided, just do as it says in the title–pull.

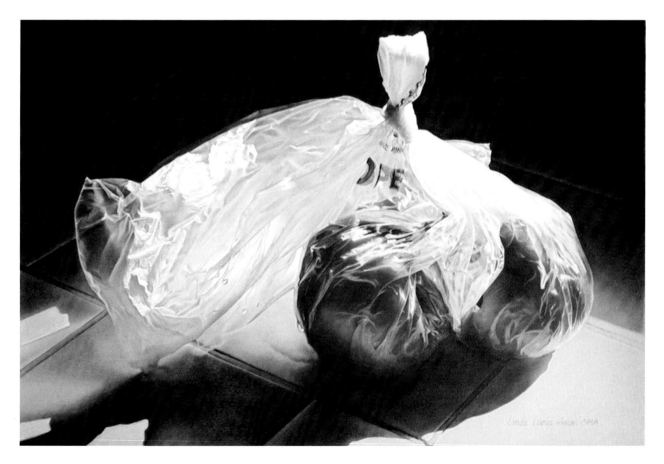

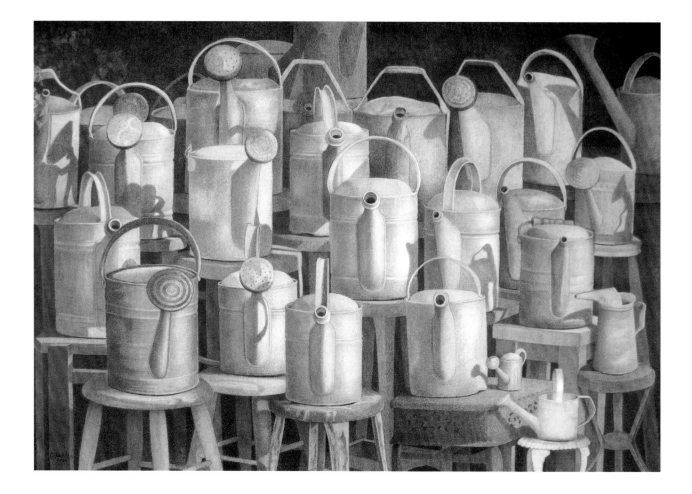

CATHY HELLER
Tin Can Alley

17.5 x 25.5"

UART 800 Sanded Paper

The watering cans caught my eye at first simply because there were so many of them. The collection grew and grew and has become a landmark of sorts in the little town of Harvey Cedars, New Jersey. Since I was always driving when I saw them I decided to stop and get a better look and that is when I discovered that each had its own personality. The variety of the supports they were sitting on only added to their character. The early morning light was perfect for photography and highlighted the unique color and shapes of the watering cans. I took several pictures from different angles so that when I returned to my studio I could re-arrange the cans into a pleasing composition. I faced the cans forward to highlight the strength, solidity and support they seem to lend each other.

I would describe my style as contemporary realism.

LINDA HENIZE
Horse of a Different Color

20 x 12"

Strathmore Hot Press Watercolor Paper

My artwork is usually about this beautiful natural world we live in. I love the ever-changing effects of light on the softness or boldness of colors and the shapes of cast shadows. Summer seems too green for me, so most of my work reflects the other three seasons–from the flamboyance of autumn to the subtleness of cast shadows on snow. I am always amazed at the array of color layers that show when you look closely at something. I also enjoy manipulating the positive and negative play of shapes formed by cast shadows. I don't think that I will ever run out of ideas when I look around–whether I am in the garden or walking in the woods

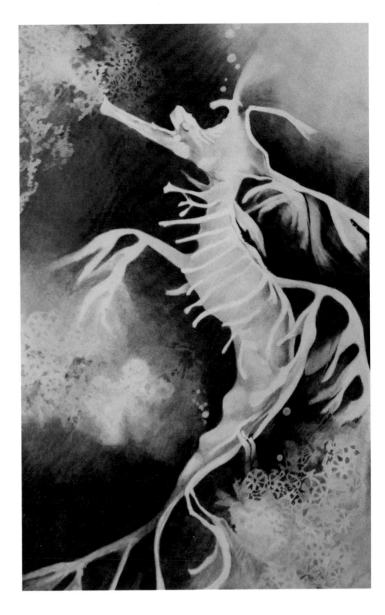

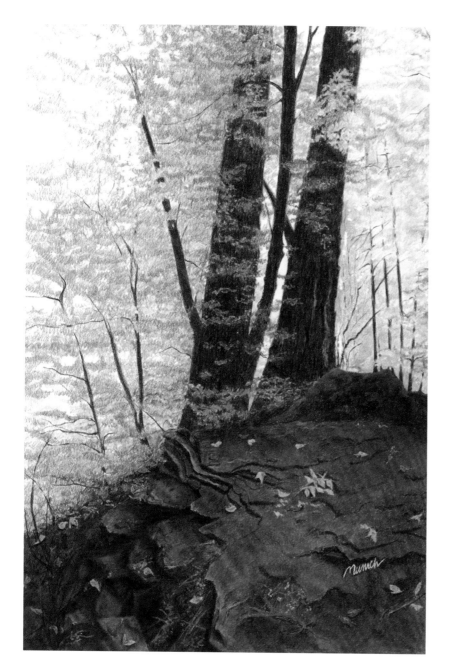

SUSAN MUNICH HENKELS
Westfork

14 x 8"

Stonehenge 500 Series Paper

Trees have always held a special magic for me. As a small child, I remember the excitement and challenge of climbing the biggest tree in my yard, hiding way up high and watching what was going on below. As a psychotherapist, trees have come to represent the work I do with people– exploring the roots which are the strength and foundation that always support and encourage continual growth and discovering new leaves and branches of the Self.

There are hundreds of varieties of trees that thrive in the high desert of Arizona. They have been my inspiration, along with sweet childhood memories, for my drawings. I am also inspired by their relentless courage to stand tall in the face of whatever the weather. Colored pencil is the perfect medium for the intricate details that become my meditation as I work.

I have been an artist for as long as I can remember and the tree in some form or another has always shown up in my work. My vision is to leave the viewer with a beautiful image of the tree and, more importantly, with a new interpretation of their own inner strength, purpose and beauty.

CARLYNNE HERSHBERGER
Seattle Underground

14 x 18"

Crescent Cold Press Illustration Board

There are two elements that have been part of my work for as long as I can remember–texture and natural forms. Although my work has changed over the years, these two things remain constant. Because I've been exploring different media such as acrylic and watercolor, I found that my work in colored pencil has changed. Now instead of the light layering and controlled strokes that I produced for so long, I want to paint with the pencil point. Of course, the fact that I don't have the patience I used to could have something to do with it, too.

For *Seattle Underground*, my main focus was texture. I wanted to achieve a very painterly look, have the pencil point make a mark that had the feel of thick brushwork. To do this, I used watercolor pencils. I dipped the point of the pencil in water to soften it and then applied the color by rubbing the side of the point on the board. By using pressure and a very wet point, I could get the color to build up nice and thick. The subject of this piece is the underside of a skylight in a Seattle sidewalk.

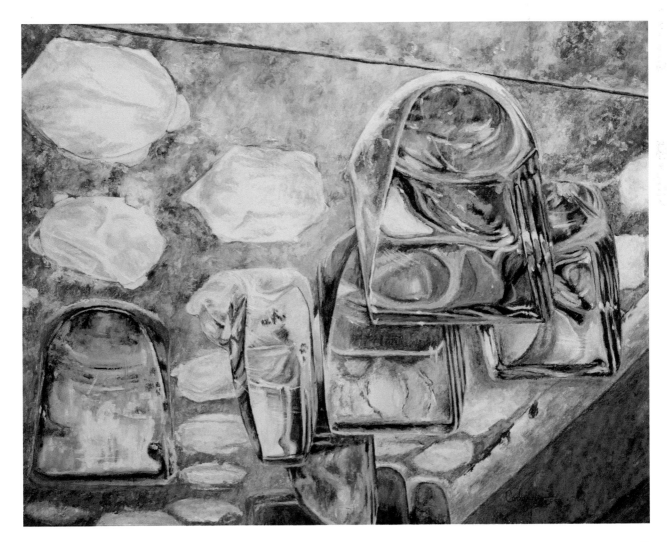

PRISCILLA HEUSSNER
Mosaic Poppy

30 x 22"

Stonehenge Paper

While experimenting with various filters in my Photoshop program, I pixilated a colored pencil image of a poppy. My challenge in Mosaic Poppy was to show the thousands of variations in hue, value and intensity that make up a picture. Each of the 4,002 squares was drawn using from one to six colored pencils. Up close, you see many colored squares, but when viewed from across the room, the painting appears to be a simple picture of a flower.

I estimated how small I could make the squares, and then drew a grid on a 22 x 30 piece of white Stonehenge. It was difficult to "stay in the lines" of each little square, so I made a template by cutting a square out of cardboard. As I began drawing, I realized that it was difficult to keep my place on the guide, so I cut another template for the guide showing a row of six or eight squares. Even though it took three months to complete, I enjoyed working on it—one row at a time.

SYLVESTER HICKMON, JR.
Prodigy

24 x 18"

Arches 140-lb. Hot Press Watercolor Paper

In my work, I convey brief moments and interludes in our lives. I leave it to the viewers' experience and imagination to interpret these moments and turn them into their own stories. I feel that our lives are moments; each one lived with the importance of the instant. The moments vanish as quickly as they come, leaving behind memories, impressions, images, colors and feelings. These moments shape the routines and rituals of our everyday lives and define who we are.

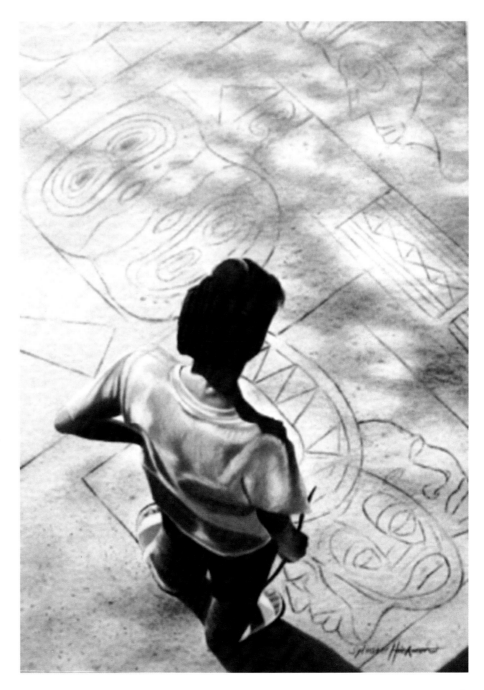

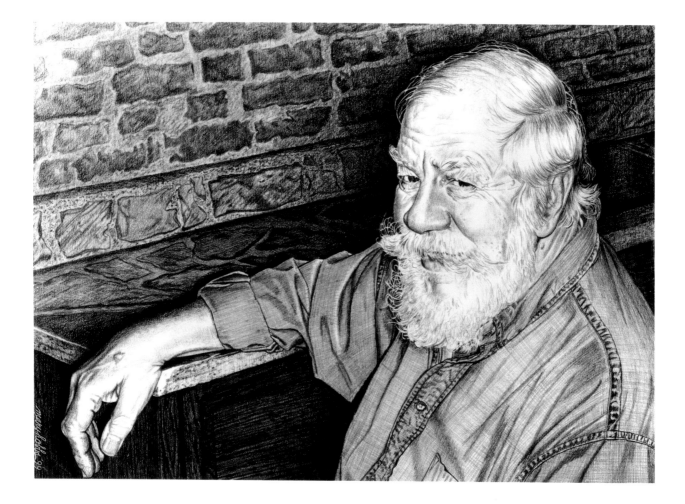

MARY G. HOBBS
Bob, A Study in Greys

17 x 21"

Bristol Hot Press Plate Paper

My art world consisted of black and white for many years. I was a newspaper fashion and furniture advertising artist. Color was a distant new friend. During those thirty-five years, my tools were coquille board and ebony pencils. I had to render both soft fabrics and hard line furniture illustrations.

Bob was an opportunity to use my knowledge of the then five grades of gray. (The five I refer to are the ones used in newspaper advertising in color separations.) To be able to expand into colored pencil with the six of each cool, warm and French grays was great fun for me!

Bob was a dear friend. He died several years ago but not before he pioneered art in our small town. He was instrumental in starting our exciting and active Valley Art Center in Chagrin Falls, Ohio. He is missed. . .

TONYA HOLLAND
Clyde Pride

16 x 14"

Bristol Board

I chose a simple, uncluttered composition that concentrated on not only the beauty and strength of the Clydesdale horse, but more especially highlighted the wonderful reflective qualities of the patent leather and shiny metal hardware of the harness and the glossy richness of the animal's coat. I started with a base layer of Indigo Blue in the dark areas. This imparts an added depth that prevents the final darks from going "flat." I built up many layers of colors, then aggressively burnished with a colorless blender pencil for the shiny portions, picking out the final bright highlights with the tip of an electric eraser. I added small circles of color for texture interest in the background. To obtain the soft, velvety look of the muzzle, I layered the colors carefully with very sharp pencil tips and refrained from burnishing them.

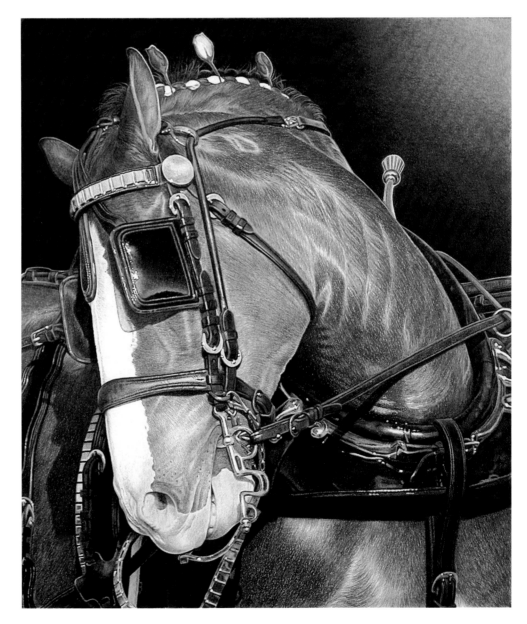

ELIZABETH HOLSTER
Isle Royale Sunrise

28 x 20"

Strathmore 500 Series Bristol Board

I served as Artist-In-Residence for Isle Royale National Park–a beautiful but remote island in Lake Superior nearer to Canada than the United States. I had the opportunity to immerse myself in this setting for almost a month, watching the sunrises and sunsets from my kayak. The earliest sunlight transformed this small bay into a riot of color that lasted briefly and then was gone, giving no hint that it had ever been so bright.

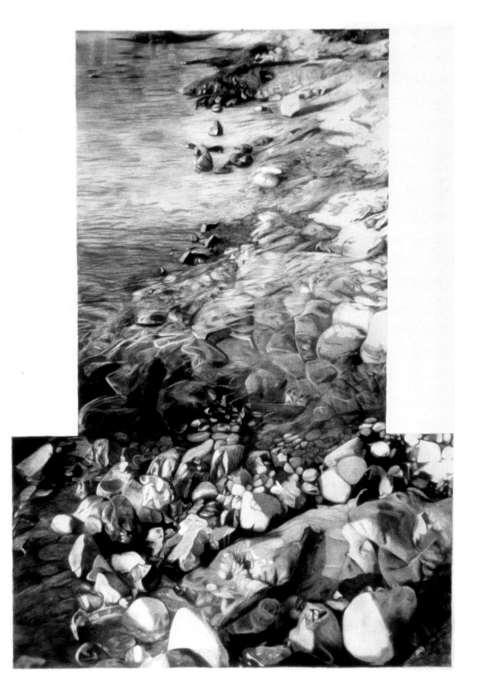

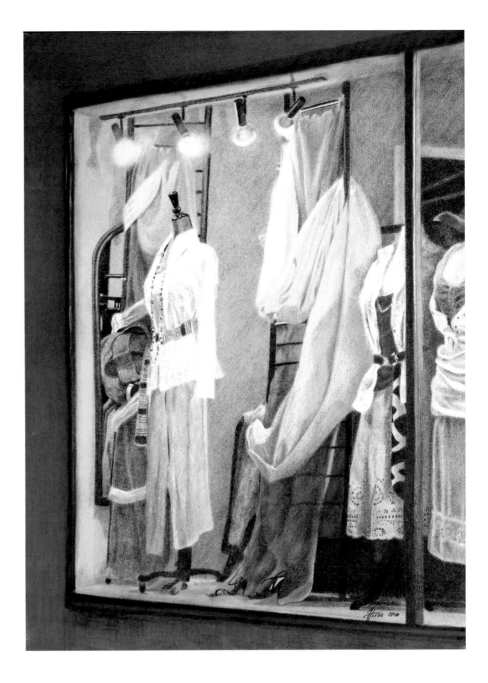

MARJORIE HORNE
Shopping After Dark

24 X 18"

Ampersand Gessobord

There is a little consignment shop in downtown Knoxville that has the greatest window displays that change weekly. I've done several watercolor paintings of these windows over the years, but this is the first time I've tackled them with colored pencil. I also chose a surface that is a little different for me. It was a bit of a challenge to work on, but I like the results. I did use solvent with the colored pencil in the beginning to get the intense color. Then I worked into it with dry wax-based pencils. I also use regular and battery-powered erasers to draw with as I work. This has become so much a part of my process that I hardly notice that I'm doing it.

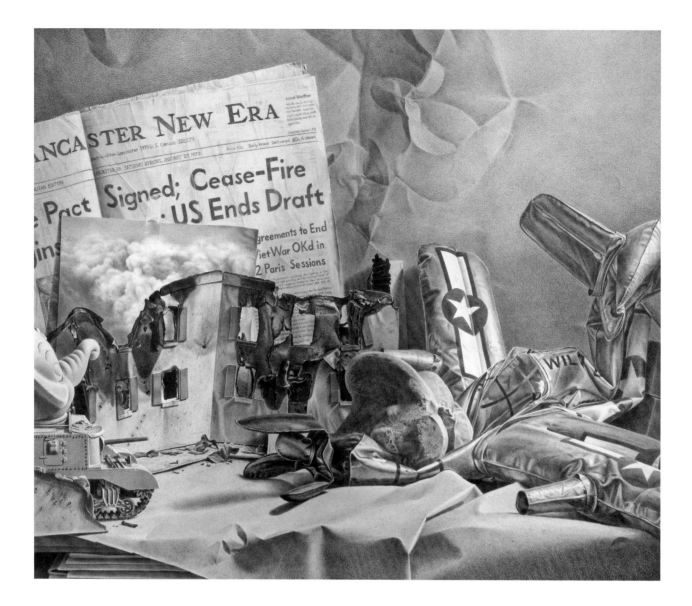

RICHARD HUCK
Still in Conflict

24.5 x 27.75"

Arches 260-lb. Hot Press Paper

Using unrelated objects collected from a lifetime of everyday travels, I create with "burned" mat board constructed still lifes. Their stillness stirs within me a feeling of combative war matched with the impression of the sublime.

These surreal-like colored pencil works are executed in the traditional way, utilizing layering techniques. Many of the set-ups I create reflect shadows of WWII of which my father was a veteran and decorated hero. In part, this series is a tribute to him. My wife, Susan, has also been integral in the thought process and ultimate end products of my life works. Her knowledge and advice is worthy of honor as my work is a tribute to her as well.

CAROLYN HUDSON

Alice

10 x 12"

Stonehenge Paper

Most of my work is of wildlife or domestic animals. This is one of the great beasts of the farmyard. I decided to make Alice as realistic as possible and letting the background become more whimsical for contrast. I thought it would add more interest to the piece instead of just another cow portrait. I work light to dark, building the layers to achieve the desired effect.

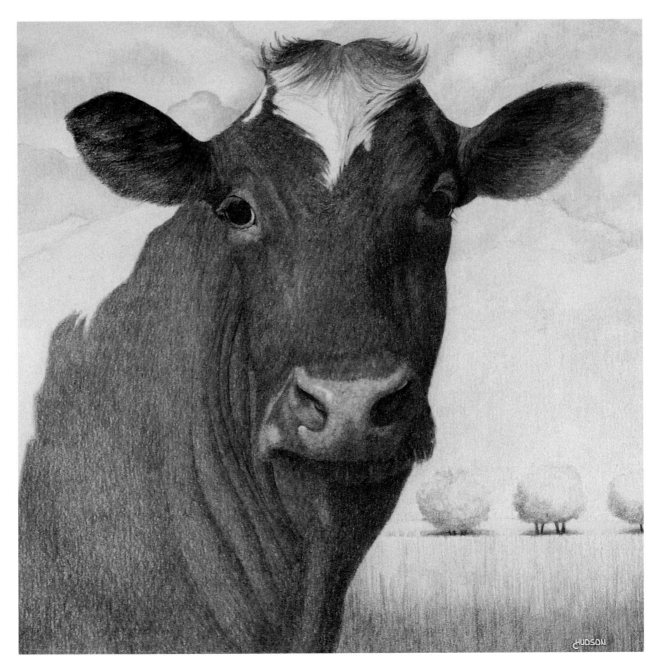

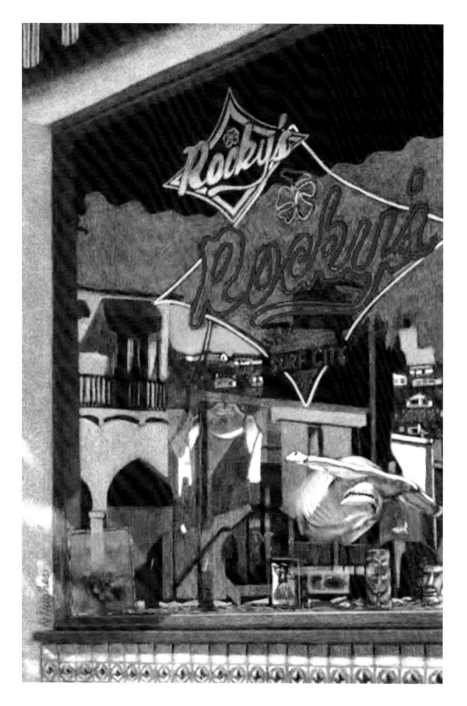

DEBORAH HUGHES
Reflecting on Rocky's

13 x 9"

Mat Board–Black

Since this building is located on a corner, this composition literally has three layers. The first layer is the outside view of the surf shop with the historic buildings reflecting on the window from across the street. The second layer consists of the unique display items inside the store (note the hammerhead shark and hula girl), and the third is the view of the blue sky and the stucco and red tile roofed houses on the hill through the second window. The most difficult part of this painting was to get the shades of white perfect to differentiate between the reflections and direct views.

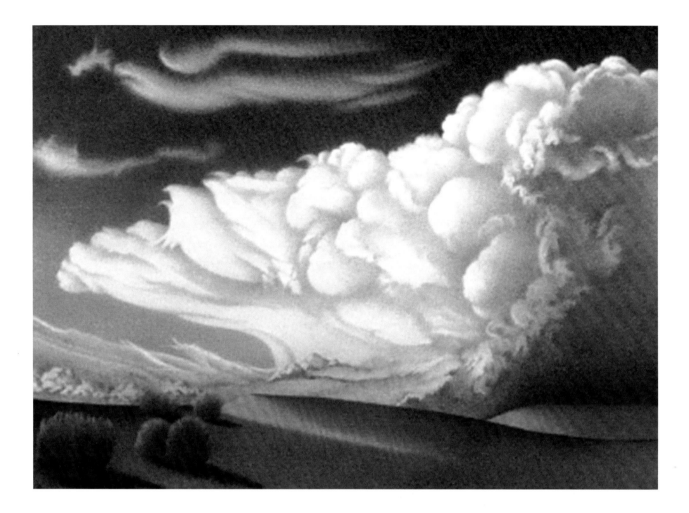

PRISCILLA HUMAY
August Jaunt

22 x 30"

Stonehenge 100% Rag Paper

August Jaunt was inspired by a beautiful yet turbulent storm that I saw late in the day in New Mexico. I was taking a train from Los Angeles to Chicago. Looking through the dusty windows of my compartment, I found the sky excitingly dramatic. As if willed, the train slowed and then stopped. I quickly drew the cloud formations and noted the color transformation of lights and darks. The opportunity was mine—I captured this slowly undulating scene with a visual understanding. Then with barely enough time to take reference photos, the train began again on its journey. Yes, I was able to document my witnessed sensation to work on later. Exciting!

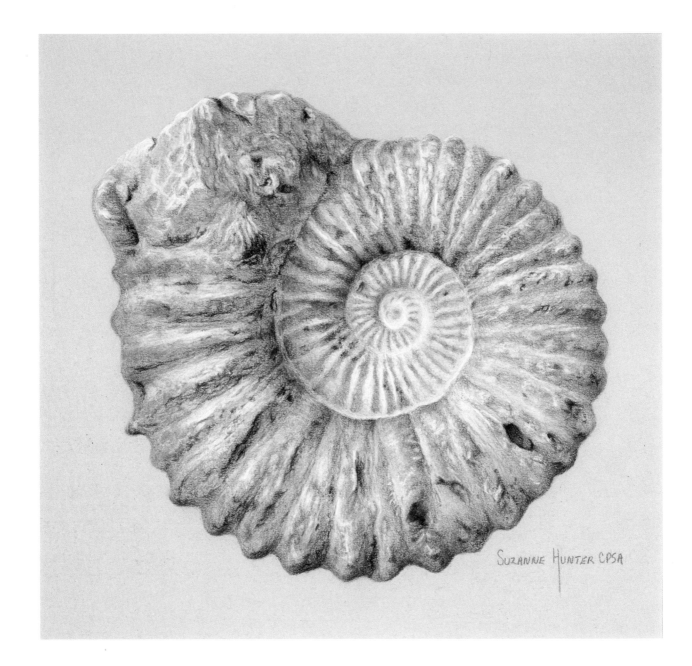

SUZANNE HUNTER
Looking At The Past

8 x 8"

Nielsen Bainbridge Alphamat Board

The beauty of colored pencil is its infinite possibility to fulfill your expressive needs. A pencil is truly an extension of your hand with all its sensitivity to touch, pressure, grasp and movement, and results in an art form as unique as your signature. Colored pencil allows me to study small bits of the natural world up close and bring its beauty indoors to be enjoyed regardless of time or location.

MONICA T. JAGEL
Bountiful

14.5 x 10.25"

Stonehenge Paper–Black

You can grow your own veggies in any sunny spot whether you own a parcel or only a pot. You too can harvest this healthy bounty!

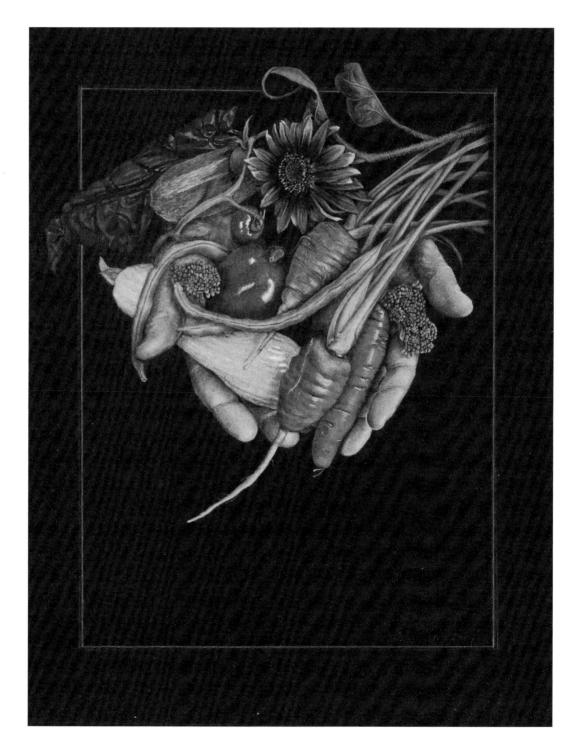

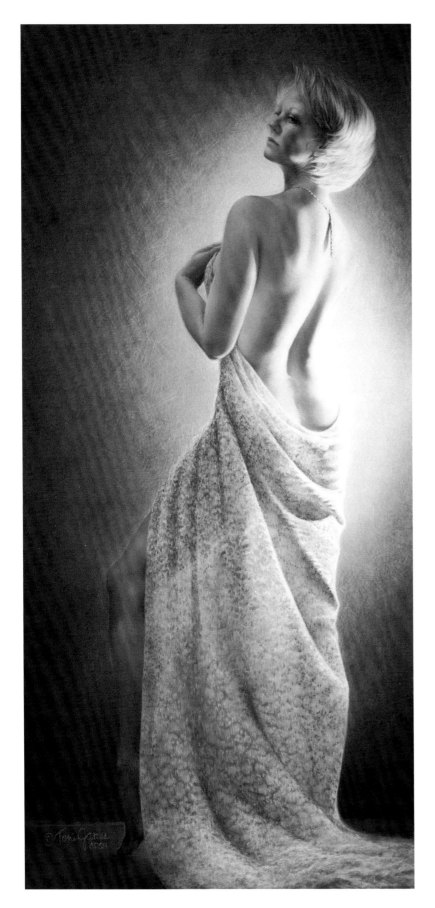

TONI JAMES
Heart, Soul, Strength &
Vulnerability ~ an Artist's Journey

30 x 14"

UART Sanded Paper

*H*eart, Soul, Strength & Vulnerability was indeed this artist's journey. Sanded supports were not new to me. I've been using them with my Prismacolors since about 1994. Uart was a new product and it was quickly becoming my support of choice, but I was curious as to how far I could take it. This piece is the result of my ponderings, a self-challenge of sorts. How far could I push it? Could I achieve the wonderful translucent glow on skin that is only achieved my many layers of Prismacolor–even when using a version of my limited palette? There also had to be drama and mood, not only in light and darkness, but also throughout the entire piece.

What I love about this piece is, at first, it seems to be very simple; but upon further study, you notice that it isn't really. She has emotion and drama and a story to share. The story she shares with me will doubtfully be the same story she tells you. We will each read something different when we look upon her. Beyond the apparent, is it her heart, soul, strength or is it her vulnerability we recognize in ourselves?

J. CORINNE JARRETT
The Wonder Years

11 x 14"

Rising Museum Board

This is my latest work. The child is the granddaughter of a good friend. Just the look on the little girl's face was enough to inspire me to produce the drawing.

JANE JOHNSON
Flags

15 x 9"

Rives BFK Paper

The painting of *Flags* is based on a series of photographs taken at a park near my home in Mansfield, Ohio. I like the way the long blue shadows cast by the trees seem to crawl along the snow-covered ground. The cast shadows also remind me of flags waving against the sky; except in this instance, the sky is white and the "flag" shapes are blue.

In winter landscapes the viewer knows that the air temperature is cold, but the blinding white light illuminating the tree trunks allows them to radiate a sort of heat and warmth.

CAROL JOUMAA
At the Return

18 x 13"

Strathmore 4-Ply Museum Board

I draw most of my inspiration from nature. My work is based on realism with a mixture of fantasy and whimsy. *At the Return* is a special piece for me because with it I achieved Signature status.

In this piece, I incorporated several forms of symbolism. It also reflects a continuing theme I have used in several works which is birth and rebirth. I represented this rebirth and renewal in the background with the desert as it transforms into a lush landscape. I based this on an old prophecy from the Middle East which foretells of the desert areas becoming green again. Another example of symbolism is the addition of the ants. Ants have a highly organized social system; therefore, I used them to symbolize how our own social structure could benefit from their example—a well organized society working together in unity for the good of all. The egg is perhaps the ultimate symbol of birth and renewal.

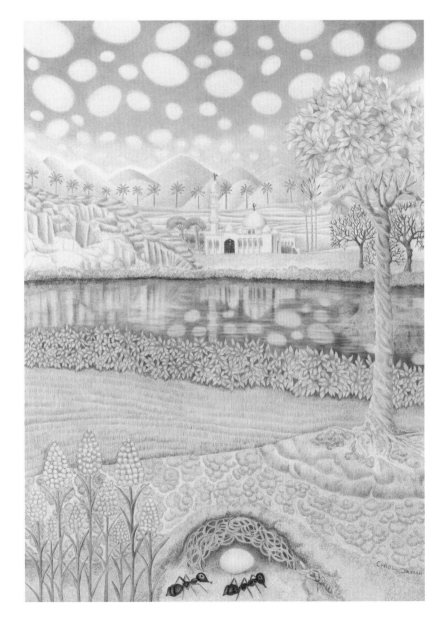

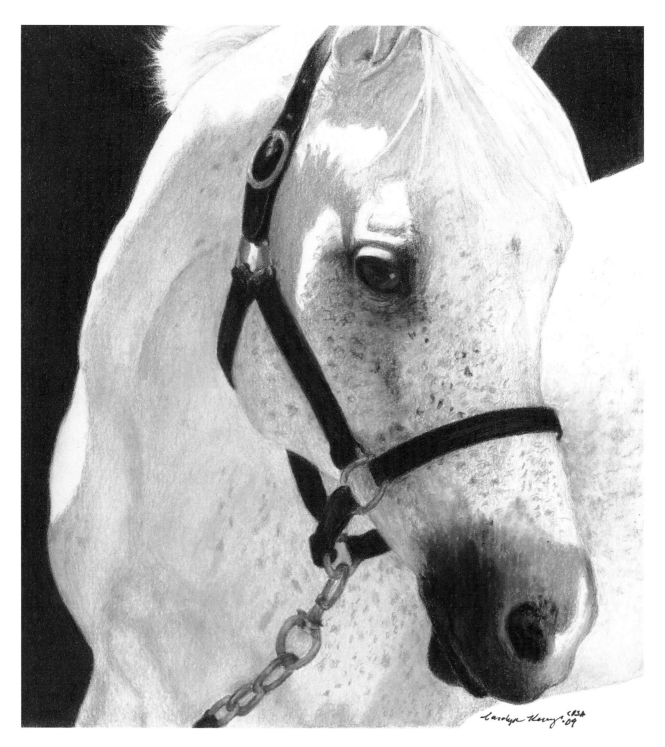

JILL KLINE
The Blue Lady

30 x 17"

Strathmore Watercolor Paper

One of my favorite painters was Surrealist Rene Magritte; naturally so since many of my works fit the surrealists' traditions. Surrealism allows one to be a little demented as it is a realm where the presentation is not expected to reach logical conclusions. Gravity may be turned upside down; size and scale may be off. The lady in this piece is based on a sculpture that I made that has appeared in a variety of ways in a recent series of my drawings. Magritte often used female figures in his works who were sometimes portrayed partly as women and partly as sculptural figures. This says something powerful to me based on how women are seen now, how images of women are used to influence our minds and our choices, and to affect our moral senses. The use of nudes in art conflicts still with America's continuing Victorian outlook.

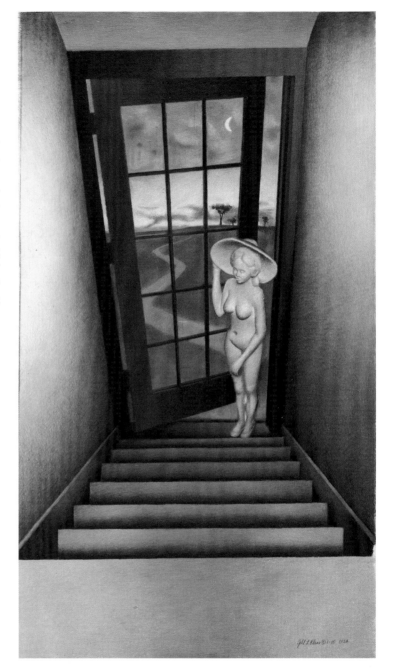

CAROLYN KENNY
Afternoon Delight

11.75 x 10.75"

Stonehenge Paper

The late afternoon Southern California sun glowed so deliciously on this little white Arabian horse that I just had to draw him. My intention was to accent the sun colors on his white, dappled coat and to capture the sweetness and gentleness of this horse.

This picture reflects my love for horses as well as the loving nature of this particular horse.

I used the Icarus board to blend, move and layer the yellows and oranges on his coat.

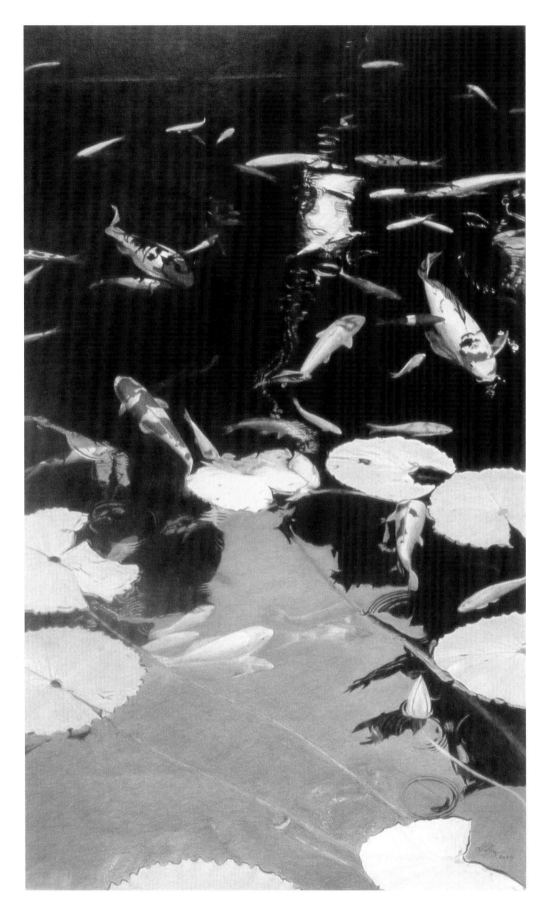

LINDA KOFFENBERGER
Beautiful Swimmers

25 x 15"

Stonehenge Paper

I am fascinated by fish. I like everything about them, particularly the play of light around them, swimming. This is what attracted me, on a bright summer day, to this Koi pond in North Carolina.

This composition is about contrast—sun and shadow, commotion and calmness, light and dark. The area above the lily pads is teeming with fish while within the sunlit area, surrounded by the lilies, there is a mood of calm and serenity. Even the colors of the fish play to this contrast with bight colored Koi outside and the pale immature fish within.

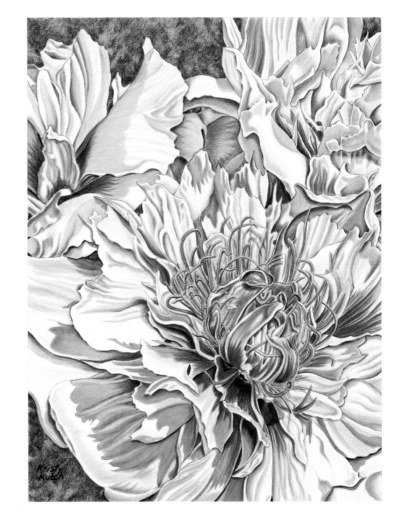

KRISTY A. KUTCH
Garden Treasures

16.5 x 12.5"

Museum Board

Realistic themes from nature appeal to me as an artist. Landscapes that evoke treasured memories are unique, but fruit and flowers are especially dear to me. Perhaps that appeal stems from being the granddaughter of farmers and having a mother who preferred gifts of flower bulbs and seedlings to finery like lace and jewelry. Whatever the reason, those subjects attract me time and again. The local farmers' market has been an unending source of inspiration, with its colorful flowers, fruits, berries, and vegetables.

Perhaps part of that appeal, too, is in viewing something that is seemingly ordinary, but portraying it in a unique manner. It reminds me of the difference between hearing and listening, or playing the correct musical notes and feeling the music. Whether it is seen from a different angle or with a dramatic play of light, the subject must appeal to me, captivate me, and truly move me. Otherwise, the many hours spent on a colored pencil painting would be a tedious chore, and life is too short for that.

Teaching colored pencil and sharing my enthusiasm for the medium has formed me as an artist. Witnessing that "light bulb" moment and the enthusiasm in the eyes of other artists has granted me a full-circle type of satisfaction.

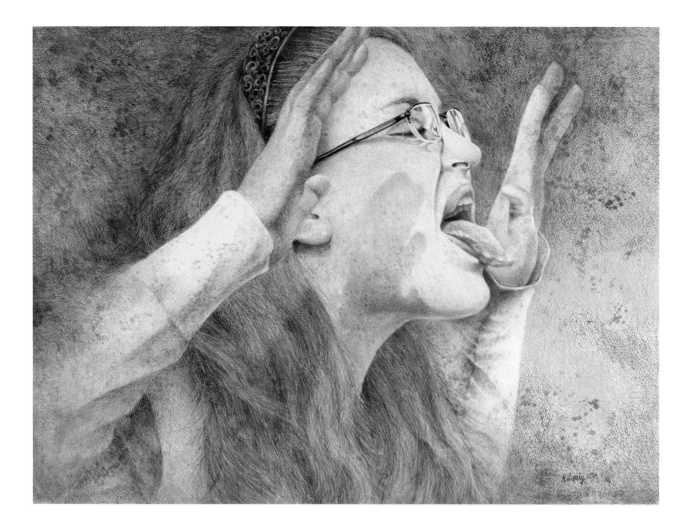

KATE LAGALY
Mischievous Mood

21 x 29"

Watercolor Paper

*M*ischievous Mood is a drawing inspired by my daughter. Since I caught her in an uncharacteristic mood in this drawing, I decided to try to capture an 'uncharacteristic' feel by changing how I approached this piece.

I completed this piece in three layers on watercolor paper. The first layer was a value study underpainting using one color. I used an uncharacteristic color and melted this layer with turpentine. Next, I drew with two additional colors over the value study before using the turpentine again–applying it vigorously to soften and smudge the background. I dissolved three colors on a separate board with turpentine and then painted and splattered them over the drawing. This session was loose, free, and messy. I wanted it to convey fun and to add excitement to the drawing. I added details, pulled some parts from the background, and lost some of the edges. This is when she started to appear as if she was coming out of the background.

ROBERT C. LASKY
Field of Creams

10.50 x 14.25"

Strathmore Bristol 500 Series Vellum

I undertake thorough background research before beginning a new piece and this painting was no exception. I made extensive efforts to absorb the essence of the subject matter before attempting to render it on paper. The more I got into the topic, the more enjoyable the research became.

I learn a lesson from every painting and this one was also no exception. I learned that that one must exercise caution before making research commitments. There are over a thousand ice cream flavors! The piece is complete, but I'm still working diligently on the research.

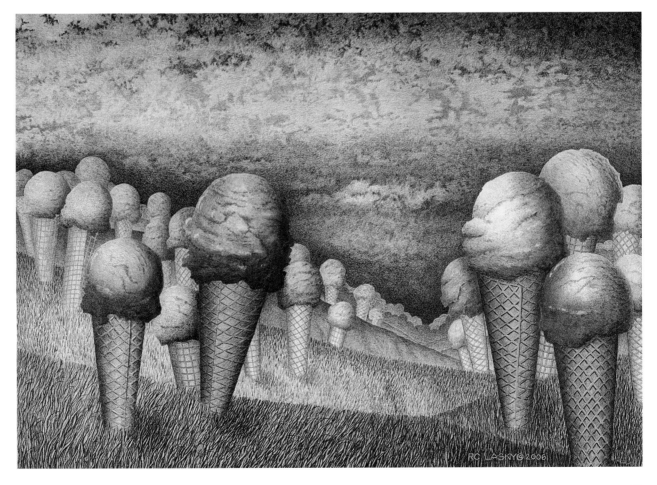

DONNA LEAVITT
The Calm

12.5 x 10.5"

Strathmore Paper–Hard Surface

The Calm is part of a series of work dealing with stones. It is an attempt to bring landscape into a close-up image and to examine a small area minutely. (Lessons from a small granddaughter!) I like to make my compositions using the negative space as a powerful element of the total presentation. Here I have tied the mass together with black shadow to enhance the imagery. The rocks reside in a wonderful tidal area along the Strait of Juan de Fuca (WA) that is a favorite destination and that provides me with endless possibilities of seeing.

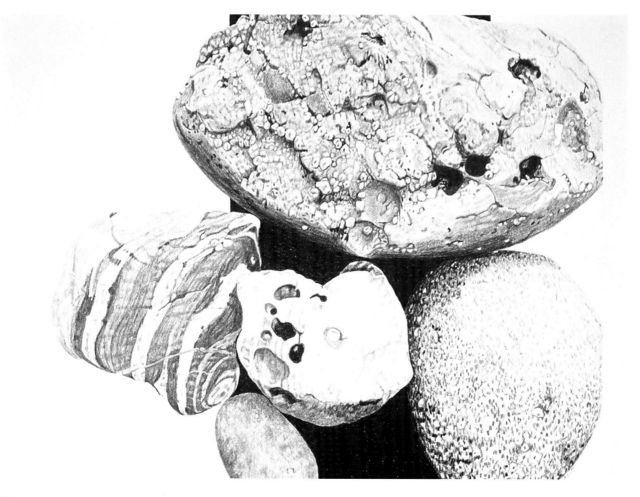

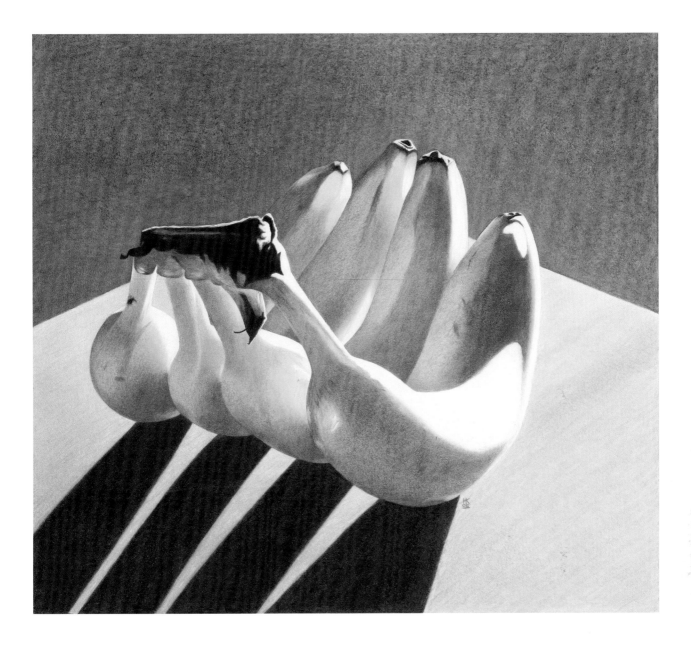

HEIDI J. KLIPPERT LINDBERG
Banana – Split, Too

18 x 20"

8-Ply Archival Mat Board

I have created a distinctive technique with colored pencils that gives a sculptural quality to my work. My objective is to showcase the very essence of my subjects in glowing color to create an intimate portrait with depth and movement and to make the virtually tactile images look almost alive.

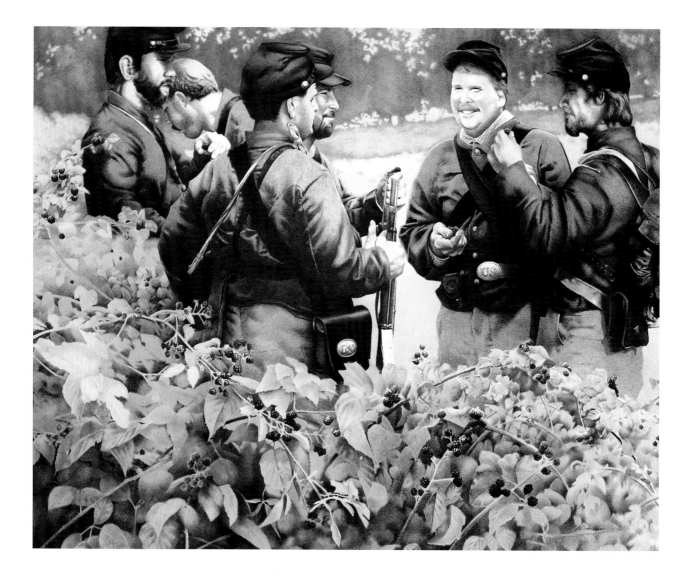

AMY LINDENBERGER
Calm Before the Storm

29 x 37"

Crescent Acid-Free Rag Mat

My primary body of work now focuses on the lesser known people and events of the American Civil War era. So often, Civil War-themed art focuses on dramatic battle scenes and heroic figures. *Calm Before the Storm* was conceived to do just the opposite. Abraham Lincoln was known to refer to the Civil War as "The People's War," since it was fought largely by volunteers. In the very early stages of the War, the common foot soldier understood little of the realities of war and looked upon the whole experience as some sort of grand adventure–an opportunity to see the world beyond his own farm or small town, offering once-in-a-lifetime experiences he could relate to his grandchildren many years later.

This piece presented a number of artistic challenges centered around two issues: 1) depicting the interaction between a group of figures in a relaxed and natural way, and 2) capturing the density of the blackberry bushes without overwhelming less important areas with detail. The artist Winslow Homer worked for Harper's Weekly as their "special correspondent" during the War, traveling with the Union troops and working in the field to depict their actions. As part of my research, I looked to Homer's artwork for inspiration in hopes of capturing that same "life in the midst of war" quality.

DYANNE LOCATI
Portland Rain

30 x 20"

Nielsen Bainbridge Alphamat Board

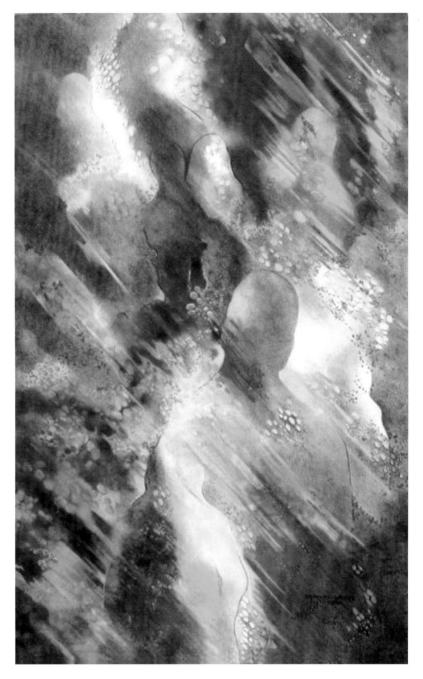

To develop a series, I start with an idea then cultivate that idea into artwork using a variety of mediums, styles and surfaces. This painting was part of a series depicting city street scenes. I was inspired by a newspaper advertisement to sell clothing. That photograph was of people walking down the street. I thought what a great idea!–And a new series was born…

I begin a painting without drawing an image or sketching a scene. Simply applying color to the surface allows imagination to grow and the painting starts to take form and shape. The work evolves and begins to take on the abstract image that I imagine. I then allow atmosphere, mood, and illusions to take over. This helps me create a piece of art, not copy what the camera has captured. For me the essence of the street scene comes alive.

Textures are a wonderful addition to my artwork, both implied and actual. This painting is full of implied texture in the image of rain and stormy wind blowing in an oblique line across the surface. People are subtly placed in the composition using a vertical line that created resting places for the eye before continuing across the rainy surface.

Color is applied at random using many layers of colored pencil. This painting has a wide variety of color using the full spectrum of the color wheel. However, it has the illusion of being a blue and orange complimentary color scheme.

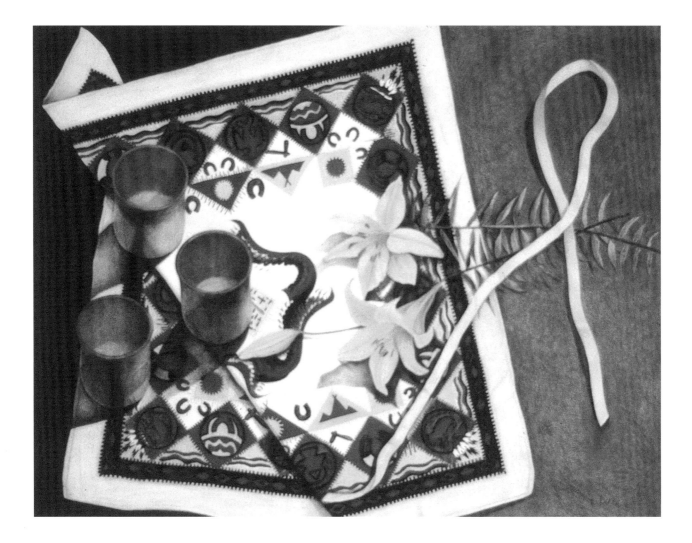

RITA DUNN LUDDEN
Indian Scarf with Three Yellows

21.75 x 28.5"

Acid-Free Bristol Paper

In this painting, I hoped to show a strong design base with the directions of the ribbons and lilies leading the eye into the objects of numerous shapes and colors. I found that working with many forms, colors and spaces keeps a vitality and spontaneity at a high level of interest while working.

In my studio at the Torpedo Factory Art Center in Alexandria VA, I speak with thousands of visitors and show them the step-by-step process of creating colored pencil drawings. For many years now, it has been a joy of working in this wonderful medium.

TERESA McNEIL MacLEAN
Waiting for a Train

6.25 x 12.5"

Bristol Board

A few years ago, we took the train from Santa Barbara, California, to Tacoma, Washington, to visit relatives. I sat by the window quickly sketching passing scenes in my journal. When a station stop was long enough, I'd step out, sketch and photo. I focused on the amazing vanishing point of the train tracks as they receded off into the future or past. When we returned home, I drew a vanishing point series, using those sketches and photos of train stations we had traveled through. To highlight the angles and the triangle of the vanishing tracks, each piece is square. Primary colors are predominant amidst the metal grays. In this drawing, my husband is in the foreground; and in the distance, our daughter stands between our train and the adjacent tracks. I've used the burnishing technique with colored pencils on the same surface I've used since 1976.

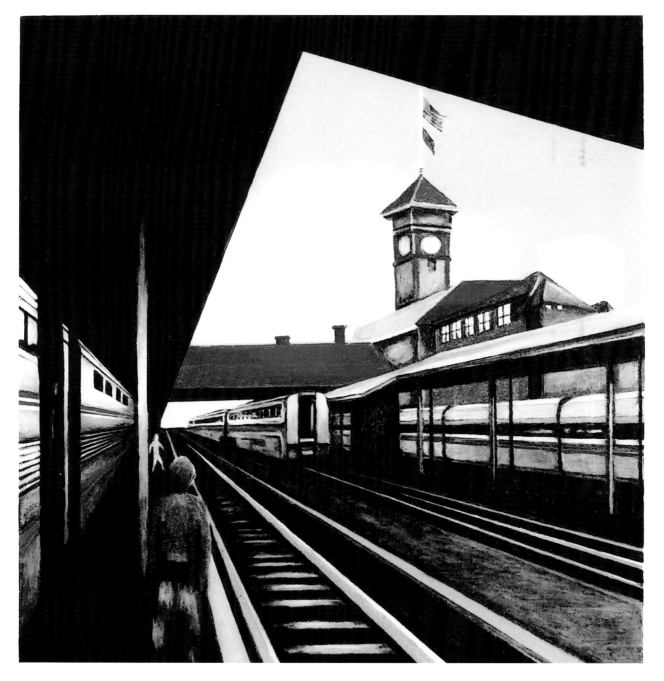

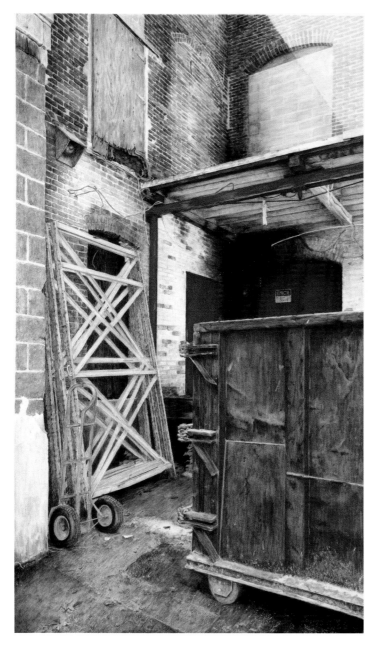

PAULA MADAWICK
The Dye Works

25.25 x 15.125"

Arches 140-lb. Hot Press Watercolor Paper

I'm a realist. I like to capture the unexpected beauty found in unexpected places. I instinctively recognize my landscapes. My subjects are usually outside and are often temporary landscapes. I spend a lot of time capturing what I intuitively know will translate into interesting drawings.

The location of *The Dye Works* grabbed me when I was working on another project at this site. I turned a corner and saw: red, yellow and blue. A few days after I recorded this, the red dumpster was exchanged for a green one, and the blue hand truck was gone. I would not have drawn the latter image.

My medium is water-soluble colored pencil, and my favorite surface is Arches 140 lb. Hot Press watercolor paper. I like to saturate the paper with color; this is accomplished by wetting the base color for the different objects in the drawing. When the surface is dry, I re-draw, sometimes re-wet and draw again and again, layering color. I draw what is seen but not noticed.

LINDA J. MAHONEY
What She Sees

20 x 16"

Stonehenge Paper

I didn't realize until I was an adult that I have struggled with Attention Deficit Disorder all my life. Once that was determined, so many things from my past fell into place. This painting is a representation of all the ideas bubbling away in a young girl's mind–especially when she should be paying attention to something a little less colorful and interesting.

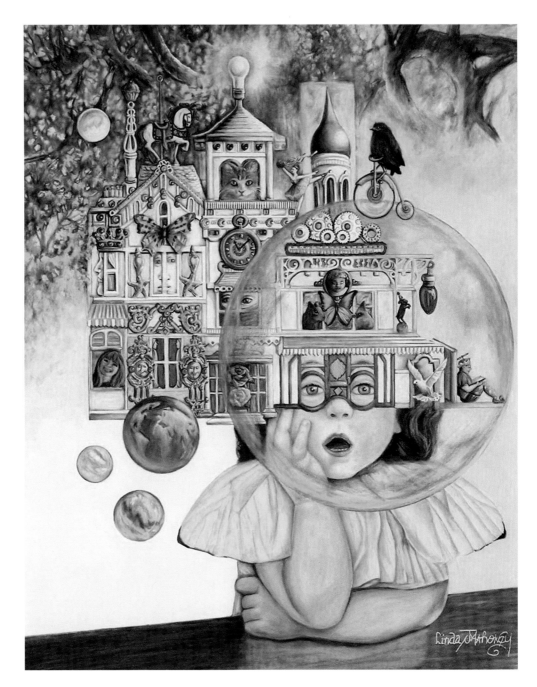

JEAN A. MALICOAT
Neptune's Treasures

10 x 14"

Stonehenge Paper

Whenever I take a vacation to the Gulf of Mexico or the East or West Coast, I usually collect seashells. I have also been given several from other countries and have bought many more. One day, I was trying to decide what to do with some new shells when I realized they would be great subjects for a painting. I had so many to choose from that the hardest part was deciding on which ones. I really wanted to capture all the special colors and textures of these shells. I used strong lighting from the top left down to the bottom right so that a couple of the more transparent shells would show light filtering through them. I used lots of heavy burnishing as the final step in my work, and this seems to add a special glow to the shells. I'm proud to say that this piece is the one that earned me my Signature status.

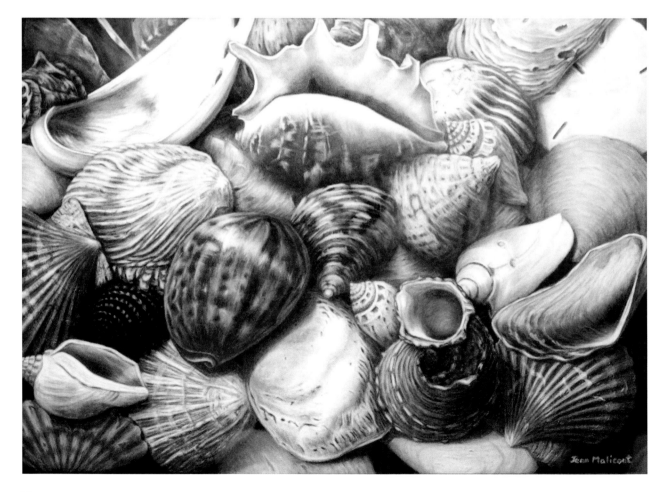

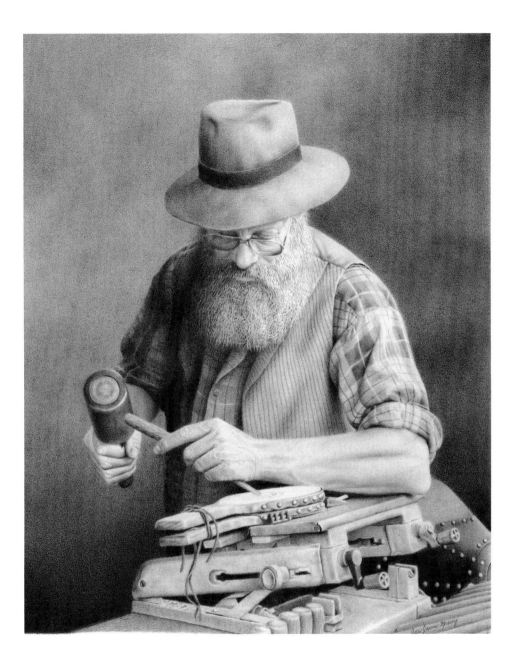

ANN JAMES MASSEY
The Woodworker

12 x 9" Collection of Imogene James

Bristol Paper–Plate Finish

Resting in an Oklahoma hotel room in 1983 after a long day at the art fair where I was exhibiting my work, I saw a TV ad for Silver Dollar City in Missouri. Intrigued by the images, I took a detour to this marvelous arts and crafts theme park. The Woodworker is based on one of the artisans there, though he would not have recognized himself for the artistic changes I made.

I started with a quick gesture sketch on tracing paper using a regular pencil to decide the composition, size and basic proportions. After I refined the drawing and transferred it to my Bristol paper, I gently built up fifty-plus layers, without erasing or smearing, using needle-sharp black colored pencils. To save time, I sharpen up to 90 pencils at a time.

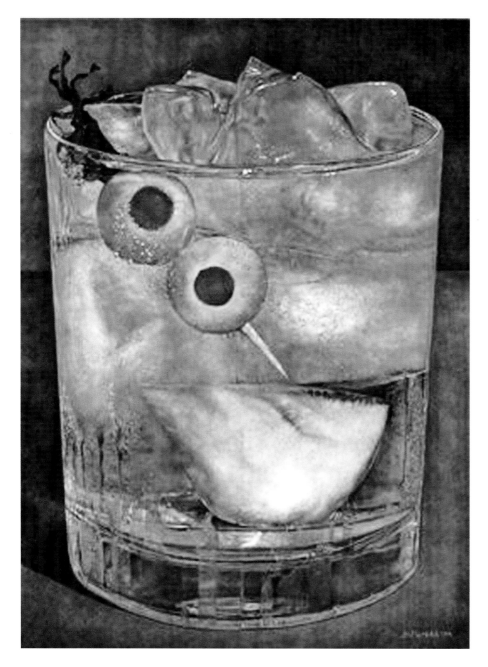

JAMES K. MATEER
On The Rocks With Two Olives

30 x 22"

Crescent Art Board

*O*n the Rocks with Two Olives depicts a vodka martini that has just been mixed. In the process of photographing it, I noticed that the exterior of the glass had begun to "sweat" and drops were running down its side. When I received the prints back from processing, I noticed there were a number of surface variations in evidence: opacity, transparency, distortion, vague forms and sharp details. All of these combined into a multi-layered composition that I found completely fascinating. Most of my work concerns itself with an obsessive desire to conquer the textural surfaces around us. I start my compositions with a minimal linear drawing and begin layering colors in a basic crosshatching technique. Value contrast is a major consideration in all my work, while color accuracy is of secondary importance.

EILEEN MATIAS
We See You

14 x 20"

Crescent Mat Board

In 1990, after several years of working with other mediums, I chose colored pencils as my way of portraying the visions, perceptions and passions that make me an artist.

I have always been fascinated with color–brights, pastels and the rich deep hues.

I have been working on drawings of animals, nature and the environment since 1999.

I have been a volunteer with the Humane Society of Greater Akron since 1998. Since I was five, I've had guinea pigs and rabbits. The rabbits in *We See You* were in the Buckeye House Rabbit Society rescue. I use my art as a way to open dialogue about animals, endangered species and the environment.

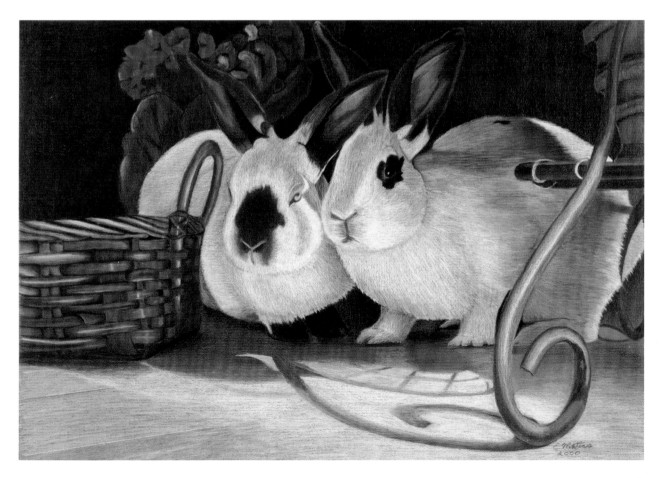

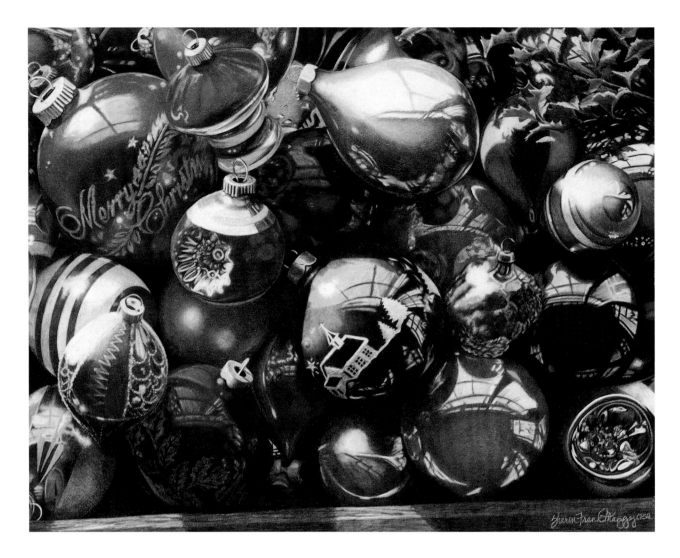

SHARON FRANK MAZGAJ
Vintage Ornaments

14 x 18"

Illustration Board

Every Christmas season I display my favorite old glass-blown ornaments in an equally old wooden box. Knowing my love of "old things," several different relatives have given me what was left of their collection. These ornaments, which have been in my family for decades, consist of a wonderful variety of shapes and colors. I am intrigued with the idea that each shiny ornament is essentially a three dimensional "mirror." After taking reference photographs, I chose what I thought was the best composition and implemented my standard "cookie cutter" method–drawing and completing each shape before beginning the one next to it. It was fun and challenging to draw the reflection of shapes and colors on each ornament. On some ornaments, I used over 30 different colored pencils that required significant layering and burnishing techniques.

The interesting story behind this piece was that I could look at each ornament and make out the distorted reflections of the window, the room or surrounding ornaments. However, every ornament had a mysterious tiny triangular shape, the source of which baffled me. I eventually realized that the source was my reflection; the "triangle" was my extremely distorted body as I stood on a stool above the box when I took the photo. I decided to leave my reflection out.

CARLA McCONNELL
Elizabeth

12 x 9"

Stonehenge Printmaking Paper

The piece included here is part of a larger series called "Views from Open Windows." The "windows" offer a momentary, emotional glimpse into people's lives and suggest a story. The characters are derived from individuals I have known or seen, and may be unique to the person or a composite of several faces. Elizabeth is a composite image of my mother and me. The background was based on a neighbor who bloomed where she sat in her small duplex.

Using many colored pencil techniques over the last 25 years, I came back to the basics with this series, layering color with a fine point. What drew me, originally, to colored pencil was the wonderful "dotted" texture achieved by no other medium. As a mixed media artist, I often and purposely combine this effect with other painting. The sculptural style portrayed in the artwork is just that, my style. It is how I see most subjects and how I draw. I think I have always been a cubist at heart and prefer abstraction to realism. It is my hope these pieces of life help viewers understand a bit more about themselves and their neighbors.

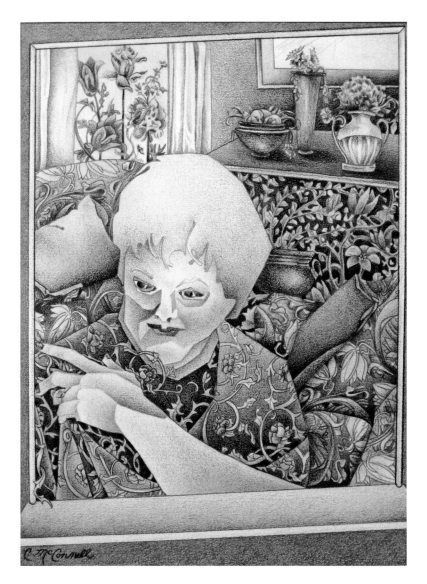

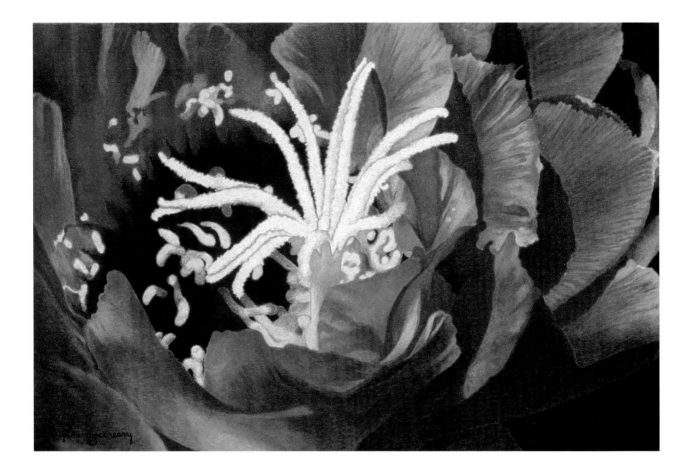

JANE McCREARY
Celebration

6.5 x 12.5"

UART Sanded Paper

I have been doing some form of art expression all my life. After retiring from teaching, I read in our local newspaper about a colored pencil workshop. Well, the rest is history. I was captivated and have been using colored pencil exclusively for twelve years.

I am inspired by the desert area I live in. When it bursts into bloom, I am enthralled with the shapes and beautiful colors. My subjects usually consist of flowers, plants and trees that cover our landscape. *Celebration* is a drawing of a cactus growing in my yard. I love to draw anything with amazing color and form that is pleasing to the eye. I am gratified to know that my work in homes and museums brings pleasure and enjoyment.

RUTH SCHWARZ McDONALD
Barkley's First Swim

12 x 20"

Canson Mi-Teintes Paper

Golden retrievers are supposed to be great waterdogs, but for some reason ours do not like to swim unless forced. We were out hiking and fishing, when Barkley decided to take his first swim. I wanted to show his personality and his determination. This is done on blue paper that I worked into the color of the water so that it is more of a vignette. I love transition from the very details of the head to the ambiguous shapes formed by the water and reflections of his body.

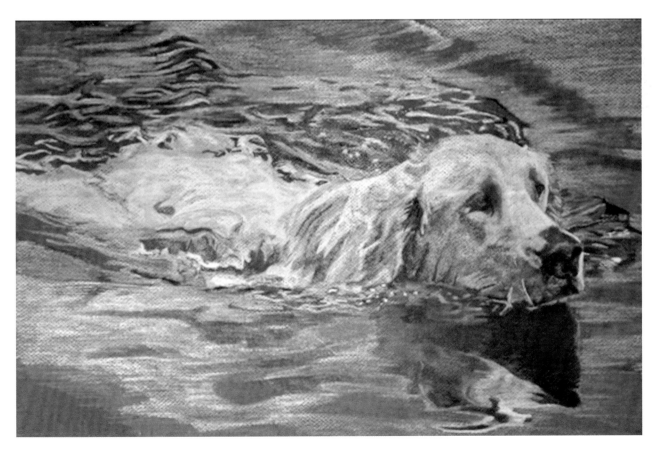

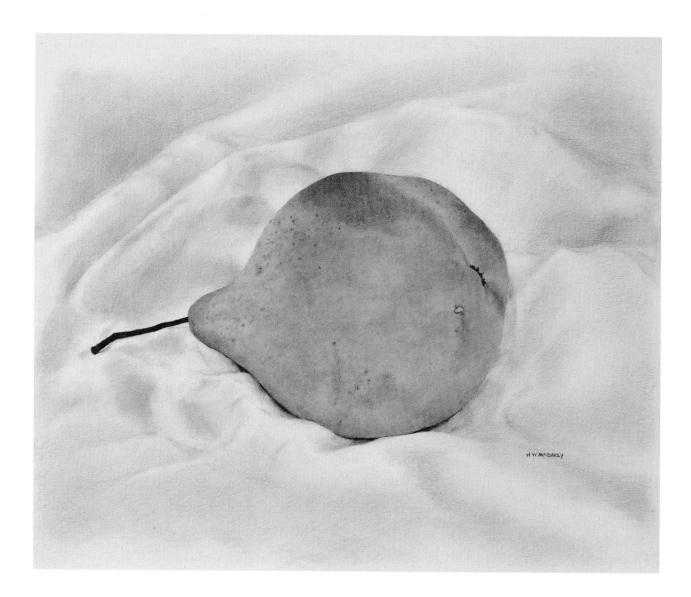

HEATHER W. McGAREY
Bosc Reclining

14 x 17"

Strathmore Bristol Vellum Paper

I've always been taken with the sensuousness of the pear, from its subtle sweet smell to its gently curving shape. In *Bosc Reclining*, I've tried to capture the feeling of the classic Odalisque with the beautifully ripe pear resting in the soft drapes of cloth. This painting was drawn from a live model.

MIKE MENIUS
Chateau by Night

7 x 5"

Strathmore Paper–Black

This piece is an image reversal. The original image was the same scene on a sunny afternoon with warm colors of high value. I chose a nighttime setting, with illumination coming only from the chateau's windows, and shadows that suggested the elements in the composition. Most of the colors are cool, but the window lights provide warm accents.

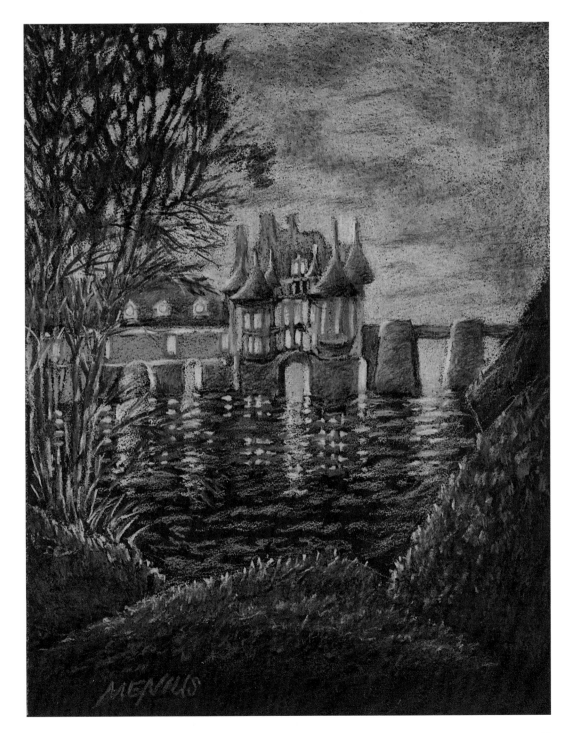

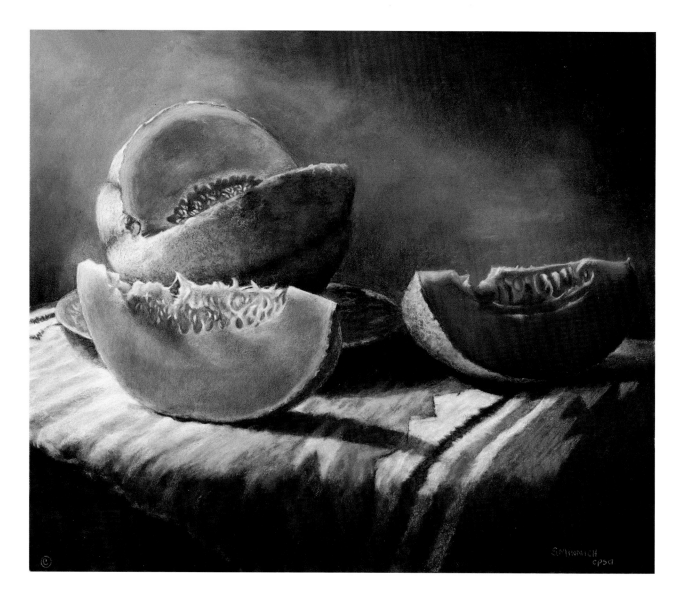

SHEILA MINNICH
Luminosity

12 x 14"

Ersta Sandpaper

The still life subject is probably my first love using colored pencils. I simply enjoy the process of "getting there." Compared to some of the other art mediums, it can become quite laborious; but none the less, for me, it is a labor of love. The simplicity of a still life mixed with color can be an exciting experience.

My goal is to catch the viewer's eye and heart with my artwork. I get the opportunity to touch people's lives through a different venue of communication. My art may touch someone that I will never meet in person; therefore, it is important that they let me introduce myself to them through my artistic endeavors. Hopefully, they will like what they see.

MAUREEN MITCHELL
A Delicate Balance

16 x 8"

Stonehenge Paper

One day, as I was barreling through my living room, an image flashed into my peripheral vision and brought me to a sudden stop. A forgotten bottle, set on a mantle ledge and brought forth in the afternoon sun was like the eye in my hurricane. Still and strong, completely contained yet balanced precariously at the edge of the mantle, it instantly symbolized the tentativeness of my daily existence. Of course, anything powerful enough to slow me in my mad dash is worthy of further study; and so, a painting was born.

Colored pencil was the perfect medium for this subject in both process and results. The slow, focused build-up of layer upon layer of color is calming and therapeutic, a meditation of sorts. In addition, the marvelous translucent quality of colored pencils work very well to depict the deep rich color of the shadows and the delicate reflection on the bottle surface. Although very simple and monochromatic, this is one of my favorite pieces, and I never get tired of looking at it and reminding myself to be still–if only for a moment.

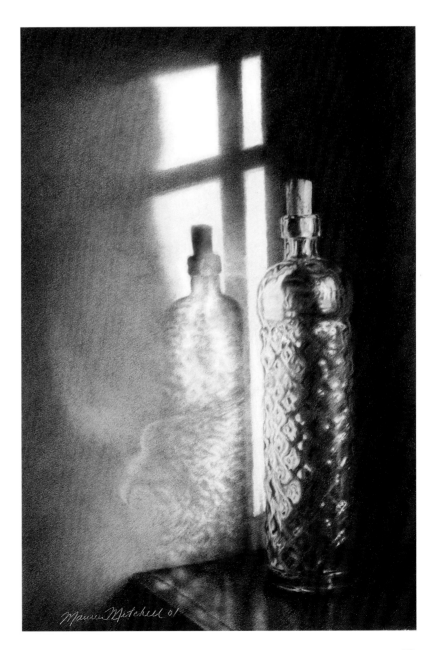

GENE MLEKODAY
Winter Warriors

9 x 13.25"

10% Rag Board

Colored pencil is a fairly unforgiving medium. An artist must begin with a clearly defined end in mind. I work from light to dark and carefully block out the image on paper that often has a degree of texture or tooth. I mask delicate spaces such as highlights, specific subjects, and areas that will be addressed later in the drawing process.

I then apply color in a wide range of strokes from broader sweeps to finer flecks, dashes, and crosshatchings. By adding layers of color and blending the strokes, I create a broad palette. The golden brown highlights in a pheasant feather, for instance, may actually be the result of several short strokes and layers of complementary colors such as orange, yellow ocher, sienna brown and dark brown. By varying the pressure when applying color—from light airy strokes using the side of the pencil lead, to firm, distinct lines from a well-sharpened tip—I build up the color and contrast and add a depth and richness to the image.

Up close, a finished image is a surprising collage of countless layered colors that are blended to create shadow and light. Drawing from a lifetime of experiences in the wild, I explore a wide range of subject matter in my work—from wolves and songbirds to upland game. My series of works profiling hunting dogs shows my sensitivity to the individual personalities of my subjects.

MARI K. MOEHL
Who Was That?

18.5 x 15.5"

UART Sanded Paper

As my Aunt Cecelia often reported, "I'm on shore patrol." With her field glasses, she kept track of lake activities and passersby. It's fun to be a busybody. A four-star busybody is often surrounded by fellow busybodies all asking the same question. My group of pears is unaware that we, the viewers, are being busybodies ourselves watching them ask the question, "Who was that?"

I find that looking for a new subject to draw is like looking for air when all the time I am breathing it. I enjoy drawing brief moments that would have been lost forever had I not noticed. My job is to be aware of what excites me, moves me to tears, and makes the blood rush to my head.

KATHLEEN MONTGOMERY
Dream Big

9 x 11"

Mi-Teintes Mat Board

Dream Big has special meaning to me. Many people cringe at the thought of snakes, but I wanted to show how beautiful many of them are. Our pet (a checkered garter snake) lived for 16 years! The title stems from a goldfish which was too big for the snake to eat. I could not see the fish passing for naught, so I documented it in a drawing.

I draw primarily on a colored ground. Using a middle value, not only quickens the progression of the drawing; but choosing a color that is basic to the drawing itself, also makes for less work. The color of the snake is the same as the surface.

ROSE MOON
Come to My House

23 x 19.5"

Strathmore 500 Series Museum Board

When I first became a Signature member of CPSA, it changed the way I worked with colored pencils. Although it was not required and probably something that held me back, I seemed to be too committed to "getting it right." Afterwards I just let go and started working much looser.

Switching from using Strathmore 500 paper to museum board was a start. Even though museum board eats pencils, I fell in love with the speed at which I was able to work. I had always wanted to just let go and draw whatever came to mind without much of a plan, so after making a few preliminary sketches I dove in and created *Come to My House*.

It was not the first in my series of houses you can see into, but it reaped the benefit of my experience with this subject. I came upon this idea when I made some sketches while thinking about my brain as a house with different rooms in it. At that time, I was suffering a loss and the first drawings were dark and negative; but after exploring this idea with color, everything became bright and positive. It gave me some proof of art's healing qualities.

CYNTHIA C. MORRIS
Look on the Bright Side

15 x 22.5"

Acid-Free Mat Board

As an artist, the lake and its surroundings are always an inspiration to me. So family outings on my brother's pontoon generally find me with my camera in hand while others prefer a fishing pole in theirs. On this particular outing, however, I found myself "hooked" on my brother's sunglasses rather than the nature that surrounded me. The red-rimmed glasses with their yellow mirrored lenses were captivating, to say the least. The result was a nice surprise. The cartoon-like images within the lenses played perfectly against the realism of the facial features giving viewers something to reflect on (. . . pun intended).

LINDA MORTON
Radial

14 x 11"

300-lb. Hot Press Watercolor Paper

I believe that art is required to express life to the fullest. I prefer to document scenes that are anchored in the past and might be lost to future generations. I enjoy the challenge of intricate pieces of art. I feel that each of us, in our art, has a special gift that must be shared with others to expand the limits of human awareness.

I am a full-time professional studio artist. While I work in various media, I prefer colored pencil. I have done work for the U.S. Marines and had my work archived into the National Museum of Women in the Arts in Washington, D.C.

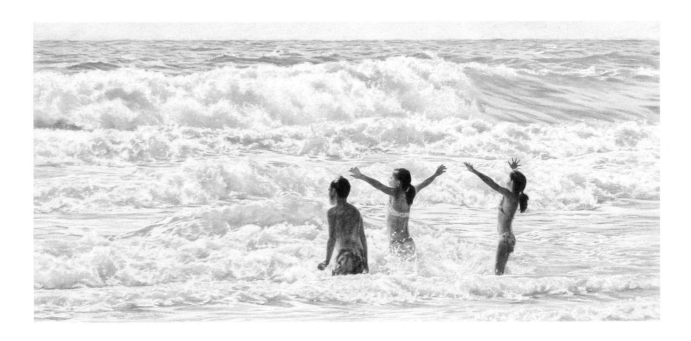

RHONDA NASS
Grace

10 x 9"

Stonehenge Paper

Many years ago, I took a class from an internationally respected quilter and teacher. We kept in touch over time through occasional cards, but I think both of us would have defined our relationship as one of casual friends. Six years had passed when she came to our home for the first time. We spent an hour or so talking before she asked if I recalled the quilt she had made in that first class together. I remembered it and reiterated how great I thought it was. She then surprised me by reaching in her bag. My amazement in seeing the quilt soared to astonishment with her next words, "Every once in a while I like to give something to someone who doesn't expect it."

She handed her quilt to me.

Never before had I so real an understanding of what grace is: the incomprehensible, invaluable gift given, not because of the worthiness of the recipient, but because of the love and character of the giver.

MELISSA MILLER NECE
High Spirits

12 x 26"

Art Spectrum Colourfix Paper–Blue

Water—elemental, essential, powerful. We need it to live, but too much can destroy. It's beautiful in its many natural forms, from gentle lapping ripples to crashing waves, lazy river, roaring waterfall or peaceful lake. We are drawn to it: to play by it, in it or on it, to contemplate it, to appreciate its beauty. Constant, yet constantly changing, it is a source and symbol of renewal.

The place by the water that we call a beach is also a stage for human activity. When there, we observe countless little plays, fragments of dramas and comedies acted out by characters in colorful costumes, in lighting that might be dramatic, bright and cheerful, or soft and subtle. In my drawings, I aim to capture those myriad scenes, bits and pieces of dramatic activity to be filled in from our own experience, by our own interpretations. We observe, and in our memories we hear the steady rhythm of the waves, the laughter of children and screech of the gulls, we smell the sunscreen and salt air, we feel the hot roughness of the sand. We are back at the water's edge.

My beach drawings are based on photos. Casual human gestures and saltwater waves must be frozen in time and saved before I can draw them in loving detail. But even when I set out to paint or draw on location, when I go looking for something beautiful in nature to inspire me, I seem to always find myself drawn to the water's edge.

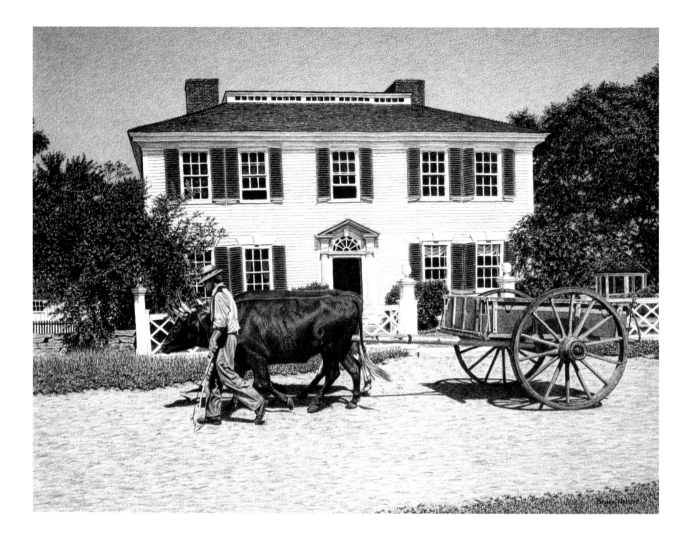

BRUCE J. NELSON
Old Sturbridge Village

18 x 24"

Rives BFK Heavy Weight Paper

Some years ago, an old Navy buddy invited my wife and me back to Springfield, Massachusetts, to his retirement party and a long talked-about reunion. We flew back and one of the places he took us was to Old Sturbridge Village. The workers there dressed in the styles worn in the past and used old-time equipment to do their daily chores. I saw this ox cart going down to dump a load of brush. I waited for it to return and took this picture. The driver was unaware of what I was up to. I had time for only one shot, but I got it. (Note that the trees are an example of my pointillism technique.)

BARBARA BENEDETTI NEWTON
Eggs in a Bowl

16.5 x 20.5"

Stonehenge Paper

My goal was as simple as the title, *Eggs in a Bowl*, to portray an ordinary subject in an unexpected way. Straight out of the refrigerator and placed on the counter by a sunny window in my studio, my subjects began to sweat. As the beads of moisture formed on the shells, I was first dismayed but then decided they added interest so I included them in my painting. I imagined the eggs to be fresh from the hen house and still wet from washing.

As I adjusted the window shutters, I was delighted to see the segmented, ladder-effect shadow leading to the dark side of my subject. The sun filled the opposite side of the bowl with warmth and created a cozy, nest-like setting.

I'm a big fan of a full range of value in still life work because I think it helps hold the attention of the viewer, especially when the color palette is limited. This full range of value also creates very interesting form shadows and cast shadows, egg upon egg. The lighter and brighter blue lower right corner balances the warm yellow and pink hued bowl interior. A spot of orange on the underside of the "main egg" gives the viewer a little surprise and a focal point.

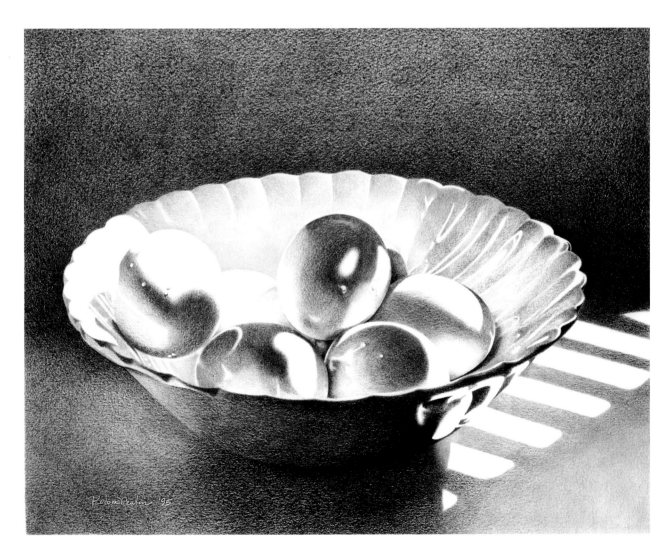

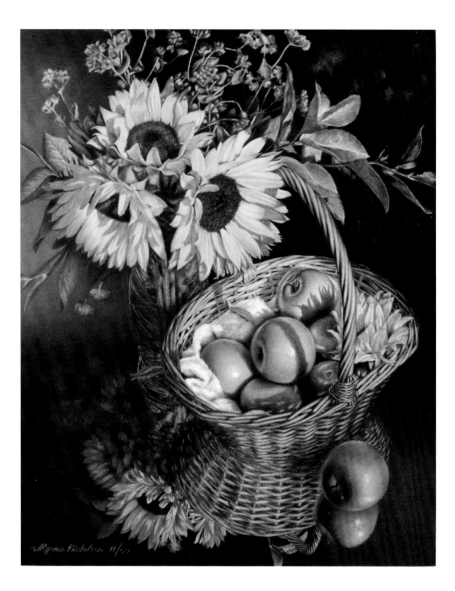

ALYONA NICKELSEN
August 21

19 x15"

Revere Silk Paper

August 21 reflects some of my most special memories. The first time I stepped on American soil was on my birthday, so I call that day my "Personal Columbus Day." Every year, each additional candle in the cake reminds me how lucky I am to be in this wonderful country. The color scheme, high contrast and the elements of the setup made a very personal connection with me as well. According to the Zodiac, I am a Leo, my ruling planet is the sun and the sunflower is my flower. Apple pie is my husband's favorite, which to me is also associated with the American Tradition of hospitality. And what apples could be better for such a wonderful treat than Granny Smith? California captured my heart with its great weather and bright sun. Bright light creates great contrast and deep strong shadows. Since I am an optimist by nature, I always look for a silver lining. In this artwork, I treated the shadows to emphasize the light and reiterate the old Russian proverb: "There is no evil without good."

EILEEN HAGERMAN NISTLER
Cactus Flower

14.5 x 11"

Stonehenge Paper–Black

The inspiration for this painting came from such a fun day. Some of my favorite ladies and I were returning from an art show in Cheyenne. All of us were photo enthusiasts, and we were joking about how we have the worst time getting our husbands to stop so we can take pictures along the side of the road. Our driver pulled the SUV over and told us jokingly, "You've got five minutes." We laughed and took many pictures. *Cactus Flower* was a result.

I usually try to have a full range of values in my painting. The style I strive for is dramatic classical realism.

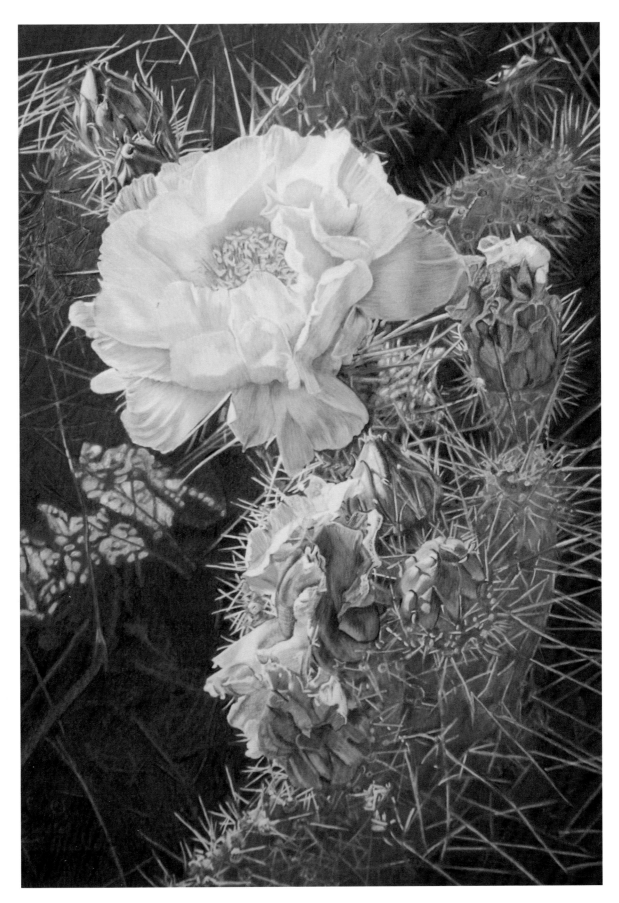

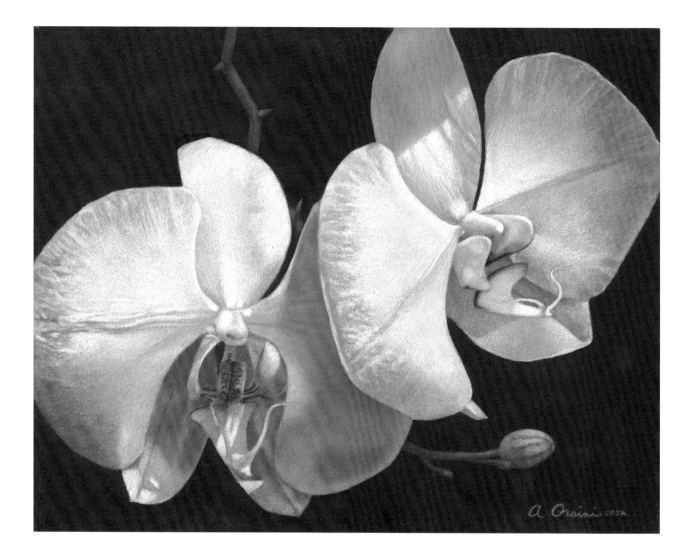

ANITA ORSINI
Autumn Orchids

11 x 14"

Pastelboard

I grew up in a rural area that I found achingly beautiful, and I had much freedom to roam and explore. This instilled in me a love of nature and a great appreciation for the intrinsic design structure of our world. Taking hold of the images that move me has always been the impetus of my work. In essence, I frame the moments many hurriedly pass by—the beauty in the every day.

Being process oriented rather than product oriented, my motto in art and life has been "enjoy the process!" I am a perpetual student; studying masters of the past and present, trying new techniques and materials, and continually framing passing moments in time in order to share a more complete vision of my world.

LAURA OSPANIK
Glass Menagerie

22 x 30"

Stonehenge Paper

I have always had a fascination with light and its interplay with glass. The transparencies, reflections and distortions produced by glass provide an endless kaleidoscope of wondrous images. This interplay was the inspiration for a series of work I produced studying light and its effects on small marbles. To emphasize the light's effect and create a different viewing plane for the observer, the scale of this piece is quite large in contrast to the tiny subjects. Colored pencil was the perfect media to depict this subject matter because of its intensity of hues, the shiny wax-like surface and the ability to work in everything from transparent layers to thick, luscious applications of color.

Having been a graphic designer, the design of a piece has always had a special importance to me. In the case of this painting of marbles, this manifests itself in the positioning of the subject so as to create a tension. Their shapes are round with swirling images, but they themselves are stagnant. This makes the viewer's eyes flow through the piece using the light and color as their guide.

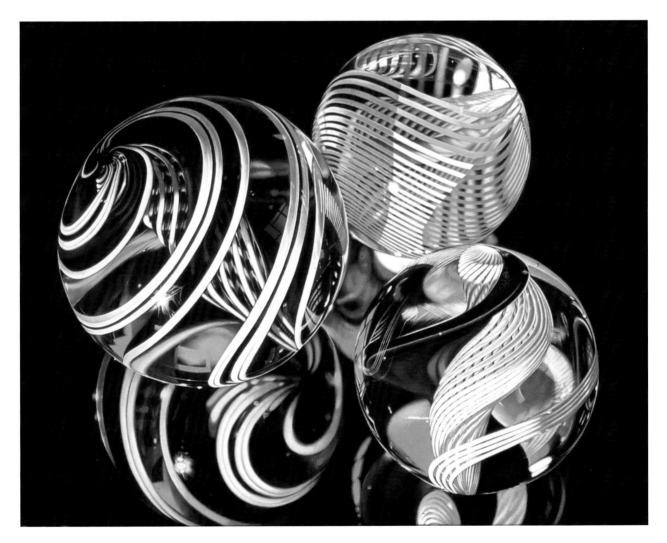

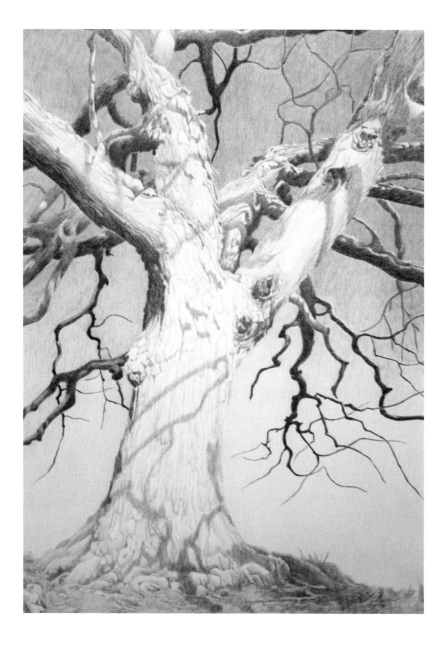

LINDA WILLIAMS PALMER
Chinkapin Oak

30 x 22"

Aquarelle Arches Paper

The Chinkapin Oak is one of a series of Champion trees that I'm currently working on. The Champion trees are the largest trees of each kind in our state that have been measured and documented. This series is not only art inspired by nature, but also by history as these trees have witnessed the events around them.

I was drawn to the rough bark on the trunk of this oak and the majestic way the tree lifted up into the sky. I choose true blue as the sky color to contrast with the black limbs that reach out from the tree. I've always been inspired by nature and especially trees. I love working with negative spaces in my compositions and the branches of trees against the sky provide this in a natural way. Each tree is unique and my purpose is to not only represent the quality of the tree but to have the drawing stand alone as a work of art.

RITA PARADIS-CALDWELL
The Willing Suspension of Disbelief

20.25 x 20"

Stonehenge Paper

This image actually happened by accident. My initial interest was in the lemon's reflections in natural light. When I brought my still life outside and the heavens and bits of surrounding landscape mirrored themselves in my setup, it entranced me. I spent days outside in the frigid New England winter taking reference photos. Ultimately my interest was in presenting the viewer with enigma–to pose a question and to provoke thought. I wanted to capture the viewer's imagination and share my delight of the lemon drama and the dazzle and sparkle of the cold morning light.

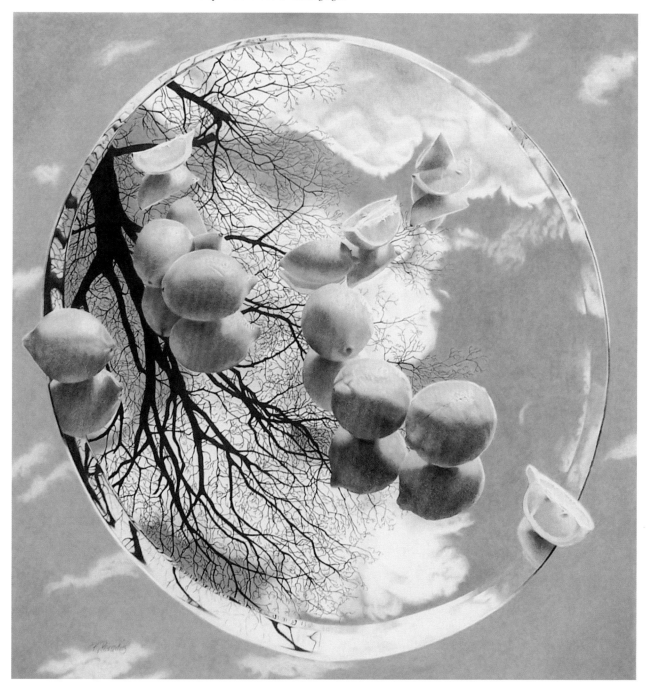

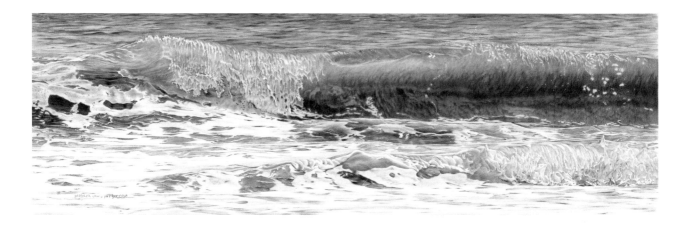

GRETCHEN EVANS PARKER
Wave I

9 x 28"

Stonehenge Paper

This piece was inspired by Ran Ortner's breathtaking 20 foot long oil painting *Open Water #24*. As a self-taught artist, I am always looking for new challenges to my skills. *Wave I* was an experiment to see if I could paint rolling water. We live near Myrtle Beach, South Carolina. One sunny afternoon, I sat on the beach with my camera set on continuous shoot. Every time a breaker started to roll in, I held the shutter down. In the end, I had over 500 photos. Those were whittled down to about 20 paint-worthy images. To achieve a wet look, most of the work is burnished either with a colorless wax blender or a colored pencil of a lighter color. To simulate the movement of the water, a directional line technique was used throughout to represent the movement I saw in the water. I loved the outcome so much I plan to do more.

PAULA PARKS
The Sentinels

15 x 10"

Stonehenge Paper

The Sentinels has always had a special place in my heart for two reasons. It was the first one of my pieces to be accepted into the CPSA Annual International Exhibition. And it reminds me of a very special time when I was fortunate enough to spend a month in Paris on a special trip called a "Cultural Tour of Paris."

We lived in the dorms at the University of Paris and spent every morning sketching in a different location around the city. The afternoons and evenings were full of trips to the special museums, cathedrals and various cultural events throughout the city. I took the reference pictures for this piece from one of the towers of Notre Dame Cathedral. I liked the unusual viewpoint rather than the more familiar straight-on front view; and until I had climbed so high in the tower, I hadn't realized that each of the gargoyles was different from the others. I also like the patterns of light and shadow on the old stonework.

I did take artistic license, of course, and moved Montmartre and the church of Sacre-Coeur, from what would have been its real position behind me, to the far distance in front of my position in the tower.

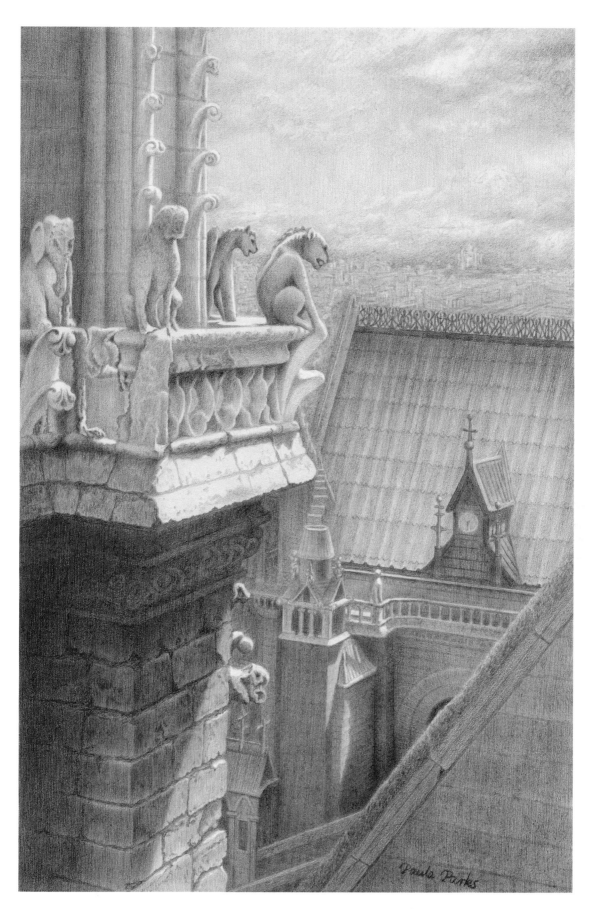

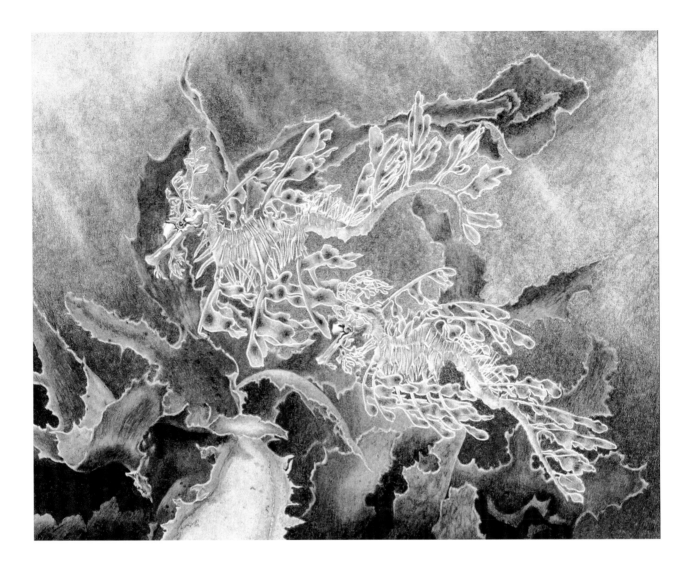

HELEN PASSEY
Pas de Deux (Leafy Sea Dragons)

16 x 20"

Arches 140-lb. Hot Press Paper

This painting was born out of my fascination with marine biology. I find these creatures intriguing, with their flowing weed-like fins and beautiful coloration. I wanted to highlight the complementary colors of the blue water and orange sea dragons. To get the rich blue-green color for the water, I layered several shades of blue and green in traditional layering, then applied solvent to blend them and bring out the turquoise color.

MONIQUE PASSICOT
The Beholder

13 x 10"

Duralene

Beholder—a person who becomes aware (of things or events) through the senses.(Thesaurus)

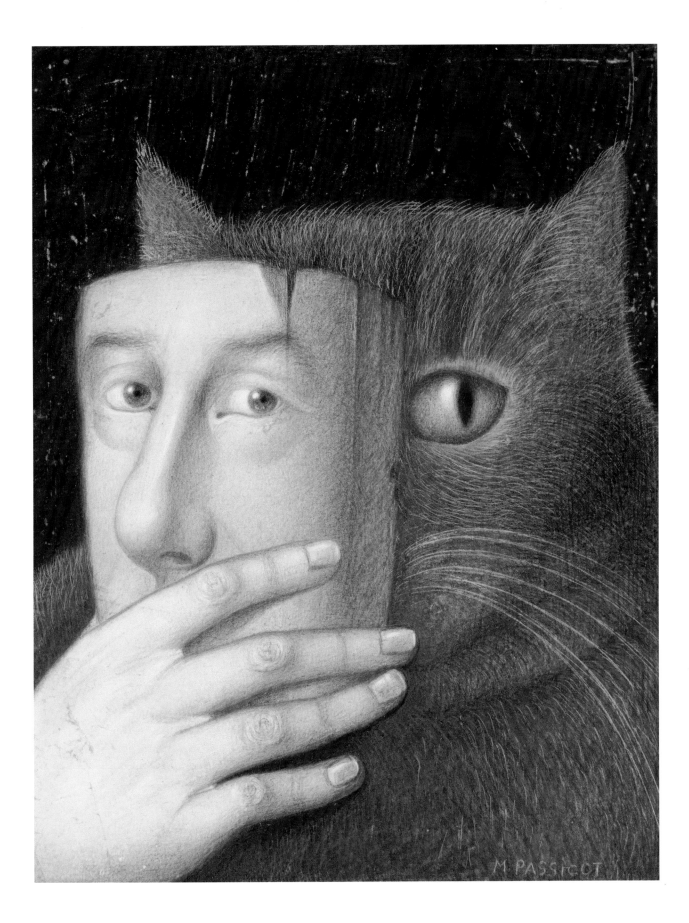

ELIZABETH PATTERSON
Highway 236, 10 AM

12 x 24" Courtesy of Louis Stern Fine Arts

Strathmore 500 Illustration Board

This is one of an ongoing series of works, all executed from the vantage point of the front seat of a car. The inspiration for the series came about during a drive home in the rain. I suddenly became fixated on the patterns of water pelting the windshield and the ever-changing distortions of the background. This subject matter has kept my interest for four years and generated over sixty drawings that depict the diverse imagery that results when water and motion transform an otherwise ordinary view.

While I strive to make technically sound drawings, technique alone does not make for a compelling work of art. The greater challenge is creating an experience in which the viewer is captivated and drawn into the composition. In this series, I am constantly striving to transform layers of pencil and solvent into the sights, sounds and motion of a rainstorm. I want my work to be appreciated for its skill, but more importantly for its ability to evoke sensation, emotion or memory; only then am I satisfied that I have effectively brought the work to life.

KELLY PATTERSON
First Day of Summer

28.5 x 18"

Arches 300-lb. Watercolor Paper

My subject matter of choice is portraits. I want to capture a look, a feel, an age, a moment in the life of the person I am drawing. Because each piece takes 200-400 hours to complete, and no one would want to pose that long, a good photograph is imperative to colored pencil portraiture, especially one featuring clear facial details. I like extremes in value, and a strong one-directional light source ensures good contrast of light and shadow. A dark background adds further drama when juxtaposed against lighter skin tones.

Once my image is lightly drawn, I start with the dark background. Using water-soluble pencils, I paint in the darkest values, which greatly reduces the time it would take if using regular colored pencils. Once dry, I can apply lights right onto the darks with light opaque colored pencils, leaving the desired areas of dark showing through. Transparent colors won't work, but opaque colors will sit right on top of the dark underpainting. I am very careful to keep darks out of the face, skin or any other light areas so they stay pure and clean. I build up layers of the skin from light to dark and will sometimes use up to 30 layers in the shadow side of the face, leaving the lightest lights as the white of the paper. I save the darkest darks for last—as finishing touches—and burnish over light areas of the skin to achieve a smooth, glowing effect. I use thick, opaque white (Stabilo White works well) to add sparkling details in the eyes, etc.

DON PEARSON
Clark's Nutcracker

22 x 16"

Crescent Acid-Free Mat Board

First of all, I don't think of myself as an artist, but I'm a hellava technician. However, if I said that, I'd have people bringing their TVs for me to repair, so I've accepted the "artist" tag. Secondly, I do my paintings for me; but if I find somebody willing to give me money for one, I certainly don't stand in their way.

I've been working with colored pencils for over 20 years (I'm a slow learner); and during that time, I've met a bunch of wonderful people, paid some bills and worked off a lot of stress while sitting at my drawing board and shutting out the rest of the world. I work from my own photographs—usually mountain landscapes. While I'm working on a piece, I put myself back in that moment and enjoy the experience all over again.

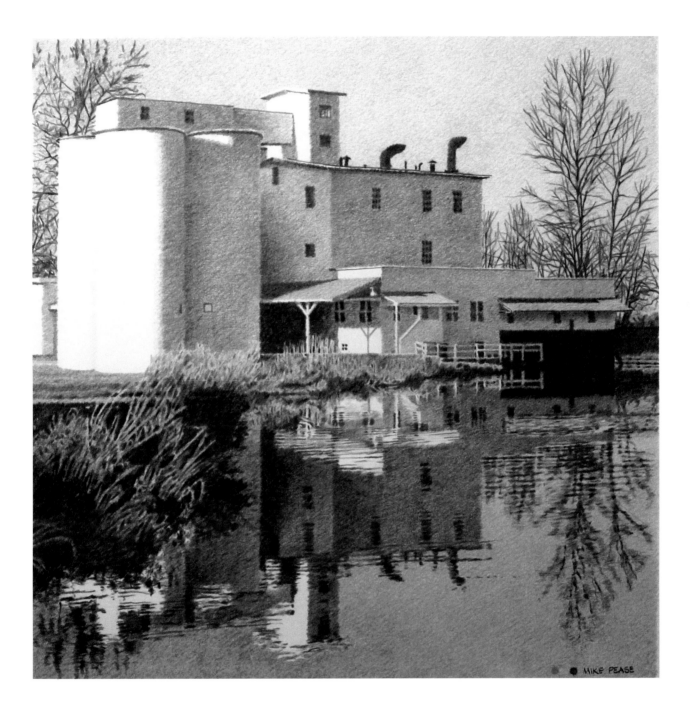

MIKE PEASE
Mill–Harrisburg, OR

28 x 28"

Museum Board

I work in both watercolor and colored pencil. My usual subjects are landscapes, both rural and wild. I look for places in my real surroundings that feel like special places to be. In my drawings, I try to capture the essential qualities of those special places–for myself and for the viewers. As an architect and an artist, I have always been interested primarily in places that help people feel comfortable, at home; places that respond to and support our needs as humans. This painting is typical of my work in colored pencil in that final, full color images are built up from strong strokes in layers of only the primary colors (blue, magenta, and yellow).

SANDY PHIFER
Bob's Fish Net

9 x 16"

Mylar Drafting Film

It is the beauty, color and drama found in nature that inspires me to create my artwork! I have a degree in Biology and a passionate interest in plants, wildlife, ecosystems and landscapes. My paintings are unique creations because they reflect both the detailed biologist and the free-spirited artist. Each painting is my memorial to a dramatic moment in nature that caught my eye.

I was intrigued by the bold colors in this Cutthroat Trout, but *Bob's Fish Net* was also interesting to create because it is done on Mylar. The translucent nature of this surface allows the colored pencil to be applied to both the front and back of the painting, creating incredibly bright, crisp colors.

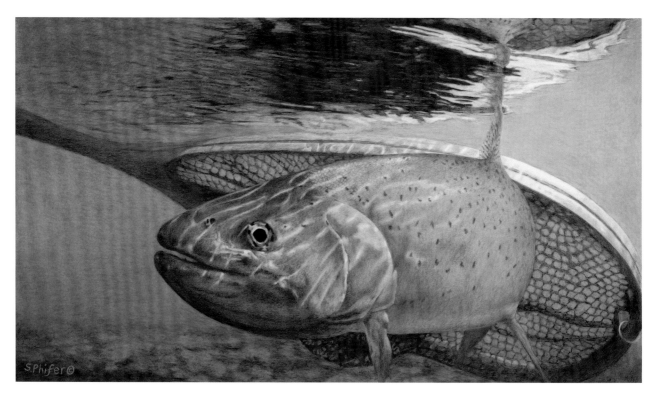

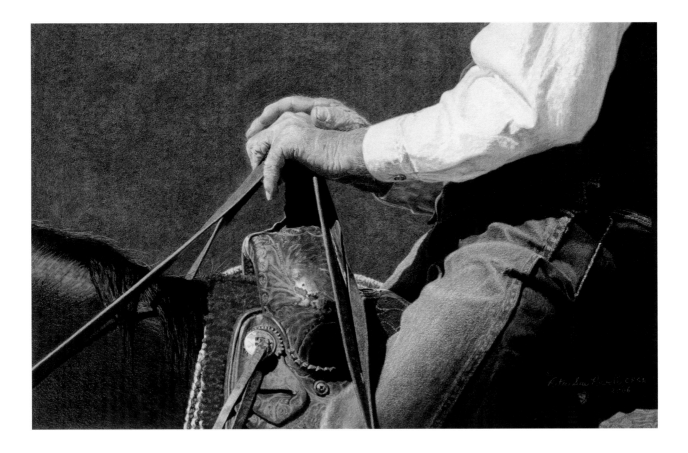

RITA SUE POWELL
Worn But Not Worn Out

10 x 16"

Strathmore 500 4-Ply Paper

Sketchbooks and pencils have been my faithful companions since childhood. Through rearing children and every animal imaginable, they have been a constant creative outlet. Hours spent in the barn, waiting for cows to calve and ewes to lamb, provided valuable time to hone my observational and drawing skills. Watching steam rise from a new born animal on a cold winter night is a very humbling and inspirational experience. I feel truly blessed to enjoy the western lifestyle along the Arizona-Mexico border. Realism, texture and special moments are my passions. I draw what I know.

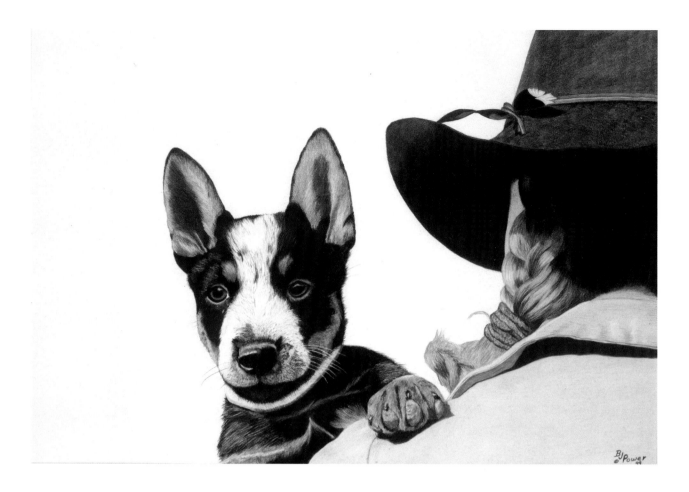

B.J. POWER
Buster

11 x 16"

Strathmore Artagain Paper

I live on a working cattle ranch in southeast Arizona and most of my art reflects my every day observances. My favorite time of year is when the summer rains start. Everything is turning green, and the water holes are full. The drawing, *Buster,* depicts a cow-dog pup whose expression shows the desire to get on the ground and start working. I have always loved to draw and paint. When I discovered colored pencil, I found a medium that enabled me to express my feelings in art.

LISA PRUSINSKI
Cygnet on Highway One

21 x 17"

Mat Board–Gray

Automotive chrome shapes have been a penchant of mine for the past 17 years. The cool, sleek feel of shapes depicted in chrome surfaces is alluring to me in such a different way than the shapes in nature. I combine my love for chrome and seascapes in this piece. The techniques used in this piece range from an initial or single layer through a fully opaque application of colored pencil.

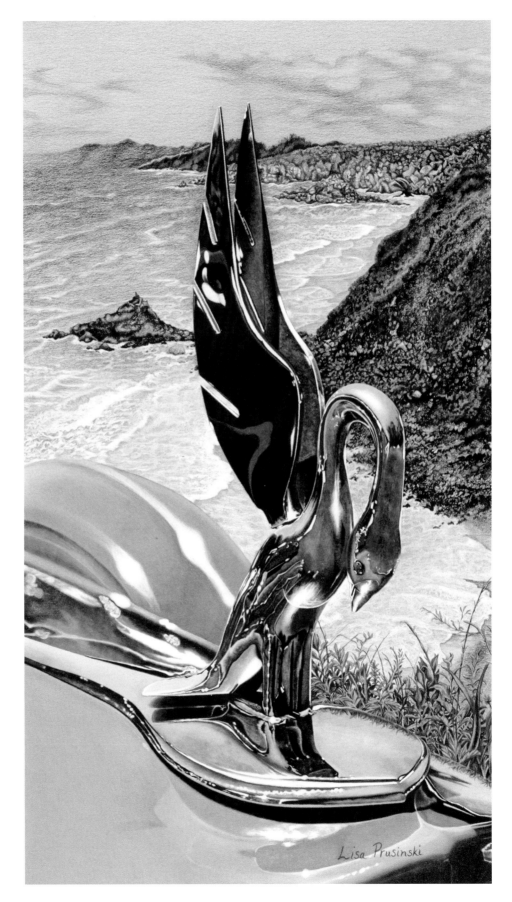

Lisa Prusinski

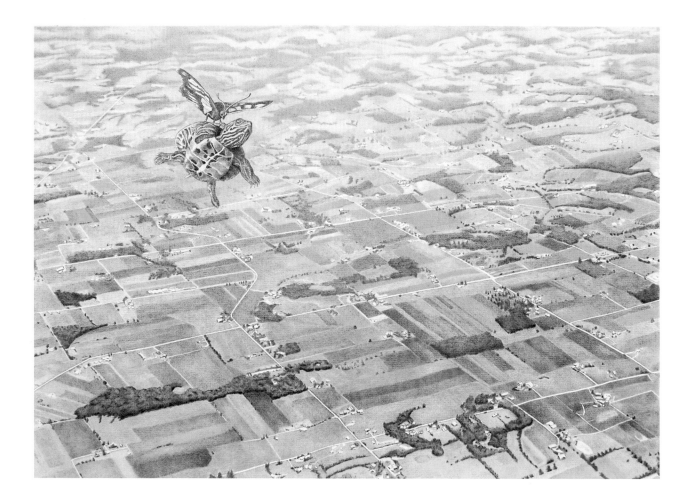

LAURENE PULS
If I Had Wings

16 x 23"

Bainbridge Pebble Mat Board–Blue

The preposterous idea that a turtle can fly represents my innocent childhood belief that if I tried hard enough, I could fly. I worked with this idea in several settings over the next couple of years but could not capture the feeling of whimsy and child-like glee that comes with having such superpowers.

Then my daughter showed me photographs that she had taken from 2,000 feet as her plane landed in Akron. Immediately, I knew that I had the setting for my flying turtle!

As the picture developed, I grudgingly admitted that neither a turtle nor I could fly without wings or strings. The one option that I would never consider is getting on an airplane! My original inspiration for *If I Had Wings* was a calendar photograph of pond turtles sunning themselves with butterflies perched on their heads. With their limbs out-stretched and winged heads, the turtles appeared to be about to take flight. And so a butterfly was added to act as a "wingman" to carry the round, rigid creature merrily through the skies.

RICHARD QUIGLEY
Self Portrait

18 x 12"

Stonehenge Paper

This over-exaggerated, smiling self-portrait projects time and place in relationship to my various experiences in life. What happens in the imagery is controlled by my sense of color, design and juxtaposition between the past, present and future. From critters to classic Cadillacs to pyramids and parking meters—my art is about the timeless nature of the universe.

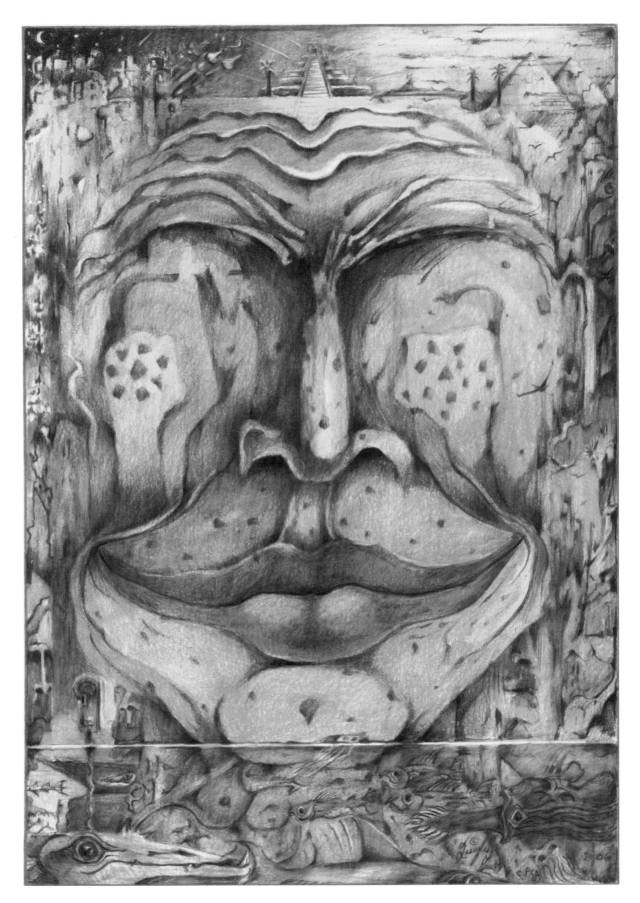

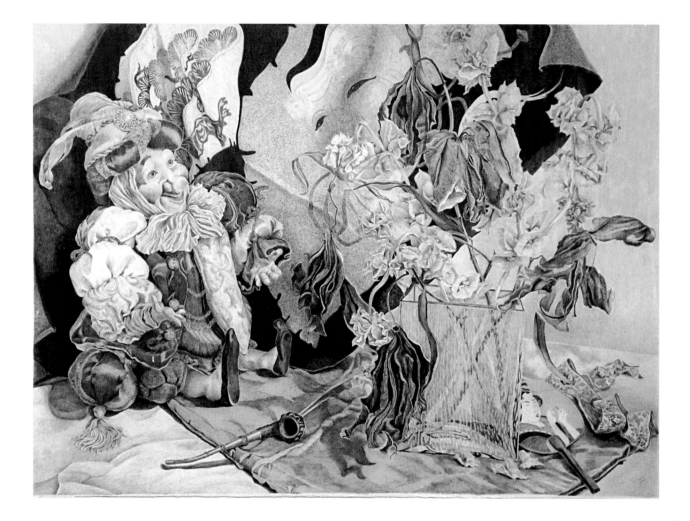

JOAN E. ROBERTSON
Ghosts

22 x 30"

Lanaquarelle Paper

I spotted this little character in an antique shop and knew I had to build a drawing around him. He is jolly and menacing at the same time, and I loved the mixed brocades. A gift bouquet of purple lilies and Bells of Ireland died before I could draw them, so I felt they fit in with the antique "Punch-type" character. The faces on the Japanese furoshiki (cloth) and fan pulled the drawing together, with the old ribbon, Japanese figure on a fan and Thai pipe adding the final ghostliness. This is a still life of flowers with their echoes of stories–yours or mine–behind all the elements

BARBARA ROGERS
Windswept

14.5 x 19"

Rising Museum Board

This painting is one of a continuing series of Monterey, California, seascapes. I am drawn to this area because of its ever-changing drama and beauty. *Windswept* depicts a late afternoon in December.

I think all art is an expression of the personality of the artist–their personal vision of what is important in life –or a running commentary on how they perceive the world around them. When I look at my body of work, several adjectives come to mind: serene, poetic, beautiful, meditative, spiritual. I believe, within the human spirit, there is an eternal longing to contemplate that which is beautiful. Turning away from the turmoil, stress, and strife of daily life and going to an art museum or on a hike is spiritually rejuvenating and emotionally satisfying.

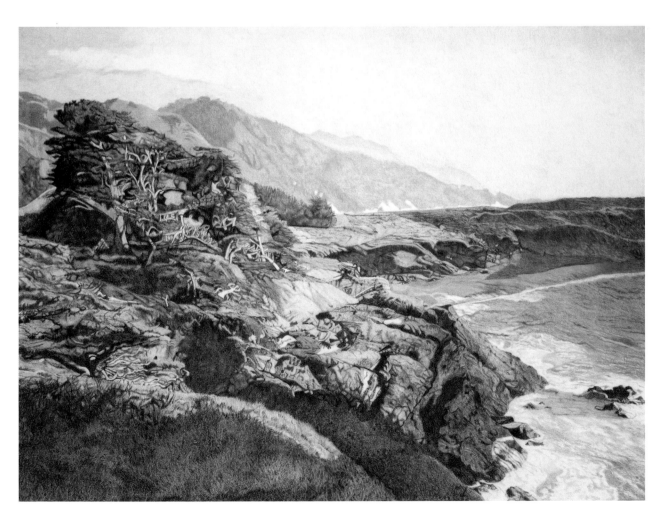

SHEILA SCANNELLI
The White Tag

14.5 x 20"

Mat Board

While taking reference photos of unusual objects, perfect strangers will ask me, "Why would you want a picture of that?" When I tell them that I use them in my art work, I more often than not get strange looks that tell me they think I'm a little off kilter. The more out of the ordinary the object is, the more I'm intrigued by its artistic possibilities. I am constantly looking for objects that are not your average vase of flowers or bowl of fruit. Various types of memorabilia often invite me to view them up close and scrutinize every square inch of their surface for interesting textures, patterns, or lines. It is these different aspects that I find interesting.

The White Tag is the result of one of my photographic excursions as I wandered through a flea market investigating table after table of assorted junk and treasures. The row of wood planes was just the kind of thing that pulls my attention. Within the arrangement, I found smooth shiny metal, rough wood grains, and an intricate play of shadows falling over each consecutive plane. All topped off with the small white tag tied to one of them.

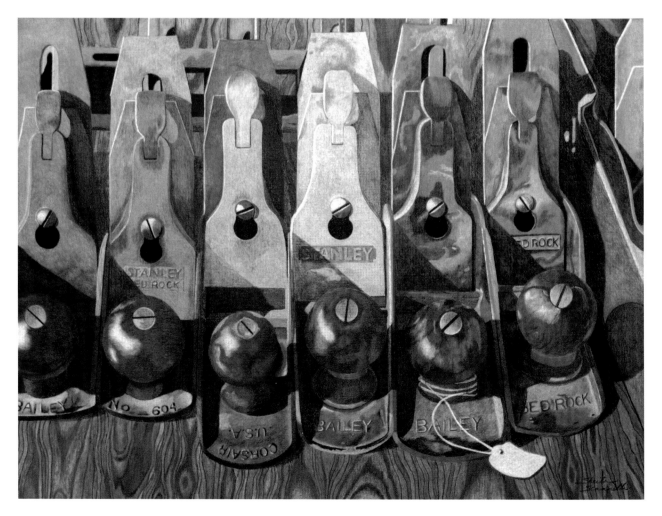

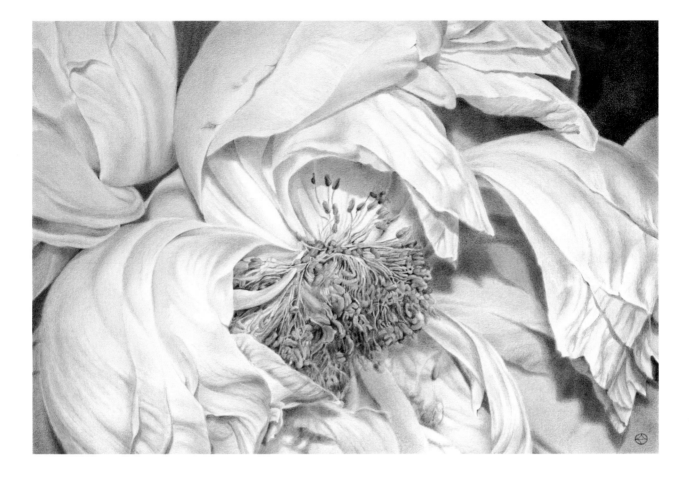

KAY SCHMIDT
Voluptuous

16 x 20"

Strathmore 400 Bristol Paper

Abeautiful white peony, slightly wilted and past its prime, was the subject of this painting. I wanted the plump and smoothly rounded petals, the subtle variations in the white hues, and the simple shapes to give a feeling of rich opulence. At the same time, being so close to the blossom contributes an abstract quality that adds to the mystery of the subject. It is the delicate translucency of colored pencils, as well as the control they provide, that allowed me to render the detail and up-close realism of this piece.

LYNDA SCHUMACHER
The Hand of Man

20 x 25"

Sanded Pastel Paper

The United States Bureau of Land Management (BLM) periodically orchestrates organized wild horse round-ups in an effort to manage the numbers of wild horses in several Western states. These round-ups are sometimes performed in ways that cause injury, and even death, to wild horses and often result in them being separated from their family groups. This practice has become a major source of controversy between wild horse proponents, cattle ranchers and large landowners. It is estimated that there are more than 30,000 wild horses being cared for by the BLM in pens and holding areas.

This piece is not intended to be a political statement for or against either side of this controversy. *The Hand of Man* was inspired by two such wild horses that had been captured during a recent BLM round-up in Wyoming. The apparent struggle they have experienced is evidenced by the small areas of blood, grass stains and small wounds on the pale horse. Even more though, is the tremendous depth of feeling these horses seemed to exhibit. Through rendering them, I sought to portray the depth of sadness and fatigue of the pale horse—juxtaposed against the alert, almost challenging gaze of the dark horse. In addition, I sought to capture the sense of relationship and nurturing between the two horses.

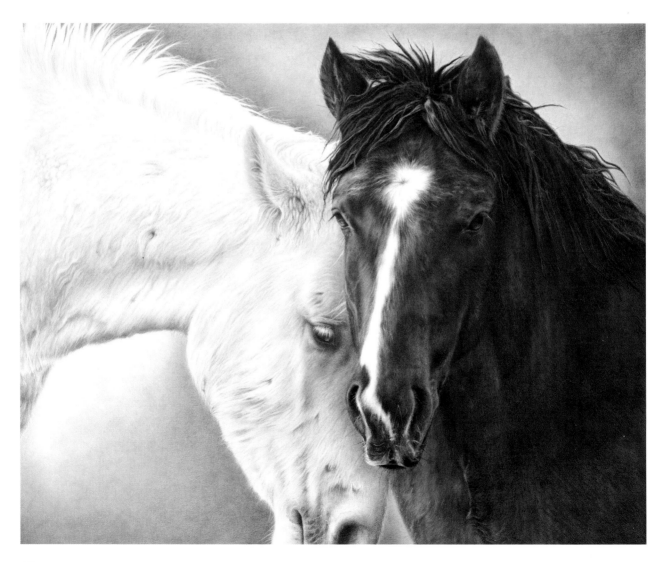

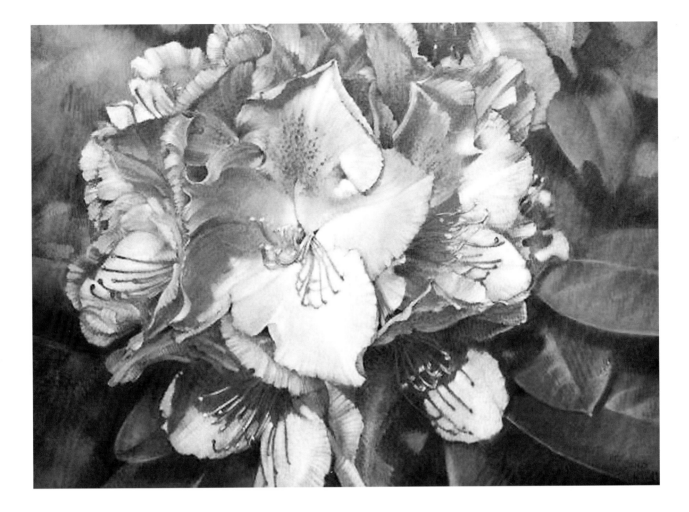

TERRY SCIKO
Spring's Hope Eternal

10 x 13.5"

Crescent Mat Board

I find the subjects for my floral portraits in my neighborhood: my garden, our regional parks and my friend's backyard. Colored pencil is my medium of choice because it allows me to express the subtle nuances of each flower, such as texture, light and shadow. Drawing with pencils brings me "up close and personal" with my subjects. When asked who inspires me, I say the old masters are certainly awe-inspiring, but I truly admire the present-day colored pencil masters.

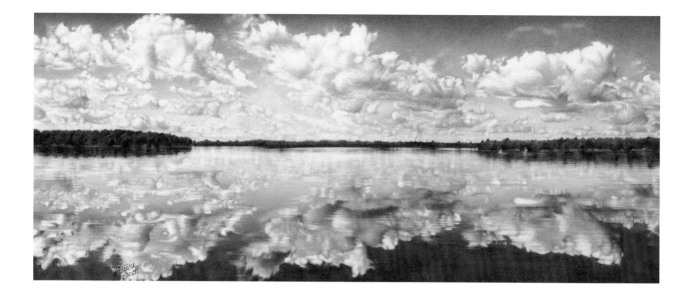

PATRICIA SCOTT
Reflections Of Lake Winnibigoshish

8 x 18"

Arches 140-lb. Hot Press Paper

Not all paintings possess a personally emotional attachment, but *Reflections of Lake Winnibigoshish* holds a wealth of memories for me. Because this lake is so large, mirror reflections on a still surface are the exception and not the rule. But in addition to the beauty of the image itself, I chose this subject and title because I will always remember my mother when thinking of Lake Winnie. Mom was an avid fisherman, and we spent many wonderful times on this northern Minnesota lake.

My vision for any piece is that the original image impacts me strongly with its beauty, its uniqueness, design, colors and light–if there's an emotional tie, that's just a strong plus. However, a piece does not have to represent a strong emotion or memory for me to enjoy working on it. Once I have chosen a subject and begun the work, the process of capturing the original drama of that image is what engrosses me and drives me to its finish. This has always been the challenge for me and why I prefer realistic representation (though any two-dimensional work is inevitably a series of abstractions.)

Over the years I would describe my own use of colored pencils as "beating them into submission," which can cause problems as I tend to overwork an area. Being self taught, I'm afraid I have not yet mastered the lessons on the subtleties of this medium, although hope springs eternal!

ALAN SERVOSS
The Storm

30 x 40"

Illustration Board

The Storm is typical for me and reflects a common thread throughout my work in colored pencil as well as in my paintings. Not being from the Midwest, but having lived here for many years, I found the land to have a quiet, almost dream-like or mystical quality. I have sought to distill, to its simplest terms possible, how I feel about this landscape where I live every day. Originally, my work was done on location or from field sketches and photos back in the studio. However, fairly early on, I opted for an approach which allowed me to deal more directly with my feelings. Working from my imagination, I use the landscape more as a reference and create places that aren't based on any actual scene but might exist somewhere. This piece is one of many "storm" works I have done; and being a rather large piece, I had plenty of time to allow it to "grow." A sense of the quietness and anticipation before a storm over a starkly simple scene was what I focused on.

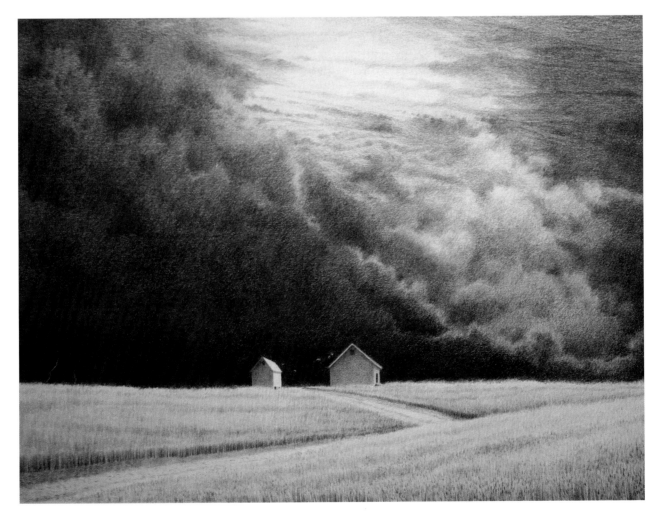

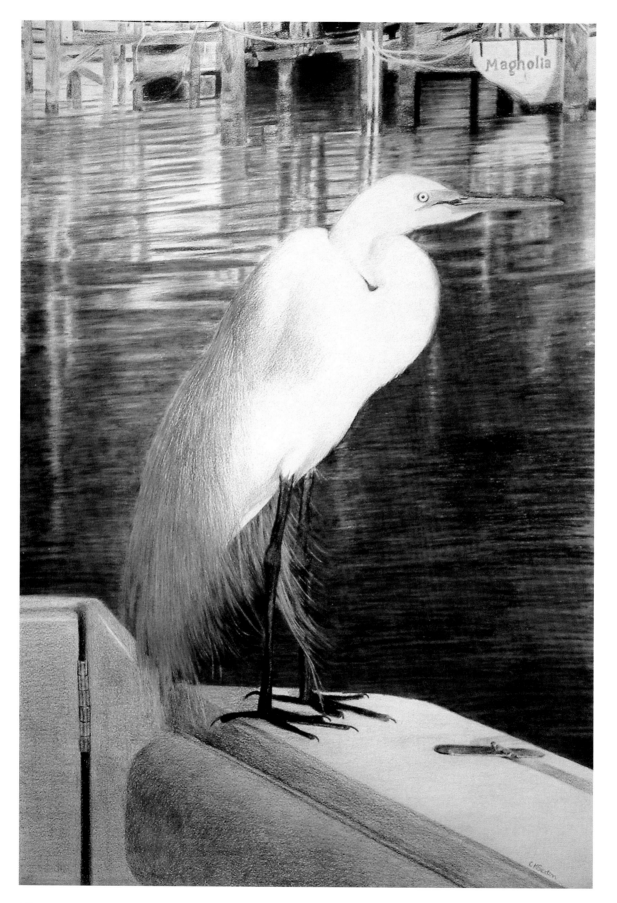

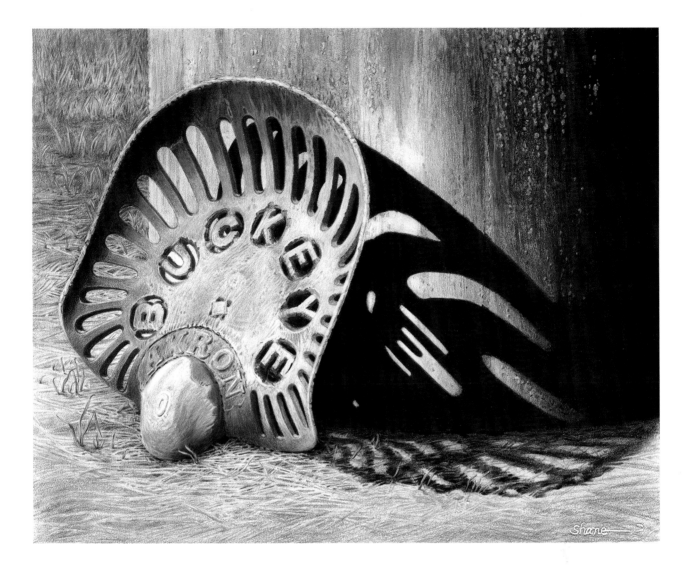

CARLA K. SEXTON
Afternoon Companion

21 x 15"

Bristol Paper

The egret was our afternoon companion during a relaxing weeklong boat trip down the Florida Intercoastal waterway from St. Petersburg down to Fort Myers. He arrived in the afternoon and patiently waited for supper and watched the sunset from the boat.

SHANE
Retired Farm Seat

15.25 x 20"

Fabriano Cold Press Watercolor Paper

Much of the inspiration and subject matter for my art comes from things around me. I am fortunate to now live on the family homestead where I was raised. This piece of land has been in our family since the 1930s.

One of the items I have displayed in my flower garden is an old seat from a piece of farm equipment once used by my grandfather. I was attracted to the dramatic shadow pattern it was casting as the way it leaned against an old round well casing. The challenge was to create the shadow patterns so they glowed with the underlying colors of the well casing still very dark. The variety of colors and the values in the seat itself also intrigues me.

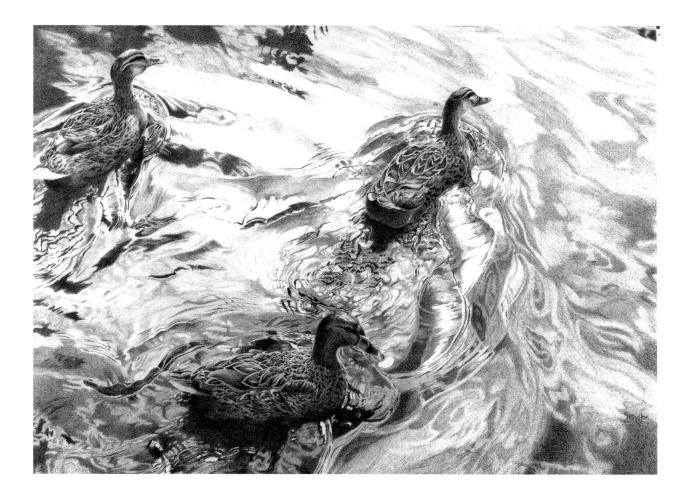

GAIL H. SHELTON
Girl's Day Out

22 x 30"

Arches Hot Press Paper

I taught "Gifted and Talented Art Students" in the local school system for twenty years. I always included a unit on colored pencil. As part of that unit, I had them take photographs in the area for reference material. Over the years, we took hundreds of photographs.

This drawing was done from one of those photographs. I took it one day as we were finishing up around the little pond area. We startled these female mallards as we walked near the edge of the water, and they swam away from us. The light, composition, and pattern in the water intrigued me. But it was so complex, I didn't know if I could capture it. I finally started in the very middle of the image, and worked my way to the edges. I worked on it off and on for nearly a year.

JUDITH SHEPELAK
Darfur

24 x 18"

Stonehenge Paper

The drawing, *Darfur*, was my attempt to visually remind people or, in some cases, make people aware of the disaster in the Sudan area of Africa. This drawing interprets a horror story being told in a calm and unassuming manner.

After having read the book, *An Ordinary Man*, by Paul Rusesabagina about the genocide in Rwanda, and being appalled by the news of the genocide in Darfur, I was inspired to translate my emotions into art.

The genocide in Darfur is a grave issue that has received varying degrees of attention. To be sure, it is an issue of power and money, but it is also an issue of humanity. The question remains as to whether genocide in any country demands a response from the leading world nations. I wanted the viewers to ask questions and to be aware that genocide continues ... it didn't end with Hitler.

Before I began the drawing, I researched the geography of Sudan, the types of animals that inhabited that area of Africa, and plants that were specific to the area. I also researched clothing to develop patterning ideas for the folds used to indicate the land.

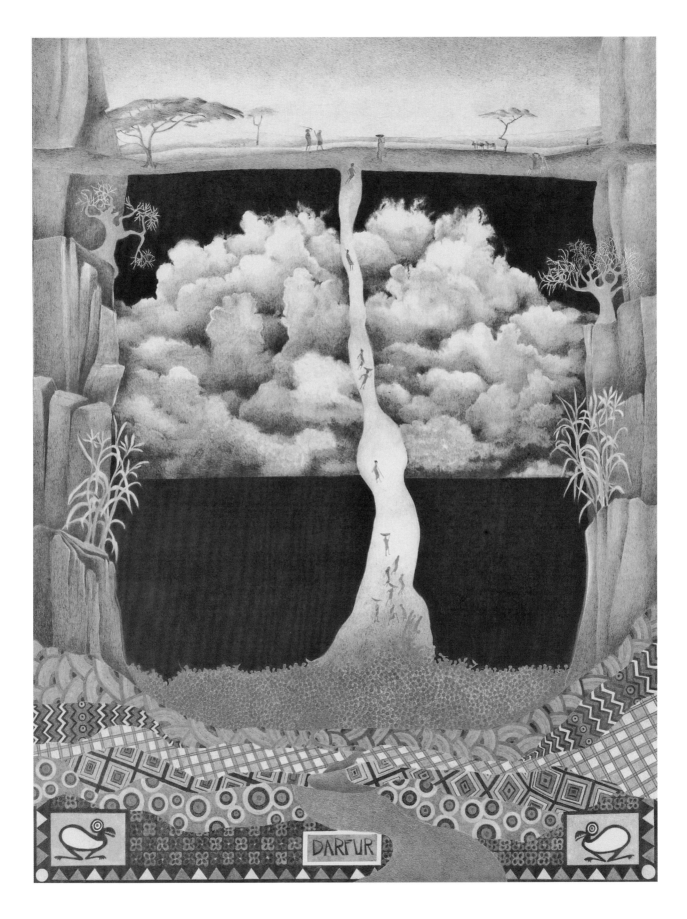

DARFUR

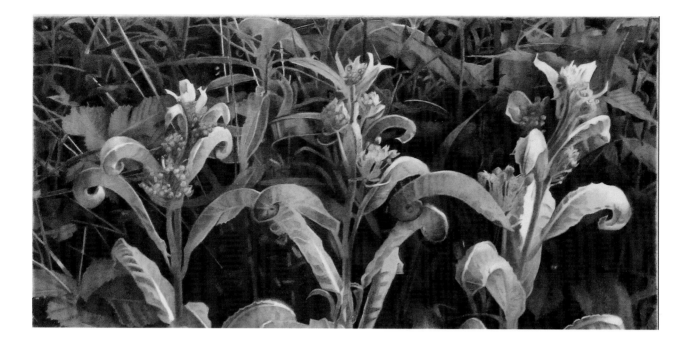

LEE SIMS
Three Graces

8 x 17"

Lanaquarelle 300-lb. Paper

My work is inspired from the landscape around my home in upstate New York. The complexity of shapes in the leaves is of special interest to me and relates to my earlier art education in abstract painting. I had drawn plant forms for quite a few years but always in the printmaking media (black and white).

Three Graces is named for Sandro Botticelli's painting of the same name. Instead of three graceful intertwined maidens, a group of three poisonous milkweeds perform their own version of a dance, their sisterly leaves gently brushing each other. The continuous line came naturally with the subject matter. It was not until the work was finished that I saw the parallel with the 15th century Florentine style.

Working from my digital photographs, the image is usually altered and sometimes spliced with another photograph. My goal is not strict duplication but interpretation.

RITA MACH SKOCZEN
Enter the Night II

17 x 27.75"

Ingres Fabriano Paper

Women are the predominate subject in my art pieces. They are portrayed in different poses and a variety of clothes. My favorite pose is the reclining, sometimes sleeping, figure. My intent is to capture the serenity that envelopes the figure, the graceful flows of the body, and the beautiful drape of the fabric.

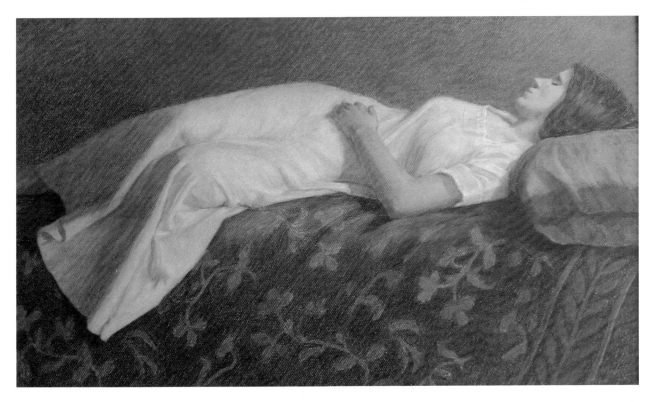

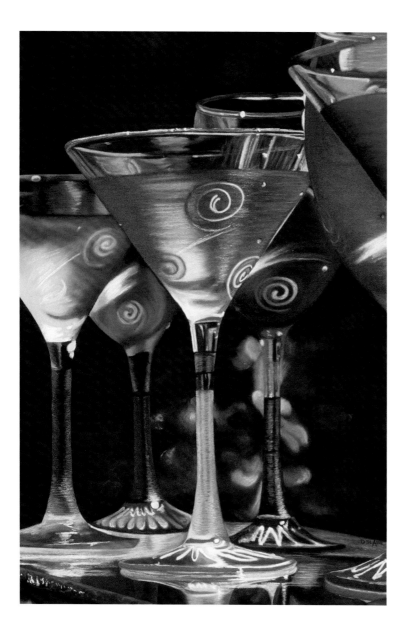

DONNA S. SLADE
Cosmopolitan II

16 x 10"

Windberg Multimedia Paper–Gray

My paintings are not photographic moments in time but represent a unique artistic interpretation through observation. I want to engage the viewers and encourage their curiosity and appreciation for the creative process. Emotion, communication and nourishment are all reasons why I am passionate about the art-making process. My goal is to enlighten people through art.

My paintings are imagined, then planned and executed in a representational, realistic style. I love the challenge of creating detail in the light and dark values with each individual stroke and cross-hatching mark. I can apply eight to ten different colors to build bold but yet sensitive color values. I work from dark to light blending my colors to create a soft, feathered look–letting the characteristics of the paper come through to achieve the textured effect that has become the hallmark of my work.

A sense of energy in my work is important to me, so I pay great attention to the composition of the painting. It is in the dynamic relationship among the various components around a center of interest that creates vitality. I strive to build action into the line that directs the eye through the work.

My passion for art and design has taken me from a 30-year, award-winning career in commercial art, advertising, design and illustration to recently becoming a full-time painter.

DAVID J. SMITH
Duets

19.5 x 13.25"

Strathmore 500 Series Paper

On those occasions when I am casting about for subject matter to draw, I like to return to an exercise I often assigned to students in my high school art classes. It is a collage technique designed to kick-start the imagination. First, I decide on a theme; it can be general or specific. In *Duets*, the theme is my fascination with Blues music. After I have decided on my theme, I search for disparate but relevant images that I can cut out, enlarge or reduce, and fit together like pieces of a puzzle. Once I have manipulated the parts to my satisfaction, a harmonic expression of my theme, I glue them down on a piece of paper and use that as the subject model for my drawing. Rather than being a narrative, I like to think of the result as a bombardment of ideas.

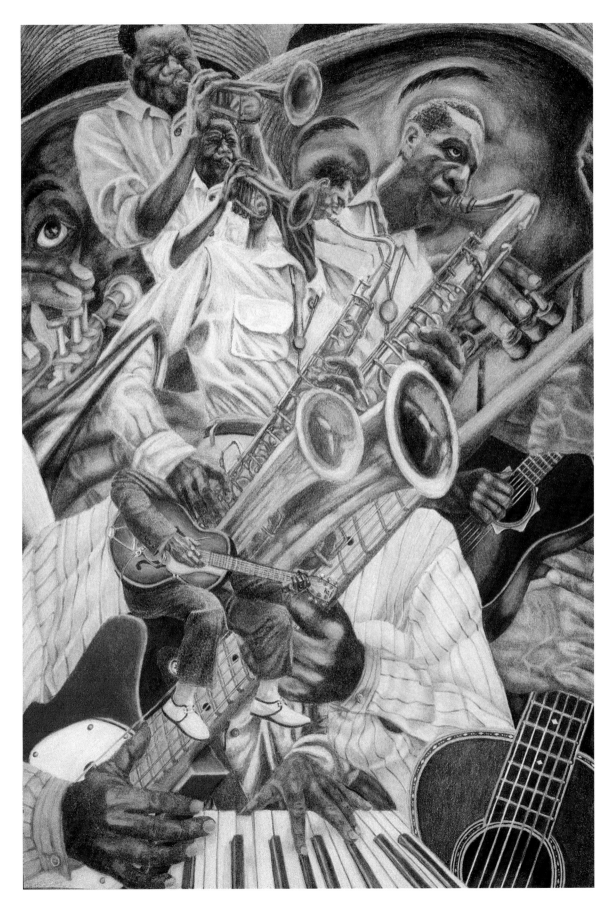

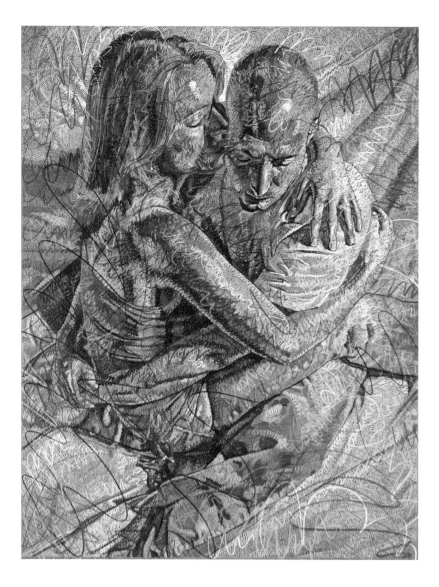

JOHN P. SMOLKO
Passion

40 x 32"

Museum Mat Board

After a thirty-five year career in art education, I am blessed to now be a full-time artist actively creating art. I always preached to my students that art was fundamentally personal expression and that is what I strive to accomplish in my work. My art encompasses people and students I know and reflects my relationship with them as an "artist in his own time." My technique of working is also part of my personal expression that grew from my passion to teach students to draw. Scribbling is as unique as your signature and takes years to master. I offer workshops on scribbling, and I have yet to find two people who scribble alike. Expressive line appears so spontaneous and fresh; and yet, it takes a lifetime to fully appreciate its dynamics. Add to that a passion for color, sometimes realistic and sometimes abstract, and there you have a complete picture of my present technique.

I do use photographs as references for my art; and many times, I like to make them black and white. This gives me the opportunity to invent all my colors and makes for some unusual color combinations. I do strive for representational art so the color is visual at times and creative at other times. This brings me to my final point: Everywhere I go people want to know how I get my ideas. As stated above, personal expression is part of it, but not the whole story. I tell my colleagues that creativity is not a matter of chance, but a matter of choice. You have to actively strive to be different in all aspects of your art. The critical aspect of creating art is not how you are like other artists, but how you are different from other artists. Become conscious of this in all you do and you will find your way and make your mark.

EILEEN F. SORG
Track 1

12 x 7"

Arches 140-lb. Hot Press Watercolor Paper

Birds have been my focus for some months now, and I have enjoyed allowing my imagination to run wild while placing them in peculiar situations, as this little wren finds herself in now. I like the improbability of this piece; of man-made versus nature and, of course, the irony in relation to the first song. I find myself at a point with my art where I am confident in my technique and skill and can therefore focus exclusively on my creativity and vision. In many ways, I am now as free as a bird.

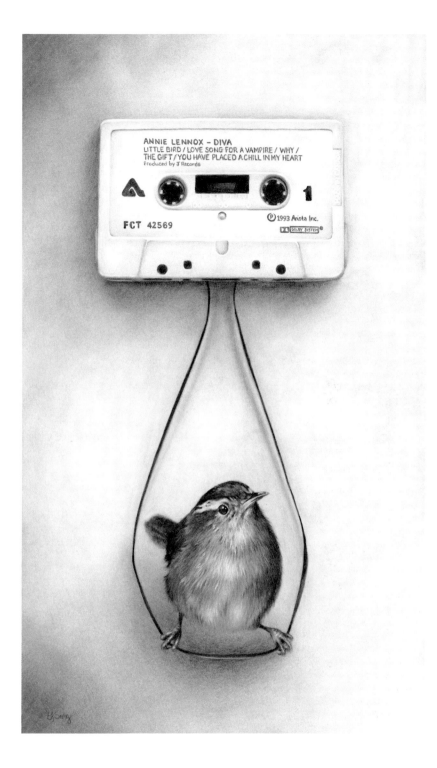

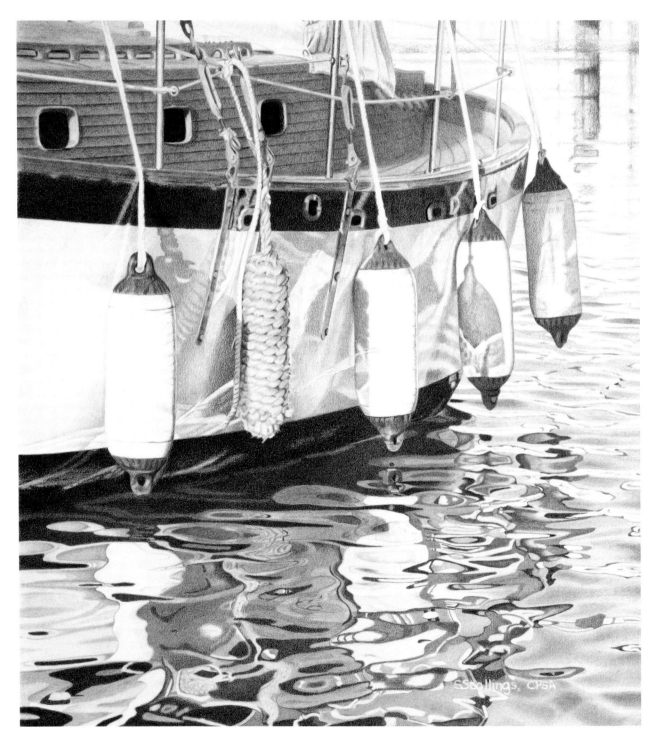

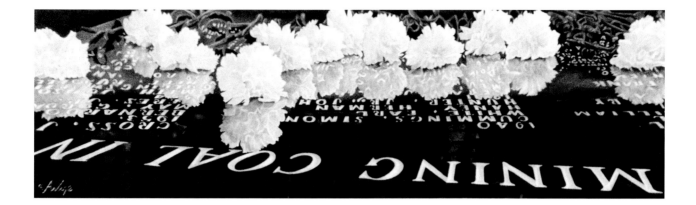

ARLENE STEINBERG
Coal Miner's Memorial

5 x 24"

Stonehenge Paper

I chose this piece not only because it is one of my favorite drawings, but also because it is my first drawing ever accepted into the CPSA Annual International Exhibition. This memorial was a tabletop slab at an old, retired mine that is now a museum. They had apparently just had a memorial service there and the flowers were still on top of the memorial. It was late afternoon and the sun was just right, so I took several photos of it from different angles. When I had the photos developed, this one spoke to me about my time there.

SHIRLEY STALLINGS
Hanging Around

18 x 17"

Rising Gallery 100 Paper

As an artist, I have always been drawn to texture, pattern and color, accentuated by light. Years ago when my husband and I purchased a boat, I became fascinated by reflections in the water. On calm sunny days we would slowly cruise the marina as I took dozens of photos of boats and their reflections. This was before digital cameras; and so I never knew until the film was developed, what was captured in pattern and color when the water action was stopped. It felt like a treasure hunt, and I was endlessly inspired by the boats themselves and by the colorful patterns captured by that instant in time on film. *Hanging Around* is one of my favorite paintings inspired by those photographs.

Although I work from photographs, I am not looking for the perfect photo. Photography is an art form in and of itself, one that can truly amaze me. There are rare times that I capture a photographic image that stands on its own merits. With all subject matter, it is the photos that have wonderful elements but can be developed into something new or better that inspire me to pull out my colored pencils.

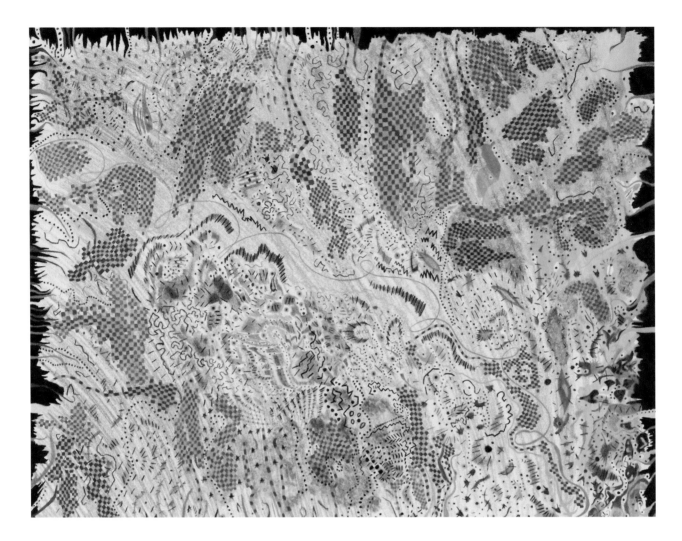

SABYNA STERRETT
Dark Celebration

17 x 21"

Stonehenge Paper

This work was started while contemplating a significant birthday celebration of a loved one who suffered from Parkinson's Disease. Not knowing when the event would materialize, I wanted to record life's milestones –if only in my imagination through my work. I put this piece aside for years. Then, when this person's death came on my birthday, I was compelled to finish it.

WINIFRED STORKAN STONE
Trail Horse

12.5 x 9"

Mylar

I have drawn all my life. As an adult I worked in watercolors for quite a while but didn't like the lack of control or the lack of brilliant colors that are inherent in that medium. I took a class in colored pencils taught by Mary Hobbs in Cleveland, and discovered I'd found the vehicle in which I wanted to work.

Colored pencils allow me to use the many photos I've taken as the basis for paintings. I like detail, different textures, and balancing composition and color in drawings. I want viewers to find a story in each of my drawings. I'll provide the starting point, and they can provide the rest.

I do like the control provided by colored pencils but am working to become looser and to communicate more of my own feelings in my work. That, I think, is what true artists work to achieve and are able to do.

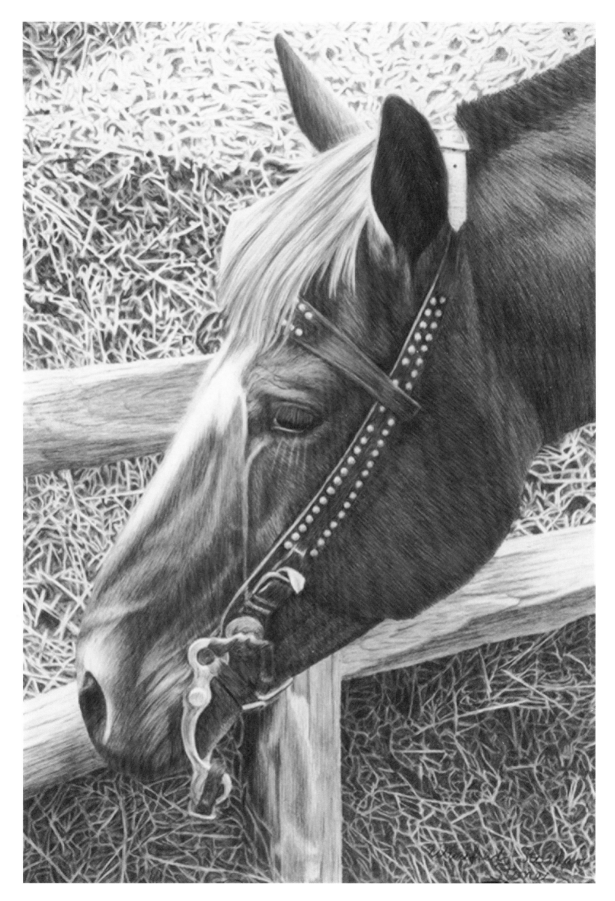

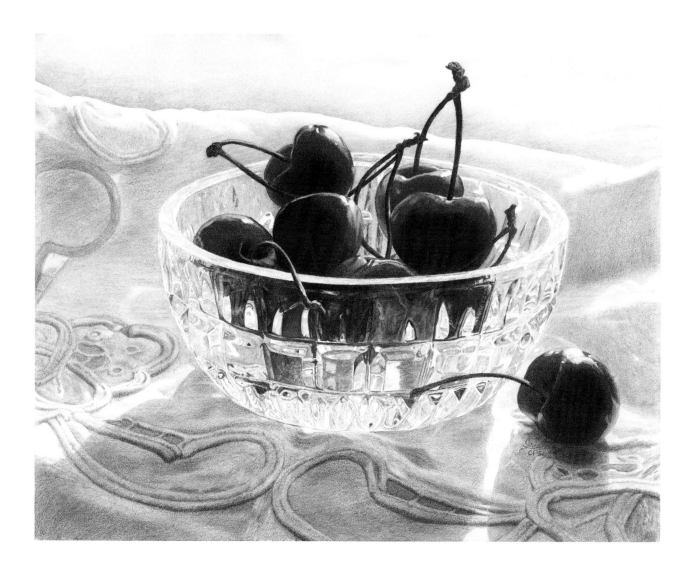

IRIS STRIPLING
Bowled Over

11 x 14"

Pastel Board

I have always admired the bright facets of sun-lit crystal, and having bought some wonderful Rainier cherries one recent spring, I decided to do several set-ups of the cherries in a crystal bowl. This composition is the result of that effort, which is rendered on pastel board, a fairly new surface for me. I am greatly attracted to the sparkle of crystal with backlighting on a lace cloth and was able to combine all these elements in this piece.

NANCY WOOD TABER
Toad of the Stones

16 x 9.25"

Crescent Mat Board

My creative process begins as a dance of sorts. I listen and open myself to receive information from the spirits of my subjects. When a particular subject (usually an animal or other element in nature) presents itself to me, I'm inspired to incorporate it into a drawing. I feel that the individual came to give me information on a spiritual level that is appropriate for me at that time in my life. Although I may interpret the information as it applies to my own situation, that same information may touch someone else in a completely different manner. The purpose of my art is to give my subjects a voice with which to share their wisdom. When the piece is completed, so is my dance with my subjects—yet a new and different dance of communion begins between the spirits of my creation and the viewer.

I enjoy using mat board for my drawings because it allows me to apply my colored pencils in heavy opaque layers. At first, the process of drawing in colored pencil seems so simple since almost everyone has used them at sometime in their life. Over the 20 years I have worked in colored pencil I have discovered that the very nature of the layering process has a meditative quality for me. The wonders and limitations of the medium have led me to understand that the lure of simplicity is often an illusion; that there are, in actuality, limitless layers to explore both in the medium and in nature.

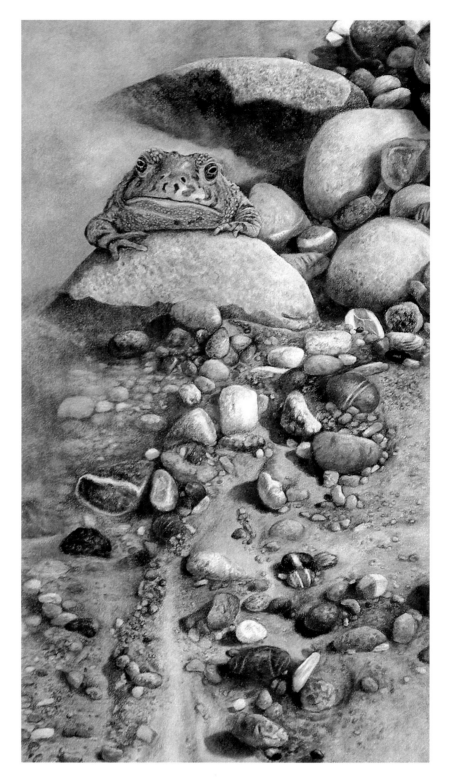

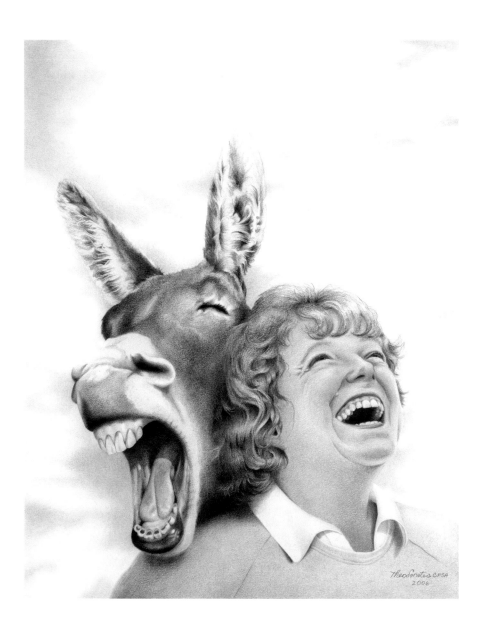

SHEILA THEODORATOS
Cracking Up

20 x 16"

Stonehenge Paper

My most successful art comes from idea flashes. Images of these basic art concepts then go through what I call a "sketch and stretch" process. Since realism in colored pencil can be time intensive, I stage and photograph my subjects and props. This gives me a reference base to blend with imagination and, at times, still life set-ups. Visual symbolism and storytelling are components played up and worked into my compositions.

Cracking Up is from my series of self-portraits and humor. I strove to capture a moment of "unbridled" laughter, when even an overcast day seems to brighten. Comparing and contrasting shapes, textures, colors, facial features and expressions between the donkey and me were great fun! (Whoa! Similarities far outweighed the contrasts!) In my original sketch, I wore my glasses. As I detailed the drawing of my nose and eye spacing, the glasses were distracting–so were left off the final artwork. I chose to balance the upright pointy ears of the donkey with my downward collar points. Finally, the background was literally cracked up–creating breaks in the cloudy sky.

WENDY THOMPSON
Eye of Nasturtium

12 x 10"

Strathmore Board–Heavy Weight Vellum

I discovered long ago that my true passion in art is creating detailed works with graphite pencil. Around 1997, people started asking if I had anything in color. I thought this a novel idea so I just jumped right in with colored pencils–but almost gave up out of frustration before I finally caught on. It took some time for me to realize that graphite pencil and colored pencil are two different tools, each to be held and used in their own manner. With this understanding I was able to transition the dynamics of my graphite work to intense color and still maintain quality and detail, soon developing the style and technique recognized in my work today. *Eye of the Nasturtium* represents my early work. I use the burnishing technique in most of my paintings, creating images that are often mistaken as watercolor. I recently realized what a "purist" I am when it comes to pencil work; even with color, I use only the pencil–no water-soluble pencils or solvents.

A lot of time and patience is required to complete a colored pencil painting, and it is this quiet time that fills specific therapeutic and meditative needs in my life. When I am working, my thoughts return to the quiet places of the woods and ponds, and I strive to emulate this in my work. If you feel a sense of quietude and tranquility when viewing my paintings, then I have been successful in conveying my thoughts and feelings to you and have hopefully given you a quiet place of your own.

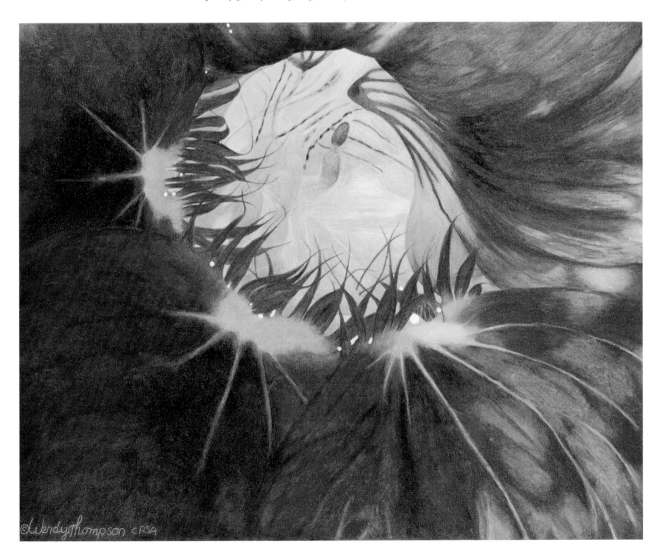

CAROL TOMASIK
Cybele

30 x 18"

Museum Board–Gray

My drawings usually begin with a figure, then surrounded by elements and patterning that appear dreamlike, rather than realistic. Its meaning is ambiguous, and it is the job of the beholder to discern who that figure might be, and how she came to be surrounded by clouds, or waves, or peonies.

RICHARD TOOLEY
Salazar's Corn

28 x 24"

Crescent Hot Press Illustration Board

I have been working with colored pencil since the late 1980s. Originally, I used this medium to produce color roughs of commercial work, preferring them over markers. It was a natural step to use colored pencil as a fine art medium.

My subject matter is usually somewhat common or easily recognized items from everyday life—objects people tend to overlook because of their basic form or function. My goal is to make the viewer take a closer look at what can be very interesting shapes and forms. I prefer to keep my color palette small and to manipulate the light, shade and color when I can.

PAUL VAN HEEST
Hydrophobic Otter

46.5 x 39"

Illustration Board

The *Hydrophobic Otter* is the third drawing in a series that highlights various phobias. My intent is to bring a bit of humor or unpredictability to what could be a serious condition.

I enjoy the challenge of juxtaposing my subjects in unlikely, if not impossible formations. I have been influenced by a variety of sources. Artists who have had a significant impact on my work (though it may not be apparent) include M.C. Escher, Salvador Dali, Norman Rockwell, Bruce McCombs and my older brother Wayne.

I have also been positively affected by my many years of teaching art at the middle school level. The creativity, humor and remarkable level of skill I've witnessed from thousands of students over the years have, I am sure, inspired me more than I realize. Finally, I receive the greatest inspiration from the original Creator. While being constantly amazed at the world around me, my hope is that I give the viewer another reason to look at what surrounds them.

JEANNE VASKO
Lace Curtain

11.375 x 9.75

Bristol Paper

I take hundreds of photographs for my portrait work. My photos are always candid, never posed. That way, I'm more likely to get an unguarded moment, a unique expression, or a look that tells the whole story.

After taking photographs at a family gathering, I discovered a great one of my granddaughter, Lindsey. The look on her face, the lighting, and that amazing dimple had me going for my pad and pencils.

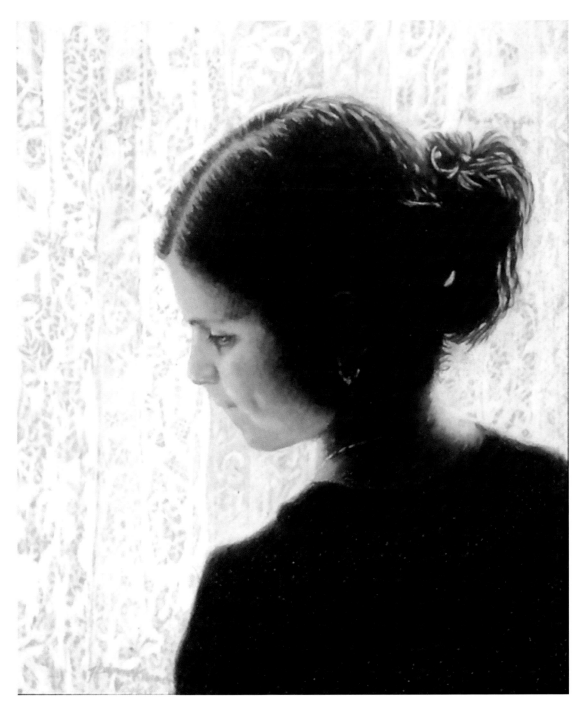

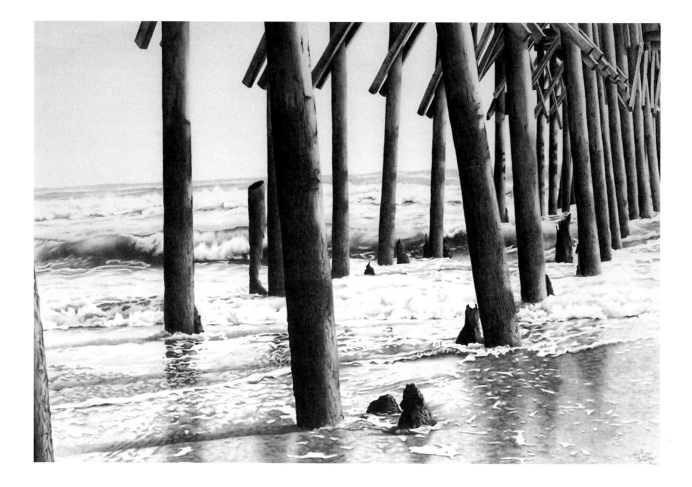

JOY ROSE WALKER
Surf City Pier

26 x 36"

140-lb. Hot Press Watercolor Paper

Selecting subject matter for my work is easy. I try to produce pieces that take me to some of my favorite places. During the summer, I spend part of almost every weekend at the beach. This is a pier in Surf City. I found the way the water breaks around the new pilings as it erodes away the old pilings interesting. Creating the breaks of the waves proved to be a dilemma for me. I shadowed them with purples, greens, blues, and browns and then lifted color with an electric eraser. This created an interesting texture and blending of color that I did not expect.

CATHERINE WARD
The Policymaker: Christy Hawkins

11 x 15"

Bristol Board 300

This is the third drawing in a series of portrait work revolving around the issues of social reconstruction. This confident young woman can smile at darkness. Enlightened, she approaches life knowing that she alone defines her identity.

I love colored pencil, each vertical stroke of the many layers of color makes me happy. The portrait satisfies my quest to allow colored pencil to choose an identity of its own in the world of fine art.

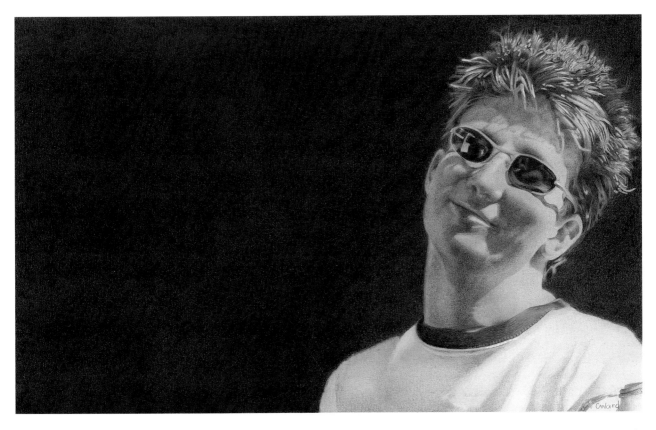

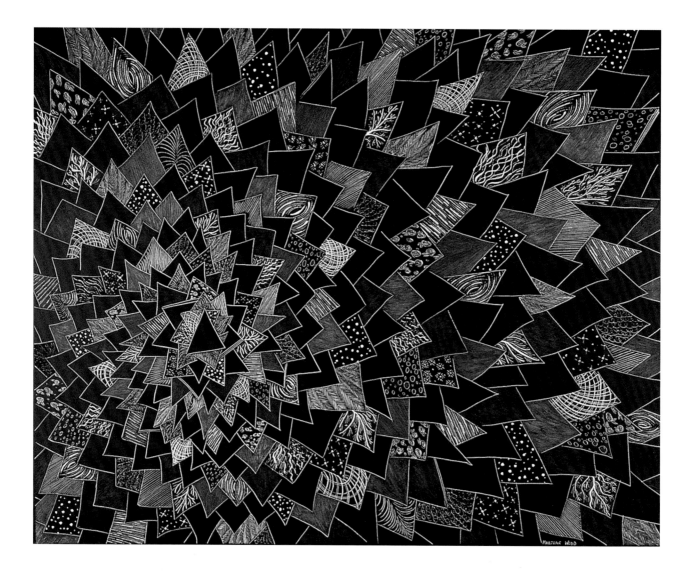

MARJORIE WEBB
Conundrum

20 x 24"

Essdee Scraper Board

Conundrum is the piece with which I attained my Signature status. Using a sgraffito technique, I etched the design into commercially prepared scratchboard, then, applied colored pencil throughout. Initially my intent was simply to explore texture and color contrasts within the geometric framework of the spiraling triangles. However, as I worked, I came to see this piece as a visual metaphor for life. Certain portions were delightful, others a chore. Some parts are vibrant and attractive in themselves; some are dull, dark or blank. Only when seen in its entirety is the pattern apparent–without the contrast of the dark and dull, the bright and beautiful would be diminished. What seemed to be random elements, both in the art and in life, have come together to form a unified tapestry.

ARLENE WEINSTOCK
January Dusk

19 x 24"

White Japanese Rice Paper

Light allows us to see; yet too much light washes away the detail. Fog and rain diffuse light and obscure what we see. My work celebrates the visual ambiguity caused by these atmospheric conditions. My images are designed to draw the viewer into the picture by providing an opportunity for interpreting what is seen. My technique adds to this ambiguity.

I use textured boards under lightweight paper, a technique known as "frottage," to create a rich painterly surface of optically mixed color. The surface adds vibrancy to the viewing experience. When standing close to the work, the viewer sees a complex abstract of overlapping textures made up of various marks and scribbles of color. As the viewer steps back from the surface, a landscape emerges. I engage the viewer to fill in the missing details and create a narrative.

Landscapes are spaces designed for personal reflection. The transitions from light to mid-range to dark and the complexity of the color mixing are a metaphor for the journey from emptiness to possibility.

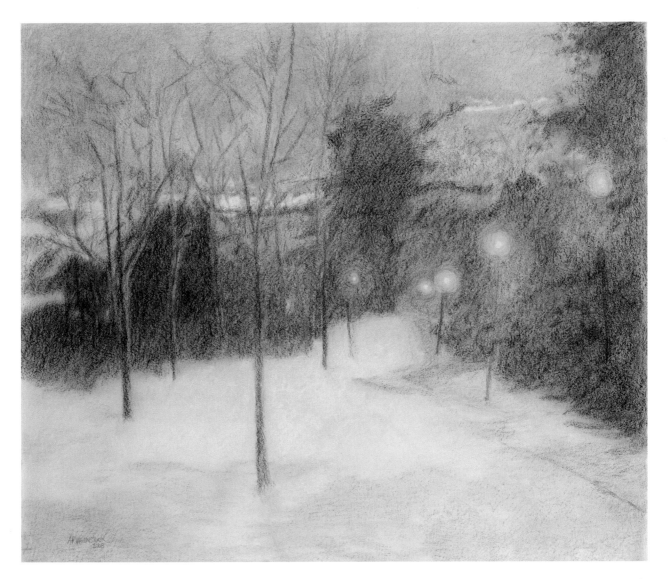

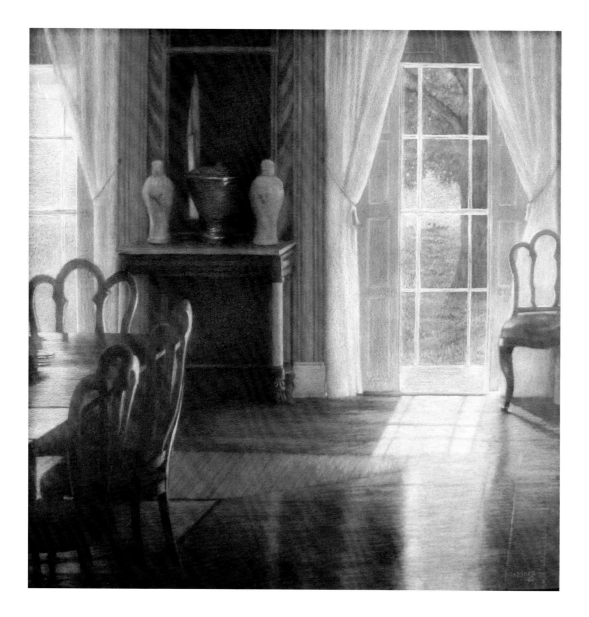

LINDA WESNER
Lake View 1

18 x 18"

Canson Mi-Teintes Paper–Sepia

When I walked through this dining room of the Rose Hill Mansion in Geneva, New York, I felt the presence of those who once lived in the house. I was entranced by the way the bright afternoon light illuminated the beautiful furnishings. I planned my composition as if I was taking the viewer on a visual tour to reveal why this interior space was significant to me.

I integrated interior and exterior spaces by bringing light into the darkened room (tabletop and floor reflections), and by repeating shapes (chair tops, table grouping, and bottom edge of foliage in right window). The table's angle leads the viewer into the room, to the shadowed objects between the windows, and then out to the lake beyond.

Sometimes reference shots need to "percolate" for several years before I have a clear vision of my intent. I kept returning to my notes and reference shot of this particular house, located along the interstate in New York, for nearly a decade.

HELEN HOGG WEST
Flight In Season

4.2 x 6.5"

Mylar

This painting is done in the style I call "fractured painting." I start by dividing the painting into different sections by overlapping circles, rectangles or other geometric shapes. Each small section represents something regarding the subject, in this case the four seasons. Each section is a small painting in itself. I like working on Mylar because of the bright colors it produces with no burnishing. The biggest drawback is that it will take only three to four layers of color. However, by using Mylar with a mat finish on two sides the artist can add more colors to the backside and create more depth to the painting. In this painting, I have included the birds that live or stay in an area during a particular season. How many birds can you find?

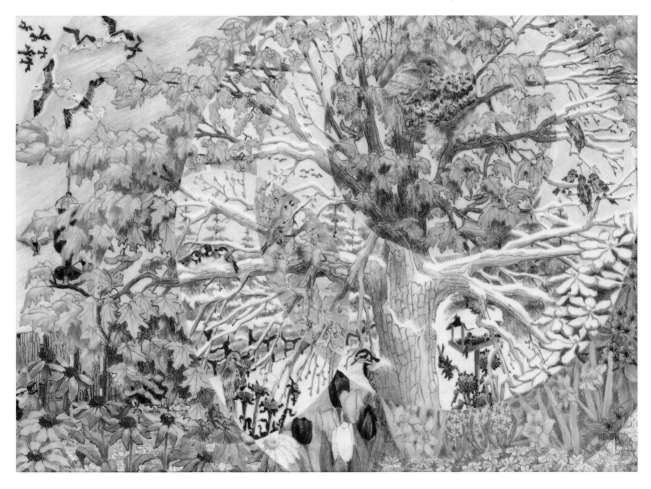

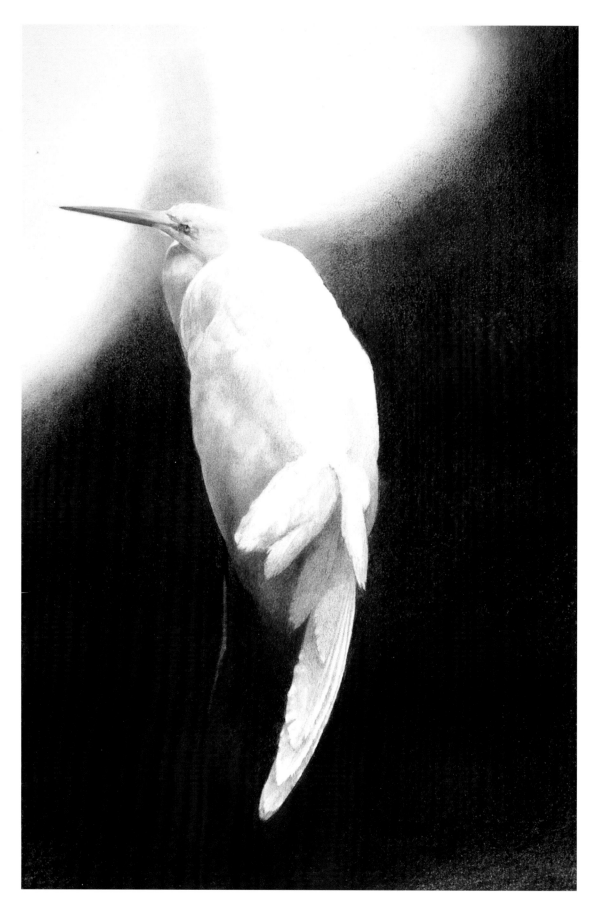

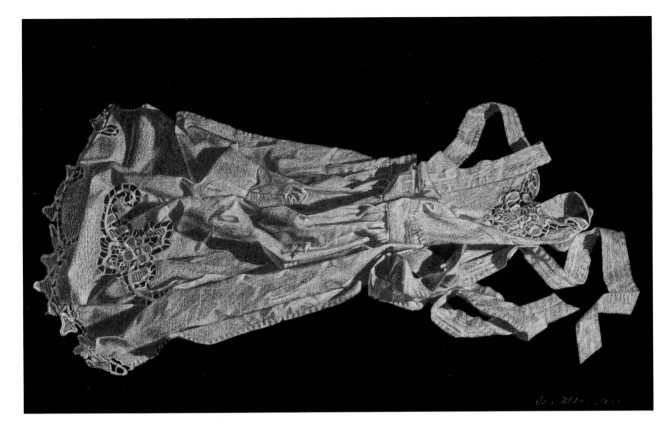

SYLVIA WESTGARD
White Egret

18 x 14"

Fabriano Uno Paper

I bought my first set of colored pencils in 1985 while on a camping trip to Canada. In a tiny general store in the woods, these pencils called my name ... try me, try me. I was enchanted and left the paints I had with me in the van and took up with the pencils. I was so fickle.

I have a strong background in drawing, so pencils, colored or graphite, are a perfect match for me. They accompany me everywhere along with my sketchbook, camera and telephoto lens, a must have for a wildlife artist. My work is based on the photographs and sketches I do on vacations, at zoos, wildlife refuges, forest preserves, animal foundations and my own backyard.

My favorite subjects are the endangered species of the world that I find only in a zoo. I have been fortunate to spend some time in Alaska photographing grizzly bears, moose, birds and whales.

I found the white egret, recuperating from an encounter with a window, at the Brookfield Zoo. She was later released into the wild.

DENA WHITENER
Company's Gone

8 x 13"

Canson Mi-Teintes–Black

I like the simplicity of this drawing done for a "Black and White" show organized by the local art guild. It is a "quiet" drawing, with a nostalgic mood, of my mother's favorite apron. I enjoyed the challenge of drawing the cut-out lace panels and trim. Colored pencil is perfect for the tonal approach of this piece.

I wanted high contrast in values between the fabric in the light and where the fabric falls in shadow. So I worked in a dark studio with one light source. Layer after layer of white colored pencil was applied with a very light touch. This light application let the valleys of the black paper show through giving it almost a stippled look. Burnishing was used in very small areas.

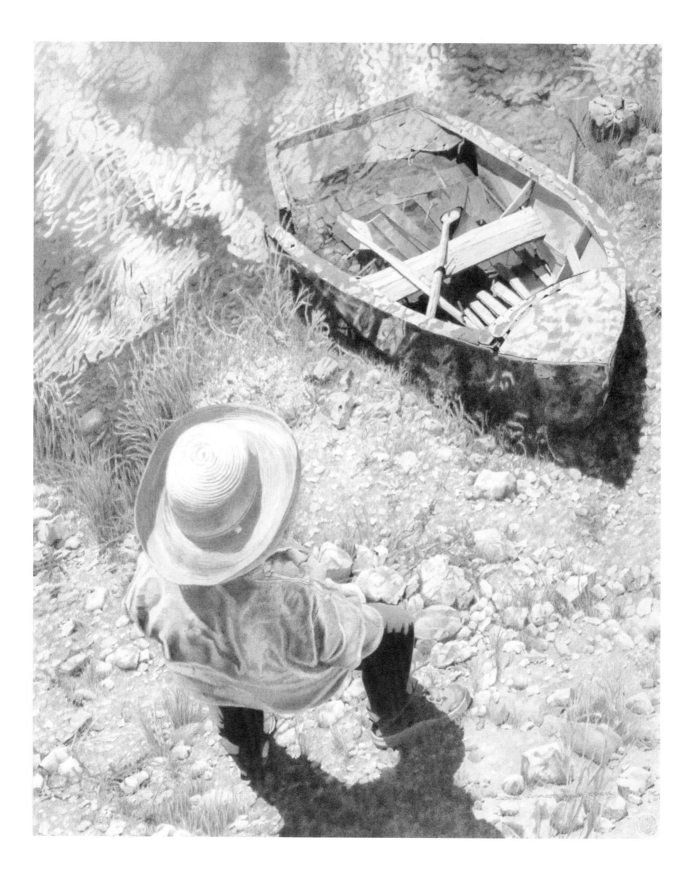

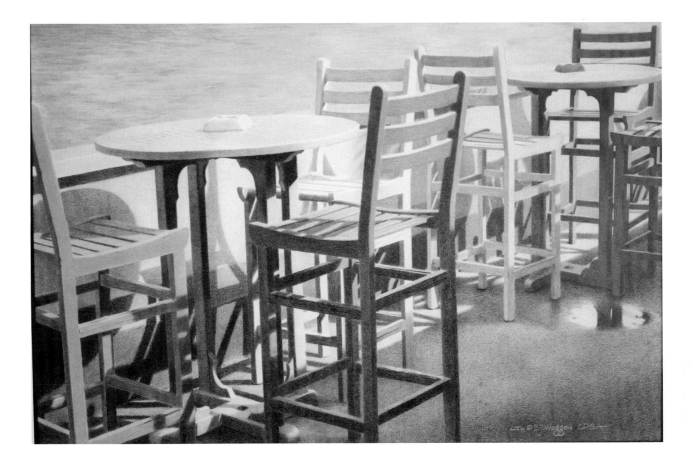

JANE WIKSTRAND
Kate and the USS Tin Cup

36 X 31"

Strathmore Bristol Vellum 500 Series

One of the joys of living in Colorado is taking advantage of its abundant beauty. Jeep trips into the high country have taken us on a multitude of breathtaking journeys where we enjoyed wonderful vistas steeped in beauty and history.

On one trip through the old gold town of St. Elmo, we crossed the continental divide above timberline and dropped down to the historical town of Tin Cup. Here in this high-country town was a small café famous for its homemade pies, so we stopped for a treat. While sitting on the elevated porch of Frenchy's Café, our friend Kate went below to look at the children's fishing pond directly in front of the café. At the edge of the pond was a half submerged rowboat. No one was sure how long it had been there, or how many stories it could tell. From above Kate, while she looked at the wonderful rowboat, I snapped the best photos of her in her big straw hat. This was a moment I had to share. The situation, the contrasts, the textures and shapes all seemed to blend perfectly to make a wonderful drawing.

BRENDA WOGGAN
Rainbow Chairs

20 x 30"

Strathmore Bristol 500 Series

When drawing in colored pencil, I look for subjects that are both dramatic in visual impact as well as intriguing to me as an artist. Because colored pencil drawings require a considerable investment of time, I need to have a deep commitment to the subject in order to maintain the momentum needed to finish the piece. This spark of commitment was there from the first glimpse of the subject matter—a sense that "I've got to draw this!" When this happens, I usually get a fairly good result.

I used a reference photo to draw *Rainbow Chairs*. My motivation was to record the geometrical interplay of light and dark in a group of tables and chairs at a Bahamian bar. This piece was a good exploration of how sunshine and shadow alter colors.

ELYSE WOLF
Tomatoes.

22 x 30"

Arches 140-lb. Hot Press Aquarelle Paper

The challenge of drawing these tomatoes was how to transform such a humble prosaic subject into art. I drew the tomatoes larger than life and arranged them together in the center of the paper so they would make a bold statement. They stand on a blank background with no other point of reference except for their own reflections. The plain white background enhances the vivid red color of the tomatoes. The tomatoes are rendered in a realistic style, but as any artist who copies from life can tell you, the more you explore a subject, the more there is to see, and the closer you examine a subject, the more elusive it becomes. No matter how realistic the rendering, you are still dealing with a two-dimensional surface, so "realism" is an illusion. Perhaps that's why I chose to include the reflections of the tomatoes. In the end, I became so connected to my subject that when I finished this drawing, I couldn't bear to eat the tomatoes because it would feel like cannibalism.

To achieve the richest red possible, I combined at least 8 different shades of red, layering them lightly to avoid waxy buildup. I enhanced the reds with several shades of orange, yellow and green. For the shadows, I used mostly dark blues and reds. I like Arches Aquarelle paper because it has a slick surface and can take lots of layering that gives the tomatoes a translucent glow.

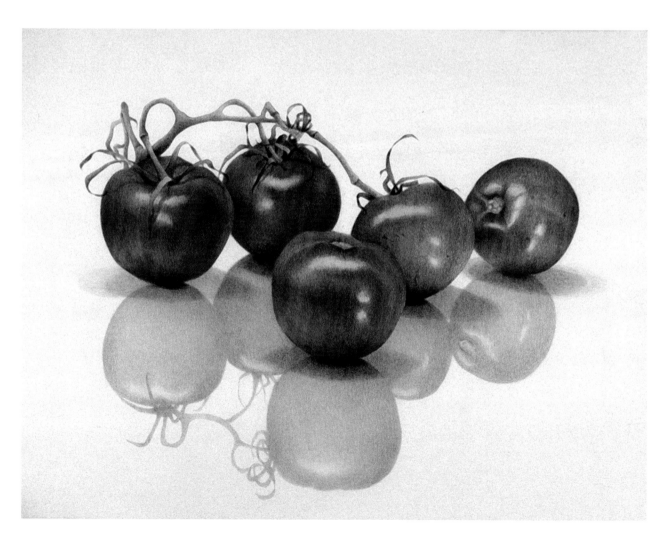

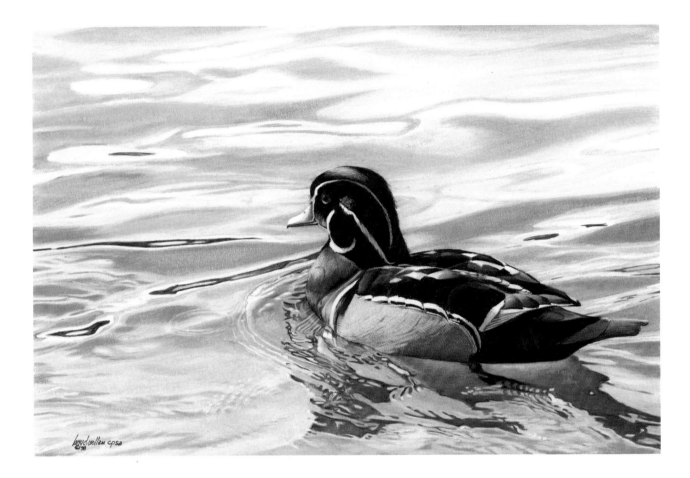

LARRY D. WOLLAM
Cruisin'

9 x 14"

Aquabee 2-Ply Vellum Bristol Board

I have worked with colored pencils since the early 1950s and have taught the medium for 37 years. I've seen colors come and go, and I still rely on the Prismacolor brand. Once I was asked to do a demonstration at an art store in Tucson where I worked as a custom framer and arts consultant. Using a different brand of pencil, I started *Cruisin'* but was having trouble blending the pencils. I reached a point in the water portion of the drawing when I was ready to destroy the rendering. Fortunately, the demo ended. I finished this piece using my favorite brand.

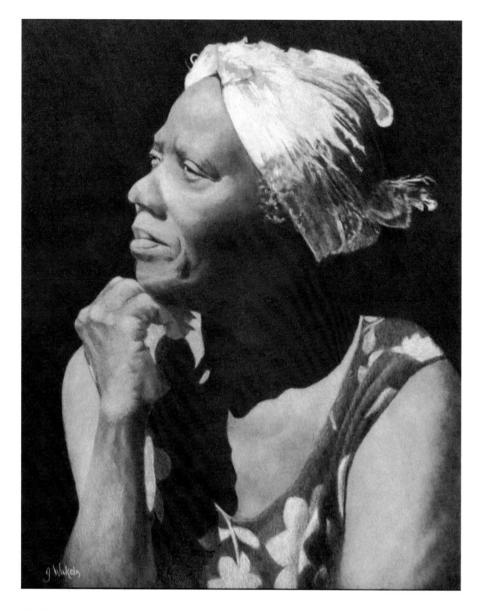

JACLYN WUKELA
Nassau Lady VIII

20 x 16"

Pastelbord

Although my work encompasses many media and subject matters, at the center I always find figures. Once you have painted or drawn a face and those eyes look back out of a face you recognize, you become lost in it. Black and white drawings are intimate works in their execution and viewing and often seem more real than real.

I found an entire new life when I came across colored pencils. I love each layer of the sequence. I don't use the more time-saving methods, but find great pleasure in laying back in my chair and doing little circles into the night.

Once, an African American friend asked why I drew his people so much. I asked him to put out his arm and I placed mine beside it. The conversation was over. Anyone could see how uninteresting my pale, puny colors looked compared to the wonderful browns, reds, purples and blues of his skin. The good news is that my subjects are everywhere. My last model was in a restaurant during breakfast the other morning. She had a great face and had on an even better head wrap. Too bad, my breakfast was ruined because I had to go meet her.

ANN YARBROUGH
Spice of Life

11 x 14"

Card Stock

When people ask me what inspires me, I have to say nature and the beauty of her colors. If I like what I see, I draw it!

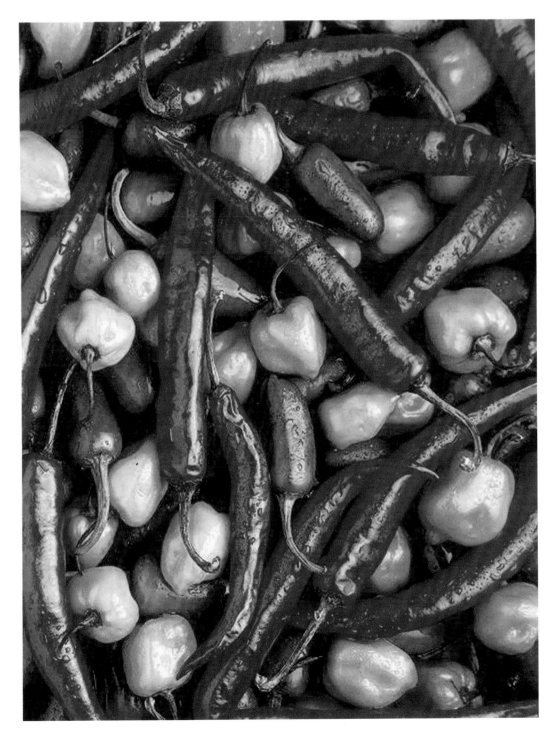

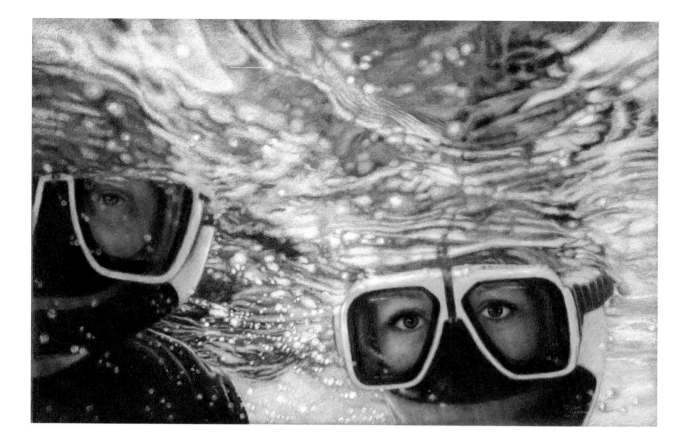

DEBRA KAUFFMAN YAUN
Skindiving in Aruba

12 x 19"

Canson Mi-Teintes Paper–Steel Gray

On vacation in Aruba, my husband and I were taking underwater photos of the colorful fish and took a photo of the two of us just for fun. We were surprised what a interesting photo we managed to get from a cheap camera! I changed the cropping and made a few other adjustments for composition. It was a challenge to capture the many colors, patterns and reflections of the water. The hardest part was the faces since it was dark inside the masks and the eyes were hard to see, so I used a mirror for myself and my husband had to pose for his likeness.

SIDNE ZENNER
Among the Leaves

8 x 11"

Fabriano Uno 300-lb. Watercolor Paper

As an artist, I try to make something ordinary extraordinary. My desire is to have viewers of my work be intrigued enough to observe a piece and then to want to return to it again and again.

I approach my work in colored pencil with a soft touch. I enjoy the results of building complex colors with many layers of pigment. With colored pencil, my work tends to be mostly representational with an ethereal or delicate feel to it.

Perhaps the subject matter adds to this ethereal feel. I find my inspiration in the garden among the leaves and vibrant colors. Flowers seem so saturated with their colors and there is mystery among the leaves. This I want to capture as well as the play of light filtering through our lives and making the world sparkle.

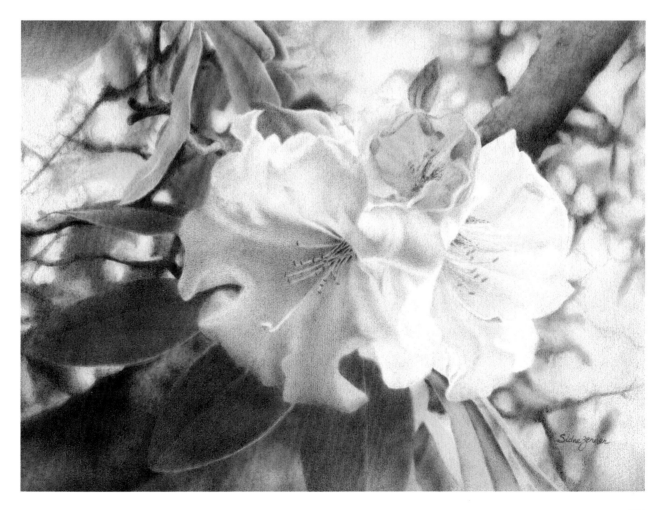

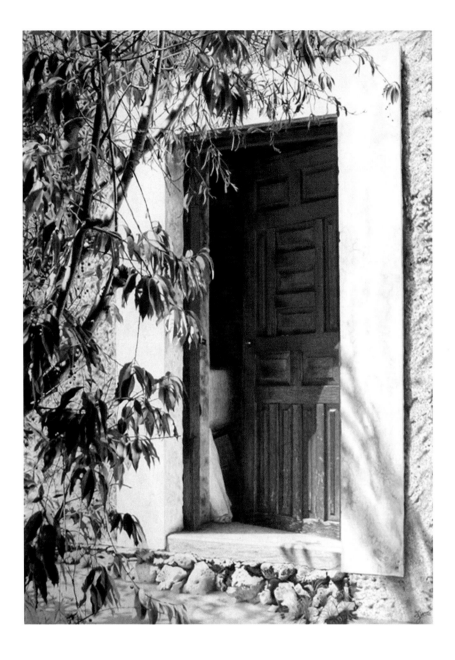

CHRIS ZINN
La Puerta Roja

28 x 20"

Watercolor Paper

This drawing is the fourth in a series of works inspired by several trips to the Bajio region of Mexico. The door is the entrance to a storage building on the grounds of a pottery artist near Guanajuato, Mexico and is the most difficult and time consuming drawing I have created so far.

I take lots of photos on these trips so I have plenty of reference material to use later in the studio. My drawings are too large and take too much time to allow me to work "en plein air."

The exuberant use of color on the buildings make them great fun to draw. The clear, bright sunlight in these high elevation cities just intensifies the color. Strong shadows reveal all the textures and pops the colors.

PAMELA ZUBROD
Sunbrella

17 x 22"

Holbein Sanded Pastel Paper

The combination of nature and manmade structures lend artists a world of opportunity. The forces of wind produce movement; precipitation encompasses texture and temperature; and light denotes the time of day and creates interest in shadows. The reaction of these elements upon natural or manmade objects result in identifiable scenarios, but it is up to the artist to make the combination memorable.

In capturing this image with my camera, I was intrigued by the design of the shadows of the leaves falling across the overhead umbrella. I had to redefine the objects to create interest and to marry manmade with nature. I did this by depicting the spines of the umbrella as wooden, rather than metal, thus creating "branches" to connect to the leaf patterns overhead. The result provides the viewer a chance to enjoy the irregular shapes of the leaves, the interaction of the overlapping spines and the depth created by their shadows.

This piece was drawn on sanded pastel paper, adding yet another dimension to the composition. The graininess allowed the colored pencil to skip along the surface, leaving areas of untouched paper to create the glow of the sun shining through the canvas umbrella. The center pole was burnished to produce a smooth texture: the illusion of a trunk for the "tree."

Nature's dynamic contribution to this piece was the light; the angle of the sun provided a variety of shadow values and a memorable, yet fleeting, moment in time.

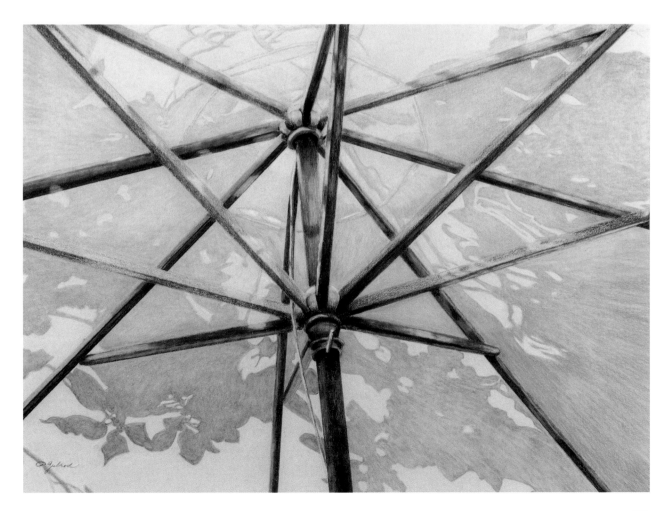

CPSA SIGNATURE MEMBERS ARTISTS' INDEX

Deane Ackerman
Sumter, SC

Patricia Andril
Arlington, VA

Bonnie Auten
Tecumseh, MI
www.bonnieauten.com

Pat Averill
Oregon City, OR
www.pataverill.com

Daniel Baggett
Plano, TX
www.bigpencilart.com

Cecile Baird
Hillsboro, OH
www.cecilebairdart.com

Jeffrey Smart Baisden
Live Oak, FL
www.jeffreysmartbaisden.com

Pat Barron
Santa Monica, CA

Donna M Basile
Scituate, MA
www.donnabasile.com

Elaine Bassett
Stanwood, WA

Melinda Beavers
Albuquerque, NM
www.melindabeavers.com

E Ann Beeman
Sandy, OR

Pamela Belcher
Kenmore, WA
www.pamelabelcher.com

Sandra Benny
Huntington, NY
www.sandrabenny.com

Bobbie Bradford
Encinitas, CA

Susan L Brooks
The Woodlands, TX
www.SusanBrooksFineArt.com

Bobbie Brown
St Charles, IL

Philip Brulia
Ebensburg, PA

Cynthia Brunk
Mashpee, MA

E Michael Burrows
Denver, CO

Barbara Byram
Parma, OH

Lynn A Byrem
Harrisburg , PA

Donna Caputo
The Villages, FL

Jennifer P Carpenter
Christiansburg, VA

Karen Coleman
Round Hill, VA

Gail T Collier
Barrington, IL
www.gailcollier.com

Kathryn Conwell
Lawton, OK

Bill Cupit
Goodyear, AZ

Vera Curnow
Rising Sun, IN
www.veracurnow.com

Susan D'Amico
Bandon, OR
www.bellalunaportraits.com

Martha DeHaven
Rio Rancho, NM

Kay Dewar
Bremerton, WA
www.kaydewar.com

Sherry Eid
Livonia, MI

Lynda English
Florence, SC
www.lyndaenglishstudio.net

Elliott Everson
Phoenix, AZ

Allison Fagan
Kanata, Canada
www.allisonfagan.com

Shawn Falchetti
Dallas, PA
www.shawnfalchetti.com

Kendra Bidwell Ferreira
Portsmouth, RI
www.kjfdesign.com

Carol Fogelsong
Alexandria, VA
www.carolfogelsong.com

Lori Garner
Argyle, TX
www.lorigarnerart.com

Donna Gaylord
Tucson, AZ

Joan Gelblat
Atlanta, GA

Jeff George
Mission Viejo, CA
www.jeffgeorgeart.com

Marilyn Gorman
Birmingham, MI

Constance R Grace
Alexandria, VA

Penny M Greiner
Cherryville, NC

Gemma Gylling
Valley Springs, CA
www.glassgems.net

Carolyn J Haas
Pittsburgh, PA

Daniel Hanequand
Toronto, Canada
www.danielhanequand.com

Shinji Harada
Kanagawa, Japan
www.color-pencil.jp

Linda Lucas Hardy
Omaha, TX
www.lindahardy.com

Cathy Heller
Woodbridge, VA

Linda Boatman Henize
Channahon, IL

Susan Munich Henkels
Sedona, AZ
www.sedonacouselinggroup.com

Carlynne Hershberger
Ocala, FL
www.hershbergerhuff.blogspot.com

Priscilla Heussner
Fort Atkinson, WI

Sylvester Hickmon Jr
Sumter, SC

Mary G Hobbs
Chagrin Falls, OH
www.maryhobbs.net

Tonya Holland
Tucson, AZ

Elizabeth Holster
Placentia, CA

Marjorie Horne
Knoxville, TN

Richard Huck
Lancaster, PA

Carolyn Hudson
Empire, MI
www.manypencils.com

Deborah Hughes
San Clemente, CA

Priscilla Humay
Highland Park, IL
www.humayfineart.com

Suzanne Hunter
El Paso, TX

Monica T Jagel
Ontario, WI
www.colored-pencil-girl.blogspot.com

Toni James
Vail, AZ
www.tonijames.blogspot.com

J Corinne Jarrett
Gresham, OR

Jane Johnson
Mansfield, OH

Carol Joumaa
Falls Church, VA

Carolyn Kenny
San Diego, CA

Jill Kline
Marquette, MI

Linda Koffenberger
Holly Springs, NC

Kristy A Kutch
Michigan City, IN
www.artshow.com/kutch

Kate Lagaly
Myrtle Beach, SC
www.katelagaly.blogspot.com

Robert C Lasky
Wheaton, IL

Donna Leavitt
Edmonds, WA
www.donnaleavittart.com

Heidi J Klippert Lindberg
Eastsound, WA

Amy Lindenberger
North Canton, OH
www.AmyLindenberger.com

Dyanne Locati
Gladstone, OR

Rita Dunn Ludden
Falls Church, VA

Teresa McNeil MacLean
Santa Ynez, CA
www.teresamcneilmaclean.com

Paula Madawick
Hewitt, NJ

Linda J Mahoney
Beeville, TX
www.lindamahoneyart.com

Jean A Malicoat
Hillsboro, OH

Ann James Massey
Paris, France
www.annjamesmassey.com

James K Mateer
Wellington, OH
www.jkmateer.com

Eileen Matias
Akron, OH

Sharon Frank Mazgaj
Uniontown, OH

Carla McConnell
Montesano, WA
www.artsister.com

Jane McCreary
Tucson, AZ
www.janemccreary.com

Ruth Schwarz McDonald
Philipsburg, MT

Heather W McGarey
Louisville, CO
www.cpsadc220.com

Mike Menius
Forestville, CA
www.mikemenius.com

Sheila Minnich
Midwest City, OK

Maureen Mitchell
Seattle, WA
www.maureenlmitchell.com

Gene Mlekoday
Maple Grove, MN
www.genemlekoday.com

Mari K Moehl
Orlando, FL

Kathleen Montgomery
Plymouth, MI

Rose Moon
Sedona, AZ
www.rosemoon.net

Cynthia C Morris
Sedalia, MO

Linda Morton
Madison, AL
www.lmortonart.com

Rhonda Nass
Prairie du Sac, WI
www.rnass.com

Melissa Miller Nece
Palm Harbor, FL
www.mmillernece.com

Bruce J Nelson
Centralia, WA
www.art-exchange.com

Barbara Benedetti Newton
Renton, WA
www.barbaranewton.net

Alyona Nickelsen
Aliso Viejo, CA
www.BrushAndPencil.com

Eileen Hagerman Nistler
Upton, WY
www.eileennistler.com

Anita Orsini
Ft Lauderdale, FL

Laura Ospanik
Cleveland Heights, OH

Linda Williams Palmer
Hot Springs, AR
www.lindawilliamspalmer.com

Rita Paradis-Caldwell
Bethany, CT

Gretchen Evans Parker
Lexington, SC
www.gretchenevansparker.com

Paula Parks
Shoreline, WA

Helen K Passey
Tulalip, WA

Monique Passicot
San Francisco, CA
www.moniquepassicot.com

Elizabeth Patterson
North Hollywood, CA
www.eapatterson.com

Kelly Patterson
Seattle, WA

Don Pearson
Tulsa, OK

Mike Pease
Eugene, OR

Sandra Phifer
Tucson, AZ
www.sandyphifer.com

Rita Sue Powell
Elfrida, AZ

B J Power
Tombstone, AZ

Lisa Prusinski
Grand Rapids, MI
www.lisaprusinski.com

Laurene Puls
Canton, OH
www.LaurenePuls.com

Richard Quigley
Eugene, OR

Joan E Robertson
Wauconda, IL

Barbara Rogers
Lakewood, CA
www.barbararogersfineart.com

Sheila Scannelli
North Canton, OH

Kay Schmidt
West Linn, OR

Lynda K Schumacher
Brooklyn, MI
www.lyndaschumacher.com

Terry Sciko
Macedonia, OH

Patricia Scott
Hopkins, MN

Allan Servoss
New Auburn, WI
www.allanservoss.com

Carla K Sexton
Arlington, TN

Shane
Valley, WA

Gail H Shelton
Winnfield, LA
www.gailshelton.com

Judith Shepelak
Oak Park, IL
www.jshepart.com

Lee Sims
Lansing, NY

Rita Mach Skoczen
Rochester Hills, MI

Donna S Slade
Wake Forest, NC
www.donnasladeart.com

David J Smith
Oxnard, CA

John P Smolko
Kent, OH
www.smolkoart.com

Eileen F. Sorg
Kingston, WA
www.twodogstudio.com

Shirley Stallings
Mukilteo, WA

Arlene Steinberg
Roslyn, NY
www.arlenesteinberg.com

Sabyna Sterrett
Springfield, VA
www.sabynasterrett.com

Winifred Storkan Stone
Solon, OH

Iris Stripling
Federal Way, WA

Nancy Wood Taber
Tijeras, NM
www.nancywoodtaber.com

Sheila Theodoratos
Shoreline, WA

Wendy Thompson
McMinnville, OR
www.wthompsonart.com

Carol Tomasik
Norton, OH

Richard Tooley
Decatur, IL

Paul Van Heest
Holland, MI
paulvanheestart.com

Jeanne Vasko
Haymarket, VA

Joy Rose Walker
Jacksonville, NC
www.home.earthlink.net/~joyrosewalker

Catherine Ward
Damon, TX
www.cathy-ward.com

Marjorie Webb
Itasca, IL

Arlene Weinstock
Long Beach, CA
www.arlenew.com

Linda Wesner
Lewis Center, OH
www.lawesner.com

Helen Hogg West
Renton, WA

Sylvia Westgard
Buffalo Grove, IL

Dena Whitener
Fairfield Glade, TN

Jane Wikstrand
Wheat Ridge, CO

Brenda Woggon
Rice, MN

Elyse Wolf
Washington, DC

Larry D Wollam
Tucson, AZ

Jaclyn Wukela
Florence, SC
www.lyndaenglishstudio.net

Ann Yarbrough
Cedartown, GA

Debra Kauffman Yaun
Buford, GA
www.debrayaun.com

Sidne Zenner
Lake Oswego, OR

Chris Zinn
Calistoga, CA

Pamela Zubrod
Collierville, TN

Colored Pencil Society of America

SIGNATURE SHOWCASE

Rita Mach Skoczen
Enter the Night II
17 x 27.75"

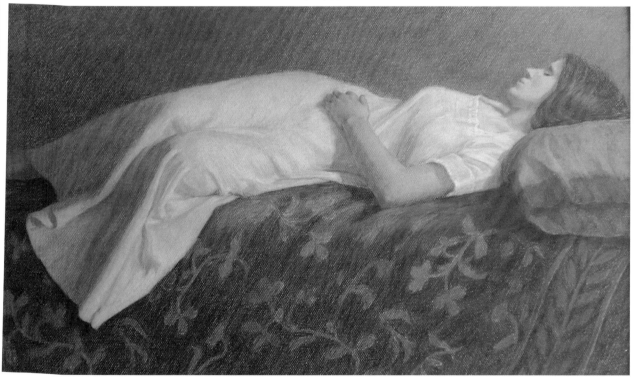

Complied by

Vera Curnow

Colored Pencil Society of America